HISTORIC PHOTOS OF
RICHMOND
IN THE 50s, 60s, AND 70s

TEXT AND CAPTIONS BY EMILY J.
AND JOHN S. SALMON

TURNER
PUBLISHING COMPANY

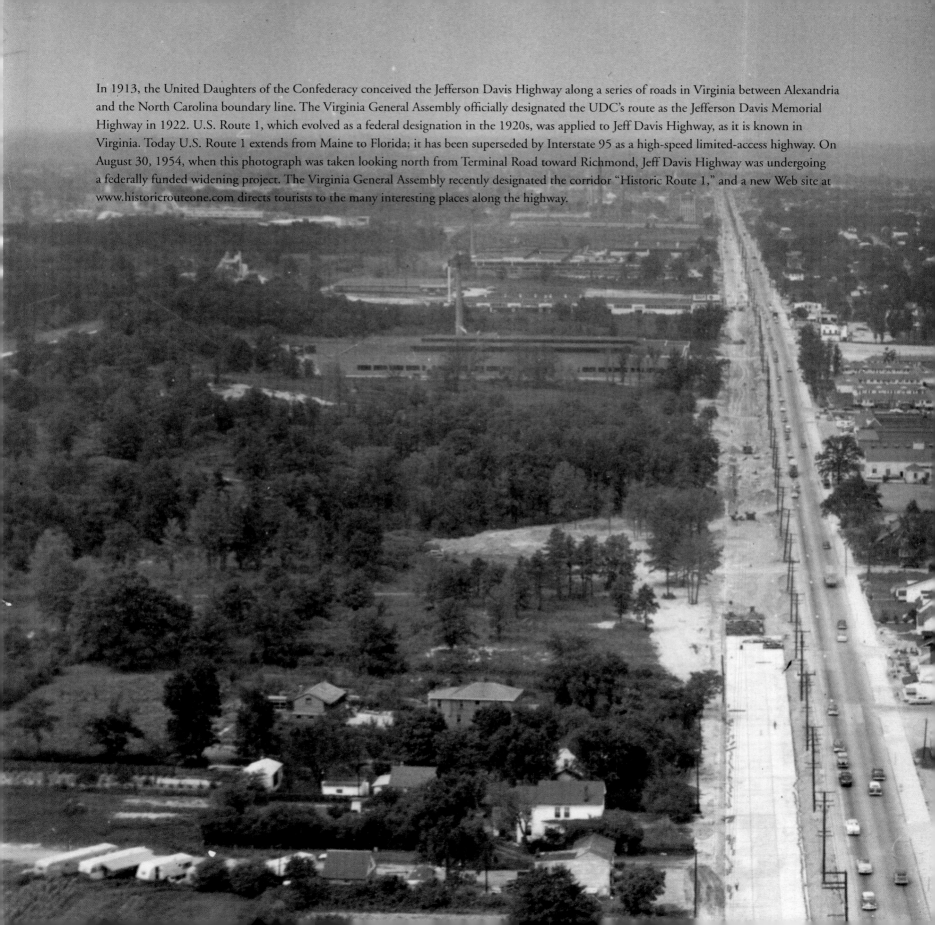

In 1913, the United Daughters of the Confederacy conceived the Jefferson Davis Highway along a series of roads in Virginia between Alexandria and the North Carolina boundary line. The Virginia General Assembly officially designated the UDC's route as the Jefferson Davis Memorial Highway in 1922. U.S. Route 1, which evolved as a federal designation in the 1920s, was applied to Jeff Davis Highway, as it is known in Virginia. Today U.S. Route 1 extends from Maine to Florida; it has been superseded by Interstate 95 as a high-speed limited-access highway. On August 30, 1954, when this photograph was taken looking north from Terminal Road toward Richmond, Jeff Davis Highway was undergoing a federally funded widening project. The Virginia General Assembly recently designated the corridor "Historic Route 1," and a new Web site at www.historicrouteone.com directs tourists to the many interesting places along the highway.

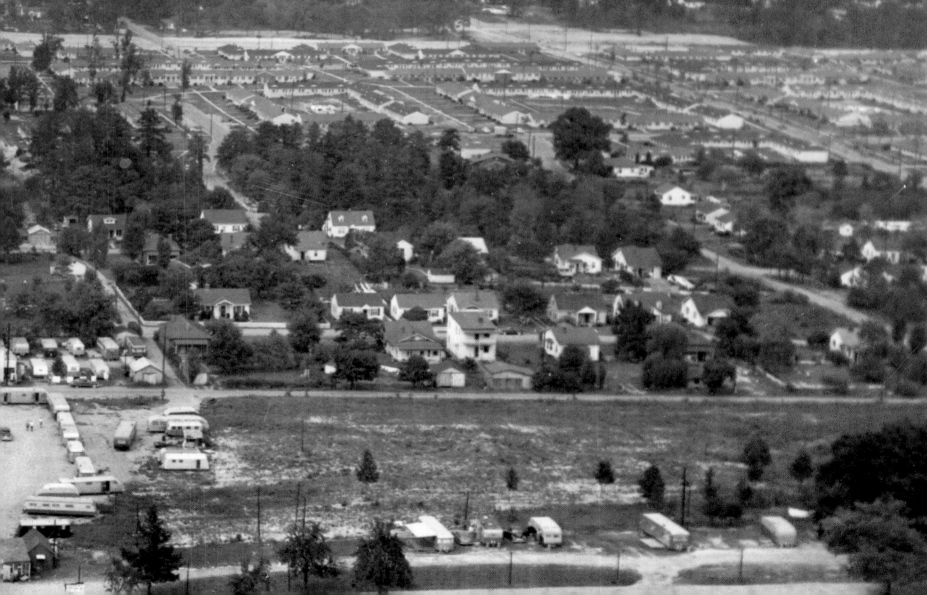

HISTORIC PHOTOS OF
RICHMOND
IN THE 50s, 60s, AND 70s

Turner Publishing Company
200 4th Avenue North • Suite 950
Nashville, Tennessee 37219
(615) 255-2665

www.turnerpublishing.com

Historic Photos of Richmond in the 50s, 60s, and 70s

Copyright © 2010 Turner Publishing Company

Library of Congress Control Number: 2010921715

ISBN: 978-1-59652-594-8

Printed in China

10 11 12 13 14 15 16—0 9 8 7 6 5 4 3 2 1

Contents

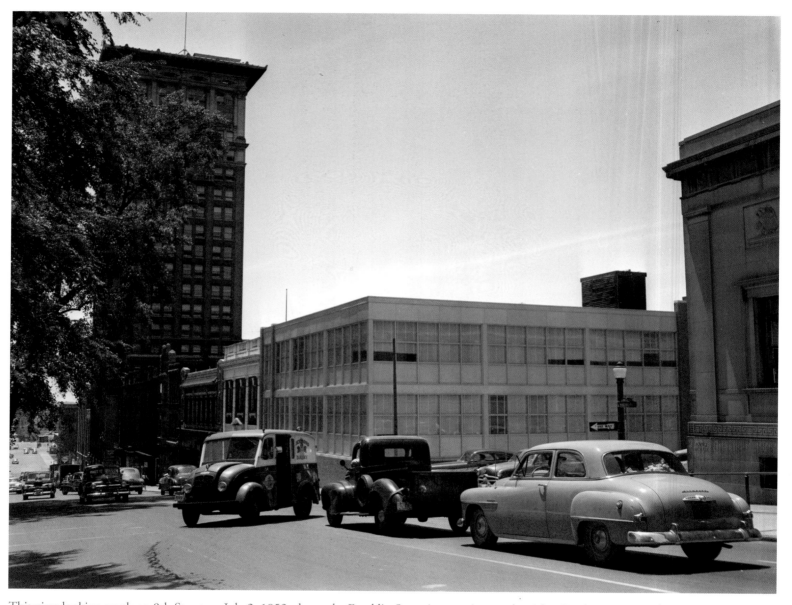

This view looking south on 9th Street on July 2, 1952, shows the Franklin Street intersection on the right. On the extreme right is a portion of the Federal Reserve Building, and the skyscraper in the distance is the First National Bank building, completed in 1913. The small building in the middle housed state government offices and was demolished several years ago for a new structure for the same purpose.

ACKNOWLEDGMENTS

This volume, *Historic Photos of Richmond in the 50s, 60s, and 70s,* is the result of the cooperation and efforts of many individuals, organizations, and corporations. It is with great thanks that we acknowledge the valuable contribution of the following:

Dale Neighbors, Picture Collection, Library of Virginia, Richmond, Virginia

Quatro Hubbard, Archives, Virginia Department of Historic Resources, Richmond, Virginia

PREFACE

The history of the Richmond area has been captured in thousands of photographs that reside in archives, both locally and nationally. Some of those pictures were gathered into *Historic Photos of Richmond,* which Turner Publishing issued in 2007. Like that book, this one begins with the observation that, while those photographs are of great interest to many, they are not easily accessible. Many new and longtime residents are curious about the city's history, especially as the streetscapes and individual buildings associated with that history sometimes seem to be in the way of progress. Many people are asking how to treat these remnants of the past. These decisions affect every aspect of the urban environment—architecture, public spaces, commerce, infrastructure—and these, in turn, affect the way that people live their lives. This book seeks to provide easy access to a valuable, objective look into the history of Richmond through photographs.

The power of photographs is that they are less subjective than words in their treatment of history. Although the photographer can make subjective decisions regarding subject matter and how to capture and present it, photographs seldom interpret the past to the extent textual histories can. For this reason, photography is uniquely positioned to offer an original, untainted look at the past, allowing the viewer to learn for himself what the world was like a century or more ago.

This project represents many hours of research. The editors and writers have reviewed thousands of photographs in numerous archives. We greatly appreciate the generous assistance of the individuals and organizations listed in the acknowledgments, without whom this project could not have been completed.

The goal in publishing this work is to provide broader access to these extraordinary photographs, to inspire, furnish perspective, and evoke the insight that might assist those who are responsible for determining the future of Richmond. In addition, we hope that the book will encourage the preservation of the past with adequate respect and reverence.

With the exception of touching up imperfections that have accrued with the passage of time and cropping where necessary, no changes have been made. The focus and clarity of many images are limited to the technology and the ability of the photographer at the time they were recorded.

The book is divided into three eras. The first chapter records the life of Richmond as it recovered from the Great Depression and World War II in the 1950s. The second chapter looks at the changes that occurred as Richmond underwent rapid growth in the 1960s. The third chapter takes the photographic story into the 1970s, when the loss of many old buildings engendered a new preservation ethic.

In each of these sections we have made an effort to capture various aspects of life through our selection of photographs. People, commerce, industry, recreation, transportation, infrastructure, and religious and educational institutions have been included to provide a broad perspective.

We encourage readers to reflect as they drive or walk the streets of Richmond, enjoy the parks, and experience the amenities of this bustling metropolitan area. It is the publisher's hope that in utilizing this work, longtime residents will learn something new and that new residents will gain a perspective on where the region has been, so that each can contribute effectively to its future.

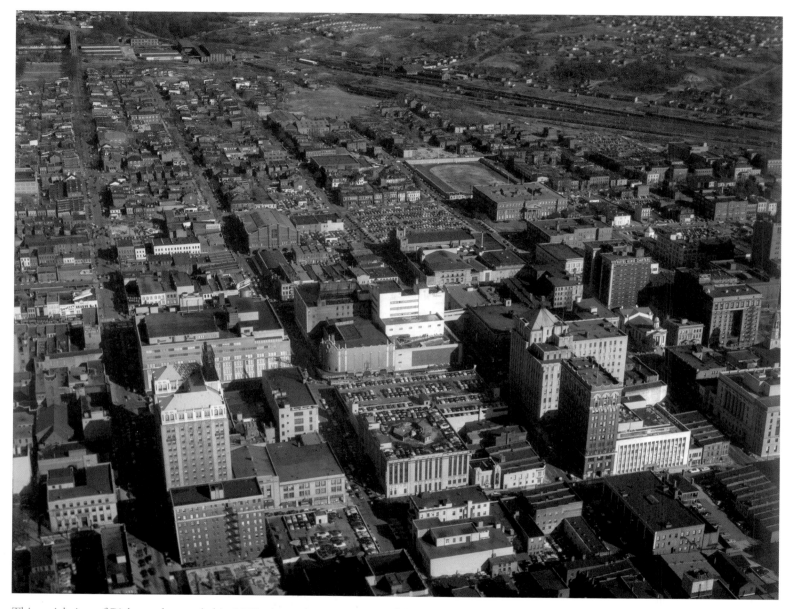

This aerial view of Richmond, recorded in 1953, shows the western part of downtown looking north from around Cary Street, with 5th Street on the left. Jackson Ward, as it was a few years before the construction of Interstate 95 obliterated part of it, appears in the upper left quadrant, and Capitol Square is just out of view to the right.

PEACE AND PROSPERITY: THE 1950s

At the end of World War II, both the civilian inhabitants of Richmond and returning veterans were apprehensive as well as joyous about the future. On the one hand, the Great Depression was certainly over, and America had emerged from the war not only victorious but also stronger. On the other hand, when the millions of veterans were discharged back into the civilian world, could they find employment, or would there be a return to the high unemployment levels of the Depression era? After all, it would take the national economy time to shift from military to civilian production.

The result, as we now know, was a period of prosperity in the 1950s without precedent at that time. The G.I. Bill, which encouraged and enabled many thousands of veterans to obtain a college degree, kept large numbers of them out of the workforce immediately after the war and gave the economy time to adjust. Production shifted quickly to meet civilian demands, especially when many veterans married and began having children: the proverbial postwar "Baby Boom." Factories that had been producing tanks returned to manufacturing automobiles, and Americans, weary of the wartime rationing that followed the worst deprivations of the Depression, wanted things to buy. Soon a cycle of prosperity began, with consumer demand driving production, and ever-increasing production prompting the steady growth of employment.

In Richmond, the new economy resulted in improvements in infrastructure and better conditions for most residents during the decade. Ford Motor Company, for example, expanded its facilities nationwide to meet the demand for new automobiles, and constructed a parts depot near Byrd Field, Richmond's airport. The growth of the airline industry enabled companies such as Ford to fly parts to distribution centers instead of sending them by truck or by rail. In response to increased demand from such businesses as well as travelers, the airport constructed a new terminal. At the same time, the Interstate Highway System was inaugurated to improve traffic flow and enable tourists and commuters to drive quickly from one place to another on high-speed limited-access highways. The new roadways became development corridors, with shopping centers and residential subdivisions sprouting up later in the decade. Shoppers still came downtown to the two big department stores, Thalhimer's and Miller and Rhoads, especially for the sales and for Christmas shopping.

All of the infrastructure improvement came at a cost, however. Old buildings were torn down to make way for the changes, especially in African-American neighborhoods. For example, parts of Richmond's historic Jackson Ward, the city's center of black culture, were virtually decimated when Interstate 95 was constructed. This pattern would be repeated in the future in other parts of the city, with other projects. At the time, the relegation of black Americans to second-class status by the white majority ensured that large-scale demolitions for infrastructure improvements would affect black neighborhoods more than white ones. Racially segregated facilities, from hotels and restaurants to theaters and libraries to parks and schools, were the norm. When the United States Supreme Court began handing down desegregation orders in 1954, Virginia and the rest of the South responded with a policy of "massive resistance." Overall, blacks replied with resistance of another sort, courageously and peacefully pressing for their civil rights in a variety of venues. In Richmond, which has been described as a "hotbed of social rest," change came slowly, but it came eventually.

It seemed that some things would never change, however, such as the domination of the state's economy by the tobacco industry. The Surgeon General's report linking tobacco and cancer was in the future, and in the 1950s, the giant tobacco companies staged celebrations and festivals to promote their products. Other more benign entertainments took place in Richmond's theaters and parks. In the 1930s and 1940s, motion pictures and plays helped take the nation's mind off its troubles. In the 1950s, the nation's troubles seemed behind it (except for civil rights inequities, which troubled relatively few whites at first), and the future appeared to glow with promise.

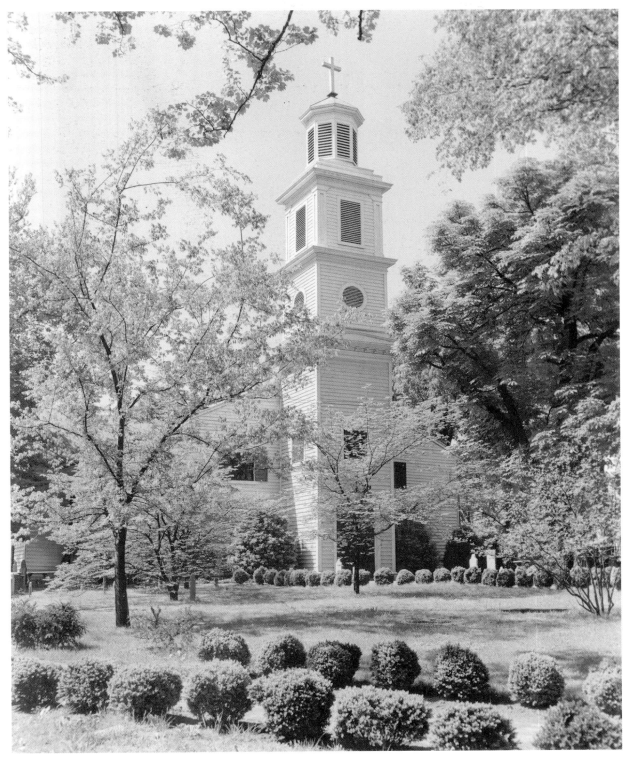

St. John's Episcopal Church, on Church Hill in the eastern end of Richmond, was completed as the simple frame Henrico Parish Church in 1741, and then was enlarged in 1772 with a north addition to make the building T-shaped. The bell tower shown here was added later. It was here that Patrick Henry delivered the oration known as the "Liberty or Death" speech during the Second Revolutionary Convention that met on March 20, 1775. Henry's speech is reenacted at the church each March. St. John's is a National Historic Landmark.

John Stewart Battle was inaugurated governor of Virginia on January 18, 1950, at the Virginia State Capitol in Richmond. From the 1920s until late in the 1960s, the Democratic Party dominated Virginia politics, and first governor and then U.S. senator Harry Flood Byrd dominated the party. The Byrd machine effectively selected Virginia's governors by throwing its support behind the Democrat it preferred during the primary election. A popular governor, Battle left office before the U.S. Supreme Court handed down its decision in *Brown* v. *Board of Education of Topeka, Kansas,* a decision Battle would have opposed.

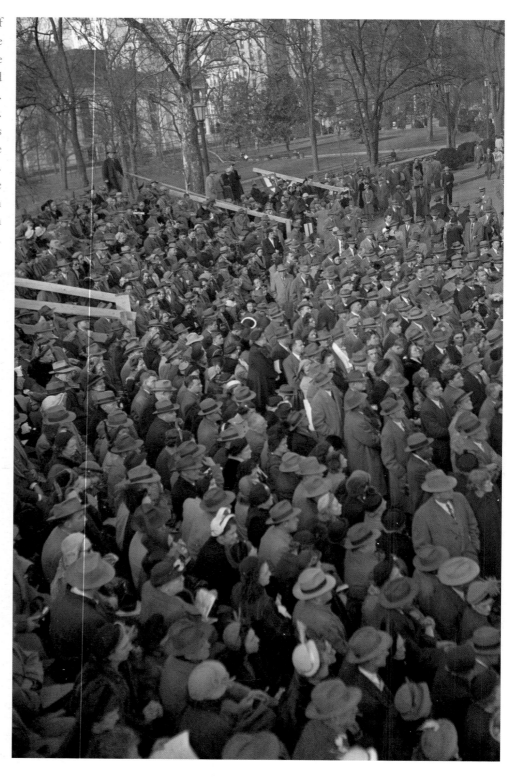

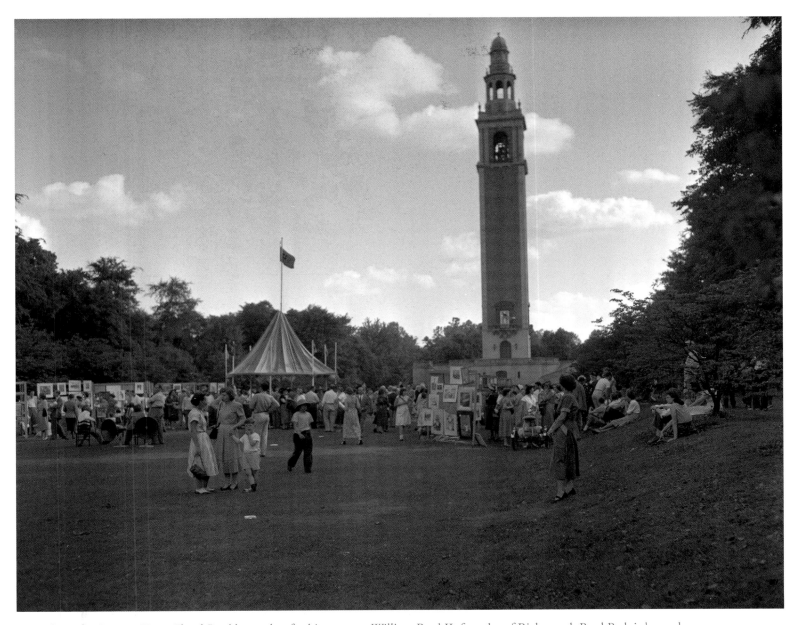

Named not for Senator Harry Flood Byrd but rather for his ancestor William Byrd II, founder of Richmond, Byrd Park is located on the north side of the James River west of downtown. It has long been a popular spot for jogging, picnicking, and relaxing. Many arts festivals, such as Arts in the Park, have been held there over the years. Seen here is the Carillon (World War I memorial) in the Dogwood Dell section of the park.

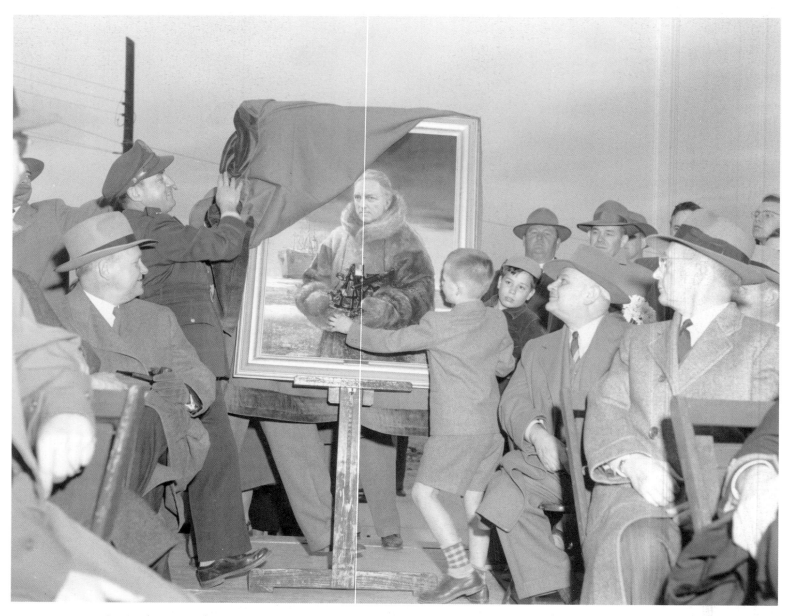

On April 1, 1950, dignitaries including World War I ace Eddie Rickenbacker and television personality Arthur Godfrey gathered at Byrd Field, present-day Richmond International Airport, to dedicate a new terminal building. The airfield was named for Admiral Richard E. Byrd, the pilot and explorer. Byrd, whose portrait for the terminal was unveiled, spoke about the newly developing Cold War with the Soviet Union and advocated a policy of applying "political force" against the growing communist menace.

In Richmond, even today, it is said that the mention of the name Bottomley to lovers of architecture will bring tears to their eyes. William Lawrence Bottomley (1883–1951) was an architect whose practice extended from New York City, where he became famous for his apartment buildings, to Richmond, where from late in the 1910s to the 1940s he designed houses along Monument Avenue and in Windsor Farms, among several locations. His houses, executed mostly in the Colonial Revival style, are renowned for their intimate scale despite their considerable size, and for their stylistic detailing. To a Richmonder, "It's a Bottomley" means that a building is among the finest exemplars of its type. Bottomley designed Milburne, seen here, which is located in Windsor Farms, in 1934.

Tobacco magnate Lewis Ginter and his development partner John Pope acquired and developed farmland north of Richmond beginning in 1883. Between 1894 and 1925, most of the new construction consisted of high-style country estates for Richmond's wealthy residents, and then in the 1920s and 1930s middle- and upper-class houses were built. The Lakeside Streetcar Line operated in the median of the principal north–south street, Hermitage Avenue, between 1897 and 1920, making the area an early streetcar suburb. The principal east–west street is Bellevue Avenue; at the intersection of Bellevue with Hermitage, another street—Pope Avenue—angles off to the northeast. The granite Bellevue Arch, photographed in 1950, was erected in 1894 on Pope Avenue at the intersection and stands today as the entrance to the Bellevue Park neighborhood.

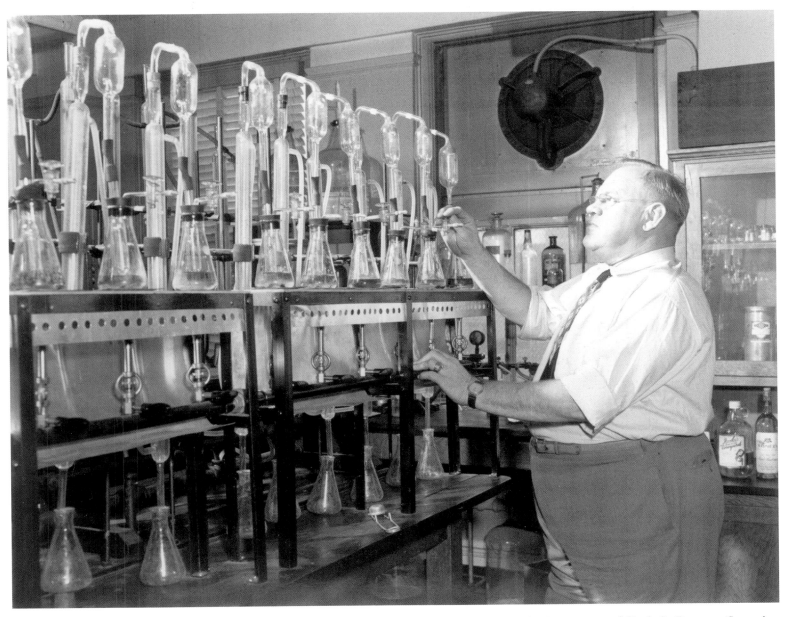

The Virginia General Assembly passed legislation on March 7, 1934, creating the Department of Alcoholic Beverage Control to regulate the manufacture, sale, and consumption of beer, wine, and spirits in Virginia. Periodic efforts since then to abolish ABC, as it is called, have failed. Here an ABC laboratory technician measures the alcohol content of the liquids in the vials.

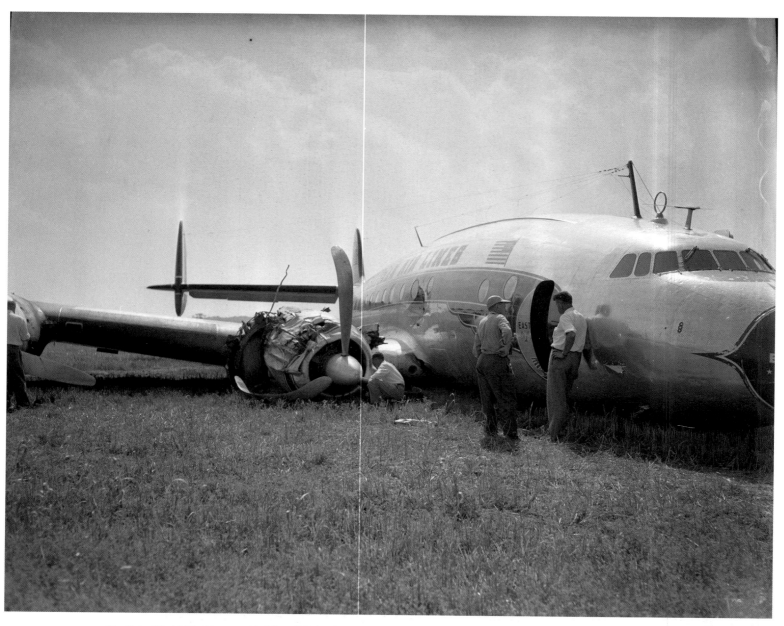

On July 19, 1951, Eastern Air Lines Flight 601, a Lockheed Constellation, departed Newark, New Jersey, at 2:15 P.M. for Miami. As it passed Philadelphia, the aircraft experienced violent turbulence and hail, so the pilot flew west to avoid the storm, but to no avail. When the buffeting continued, the pilot believed that the plane might shake apart (a subsequent investigation showed that the in-flight malfunctioning and opening of the hydraulic access door caused the shaking) and steered the plane back east. Flying just past Richmond, the pilot spotted the open fields of Curles Neck Farm and executed a gear-up belly landing. The aircraft skidded more than a thousand feet through a cornfield and across a road before coming to a halt in a pasture. All five crew members and forty-eight passengers survived unscathed.

Thomas F. Jeffress, a Richmond tobacco manufacturer, completed Meadowbrook in 1918 as a country retreat a few miles south of the city. This grand mansion, with false Tudor-style half-timbering on the garden facade, replaced a large-frame dwelling that had burned five years earlier. Meadowbrook was the last in a series of great rural retreats constructed for wealthy Richmonders, who began choosing instead to build suburban mansions in Windsor Farms, an upscale "subdivision" in the West End. Meadowbrook burned in 1967; a country club occupies the site.

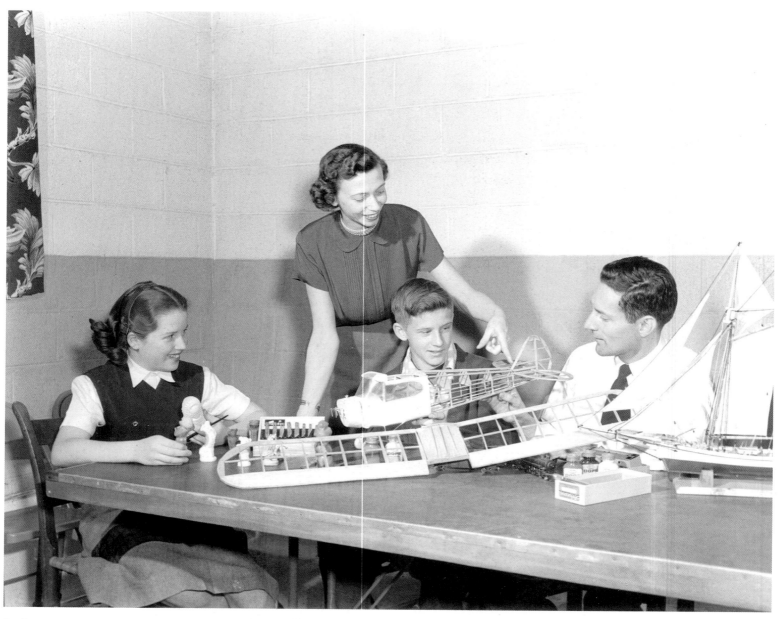

In the 1950s, it seemed that most children and many adults adopted model-building as a hobby. Stores such as Keel's Hobby Shop, located at 107 North 2nd Street, sold model kits that ranged in degree of difficulty from plastic glue-it-together models to wooden carve-it-yourself replicas. Henry K. Keel, the owner, also owned a printing company and a florist and garden center; he lived to age 96. The building that housed the shop still stands.

The Equitable Life Insurance Company constructed this building, photographed in 1952, for its offices at 409 East Main Street. After the firm moved to newer quarters in the 1970s, the American Red Cross occupied the building for many years. Today it contains the offices of a graphic-design firm.

The Mosque was completed in 1928 for the Shriners Acca Temple. In 1995, the building was renovated and renamed Richmond's Landmark Theater. The structure's ornate architecture, inspired by Muslim mosques, derives its Eastern flavor from the two spirals flanking the main entrance and the interior's colorful murals and tiles from Italy, Spain, and Tunisia.

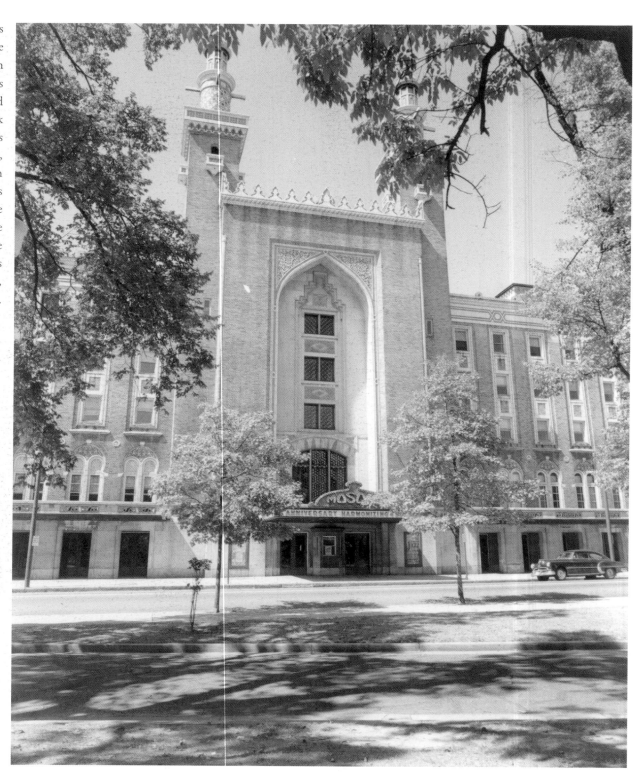

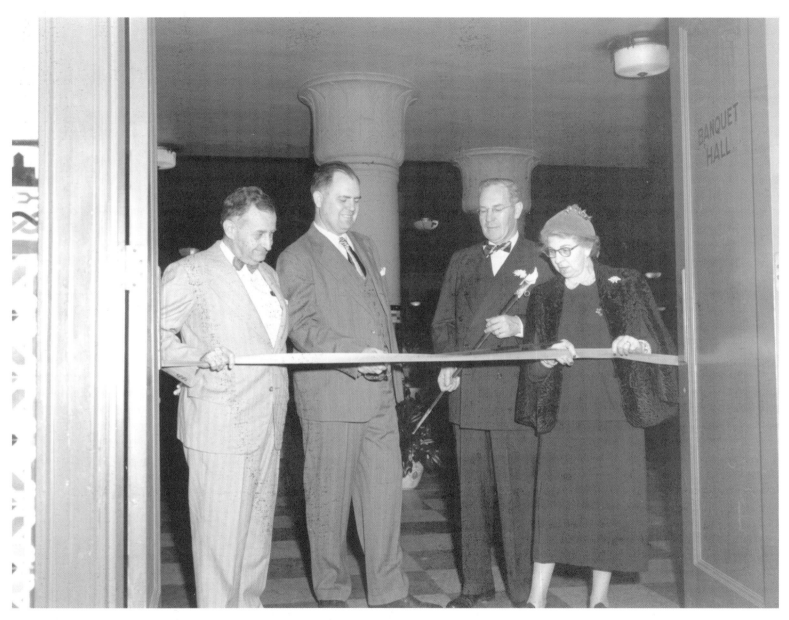

The First Annual Virginia Antiques Fair was held October 28–31, 1952, in the Mosque, a large meeting and theater venue located on the western side of Monroe Park. Sponsored by the Virginia Antique Dealers Association and the Virginia State Chamber of Commerce, the fair featured antique furniture, Persian rugs, and books. This image depicts the grand opening ceremony.

This image was used on the cover of the Second Annual Virginia Antiques Fair program. The fair was again held at the Mosque, October 6–9, 1953. Inside the program were lyrical essays praising all things Virginian. One antiques dealer began her article on the virtues of eighteenth-century Virginia furniture thusly: "In Virginia, the cradle of all that was superior in the early history of our country . . ."

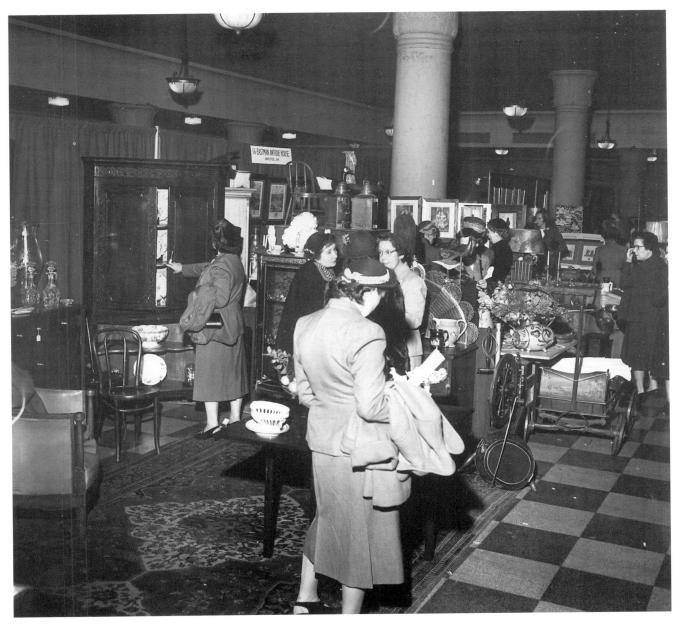

The First Annual Virginia Antiques Fair was well attended. The fairs continued to be held for several years thereafter.

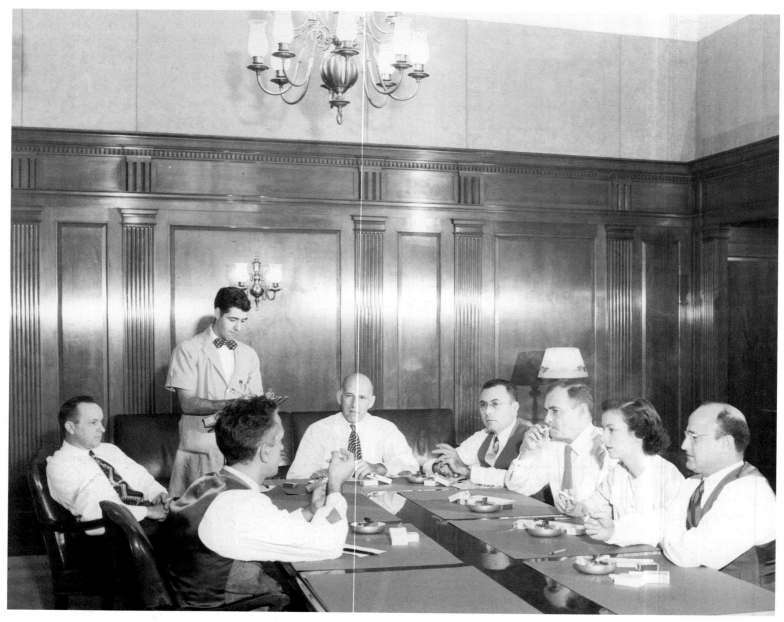

Founded in 1890, the American Tobacco Company was an early conglomerate that absorbed previously independent tobacco firms in Richmond and elsewhere—eventually more than two hundred smaller companies. Like Standard Oil during the same era, the company was broken up in an antitrust action and new firms were formed, including Liggett and Meyers, Lorillard, and R. J. Reynolds. The American Tobacco Company name endured as well, with a large plant located just south of Richmond. Here, employees give cigarettes the taste test.

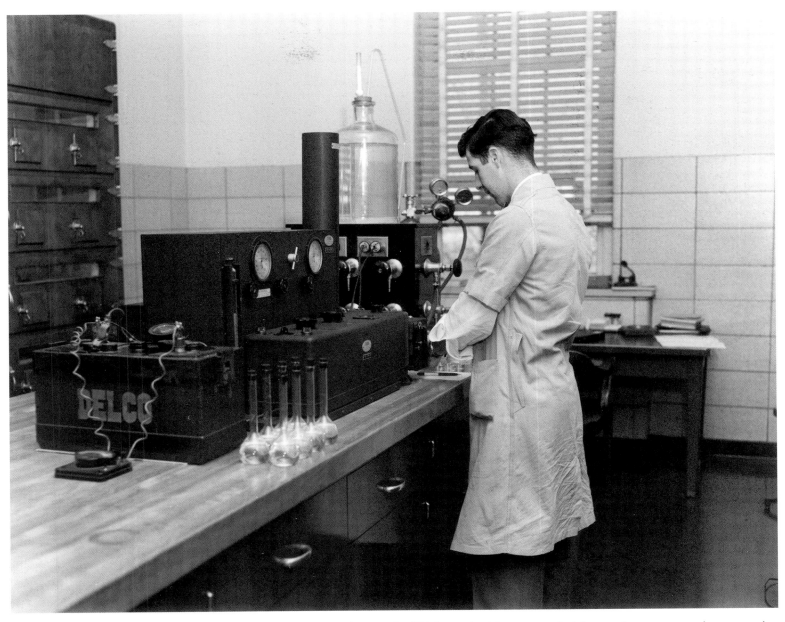

At the American Tobacco Company plant south of Richmond, a laboratory technician conducts tests on tobacco samples.

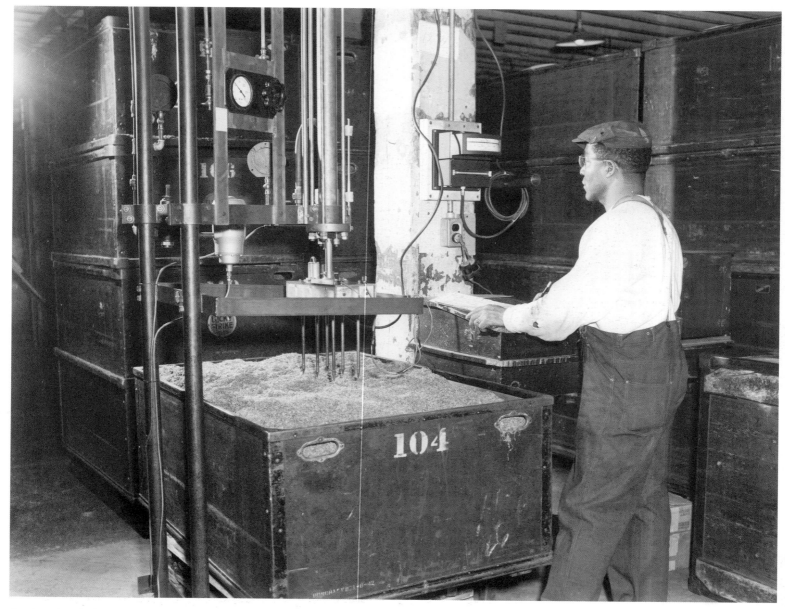

An American Tobacco Company factory employee monitors a crate of tobacco in this 1952 photograph.

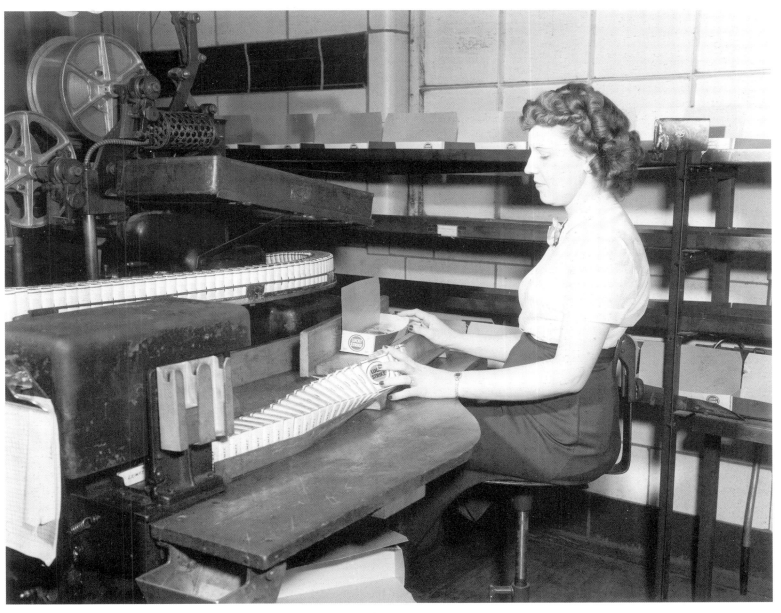

Lucky Strike cigarettes, one of the American Tobacco Company's best-selling brands, are being packaged in this photograph. In Richmond, when the wind comes from the south, the once-common aroma of tobacco from factories like this one is almost unknown today.

Ashland is a railroad town located north of Richmond in Hanover County. The rail line extends up the main north–south street, and for much of the twentieth century many inhabitants commuted south by rail to Richmond. Today, the old depot is a visitor information center, and more residents probably commute north to Washington, D.C., than to Richmond.

The Ford Motor Company opened a parts depot on Ferncroft Road near Byrd Field in 1950 as part of the company's massive postwar expansion program that began in 1947. The program included the construction of satellite factories and parts depots located strategically around the country. Photographed in 1952, workers inside the Richmond depot are sorting parts for distribution to local Ford dealers.

Diplomat Alexander W. Weddell and his wife, Virginia Weddell, assembled Virginia House from portions of late-medieval Warwick Priory in England. The priory was disassembled in 1925, and the new-old house was completed three years later. Located in Windsor Farms, the mansion speaks to many Virginians' fascination with their English heritage. The Weddells bequeathed Virginia House to the Virginia Historical Society, and it is open to the public.

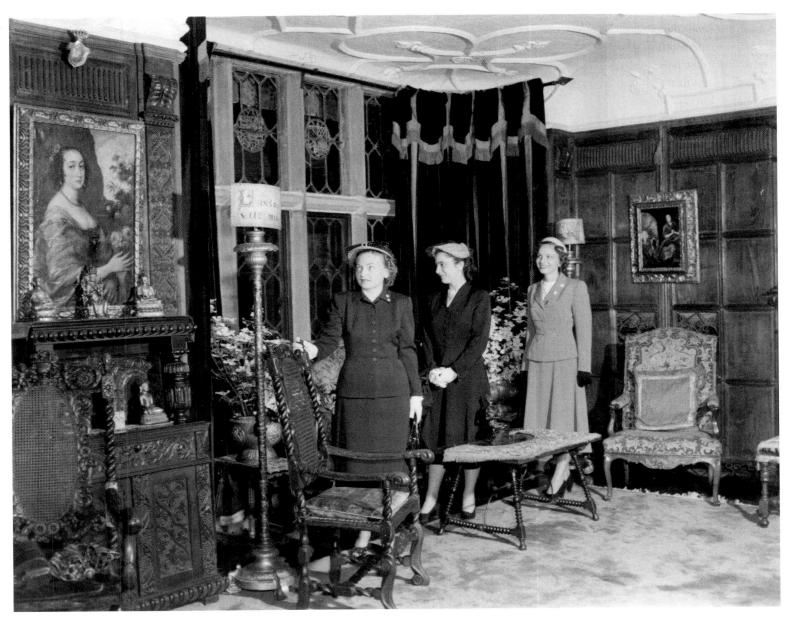

Virginia House is renowned for its gardens, which landscape architect Charles F. Gillette designed to overlook the James River. It is also known for its interiors, which feature late-medieval architectural elements. Many of the decorative items, such as the furniture and paintings, are English antiques.

This Virginia State Chamber of Commerce display window in downtown Richmond promoted the first Virginia Beach Sand Festival. At the end of World War II, Virginia Beach, which had been a seaside resort for 80 years, began to refurbish its oceanfront. The southern end of the beach, from 21st to 1st streets, was replenished with sand dredged from a nearby inlet. To celebrate the accomplishment, in 1952 the city staged the Sand Festival, now the Neptune Festival. The "queen" of the 1952 festival, Miss Virginia Beach, was a young woman from New Jersey named Virginia June Beach. Unaware of the approaching festival, she had written the Virginia Beach Chamber of Commerce for information about accommodations. The Chamber quickly invited her and her family for an all-expenses-paid vacation, provided she agreed to reign over the festival. She did agree, and the coincidental similarity between her name and the city's name attracted substantial attention from the press, much to the delight of the Chamber.

The Miller and Rhoads department store, one of two such stores that anchored Richmond's downtown shopping district for most of the twentieth century, was famous for its May sales, known as "Richmond's greatest storewide savings event!" Although there were storewide markdowns ("Designer straws" or upscale straw hats were $15 instead of the usual $22.50–$37.50), the largest savings were found in the basement—straw hats there cost only $2.69. This photograph, taken on April 28, 1952, shows the store staff members being prepared for the upcoming May sales.

The Ford Motor Company parts depot building, shown here in 1952, still stands on Ferncroft Road near Richmond International Airport. Until recently it served as a clothing-store warehouse.

This image recorded in 1952 depicts a group of Ford Motor Company executives at the company's Richmond parts depot admiring an advertisement for the "Big" 1952 Ford.

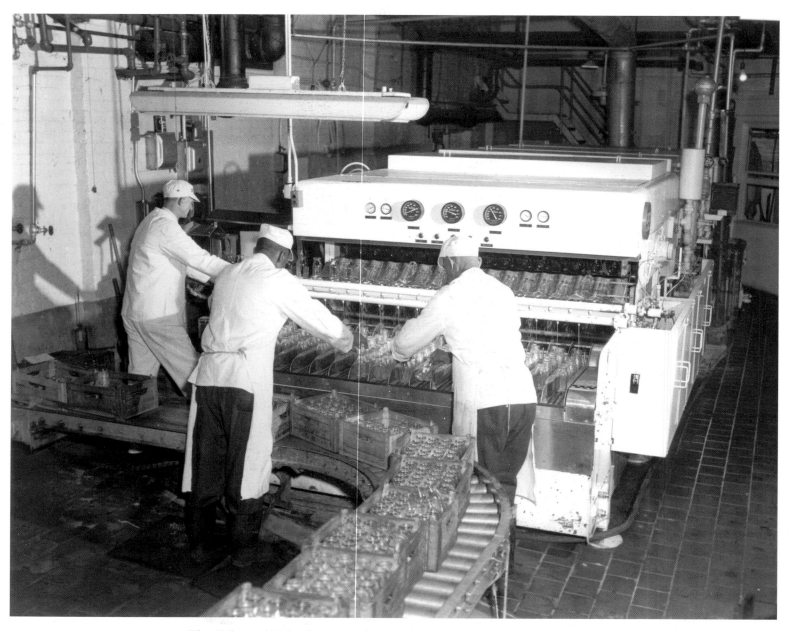

The Richmond Dairy Company plant was located at 201 West Marshall Street in the city's Jackson Ward. Workers on the bottling line are shown in this 1952 photograph. The plant was known for its giant milk bottles that occupied the corners of the building. Converted to apartments, the plant and bottles still stand.

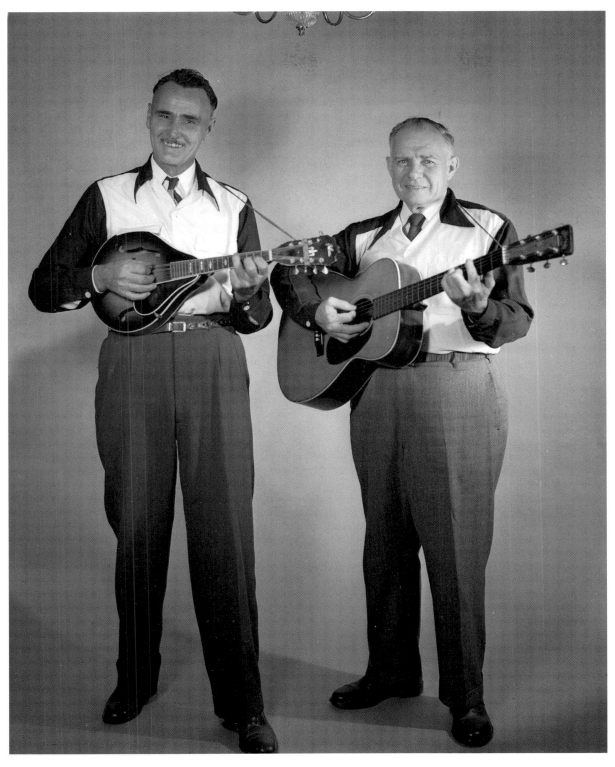

Although many musicians and singers of national stature have performed in Richmond over the years, there have been countless homegrown entertainers as well. Many appeared on local television and radio stations in the 1950s. Two members of the local group The Tobacco Tags were photographed on September 14, 1953. At left, with mandolin, is Luther "Looney Luke" Baucom, and on the right, with guitar, is Reid "Roly-Poly" Summey.

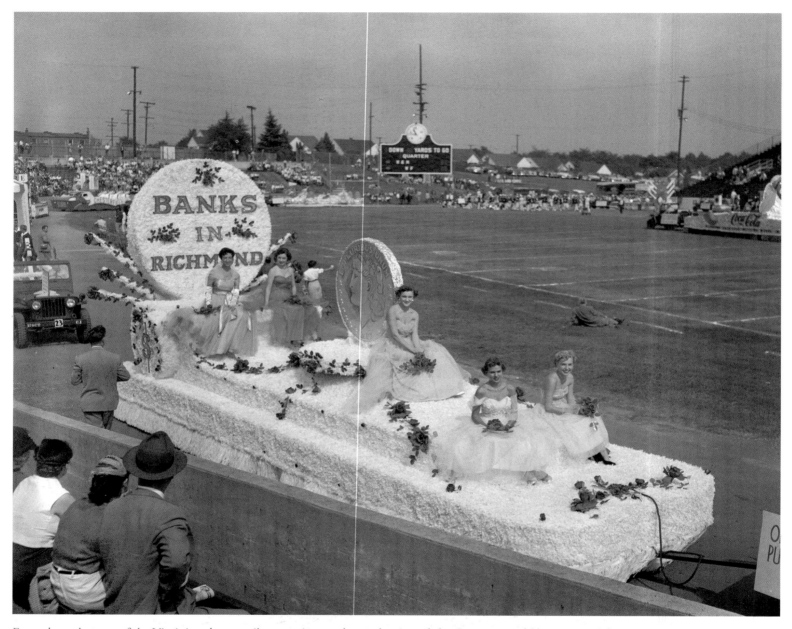

From the early years of the Virginia colony until recent times, tobacco dominated the Commonwealth's economy. This was especially true after World War II, when many veterans came home with a nicotine habit, since cigarettes were included in ration packages. In 1935, before the war, businessmen in South Boston in Halifax County—a major tobacco-growing region—organized the first National Tobacco Festival. It soon outgrew the small town and was moved to Richmond after 1941, but then suspended for several years because of the war. This image, recorded on September 19, 1953, shows a parade float at City Stadium.

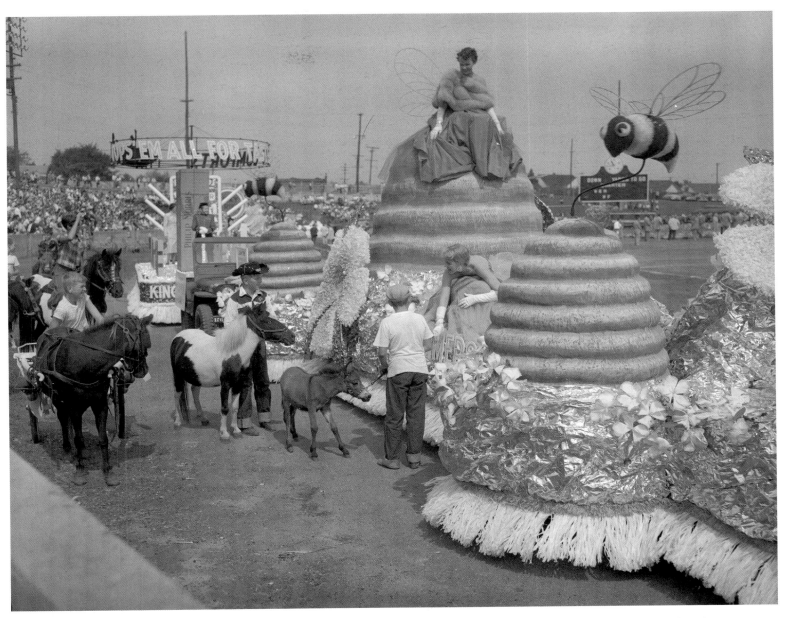

The Fifth Annual Tobacco Festival was held September 16–21, 1953, in Richmond. On September 19, when this picture was taken, there was a parade downtown, and then a pregame show at City Stadium that included the coronation of the Queen of Tobaccoland followed by the Tobacco Festival Football Classic between the College of William and Mary and Wake Forest College. Other events included "Tobaccorama" at Parker Field ("The story of tobacco in song and dance"), an outdoor concert by the Ferko Wonder Bread String Band, and the Tobacco Ball at the Jefferson Hotel. The souvenir program contained an advertisement for snuff—a photograph of a baby seated on a tobacco hogshead and holding a bag of snuff.

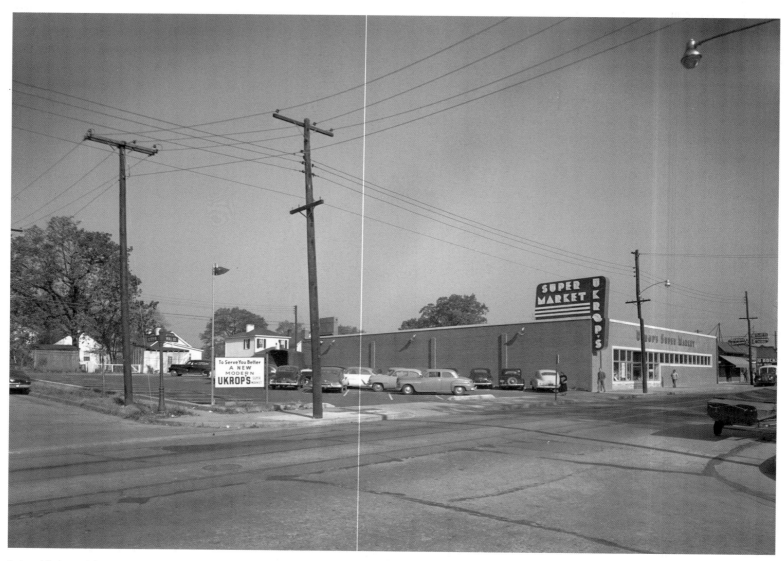

It is said that within 15 minutes of meeting anywhere in the world, two Richmonders who are total strangers to each other will be comparing local grocery stores unfavorably with Ukrop's, the family-owned Richmond-area grocery chain renowned for its friendly and highly personal service. Joe Ukrop opened the first store in 1937, and by late in 2009, when the family sold the business to the Giant-Carlyle division of Ahold, there were more than 20 stores. This one, photographed on November 11, 1953, was located at 3600 Hull Street in South Richmond. The building still stands, although it is no longer a Ukrop's.

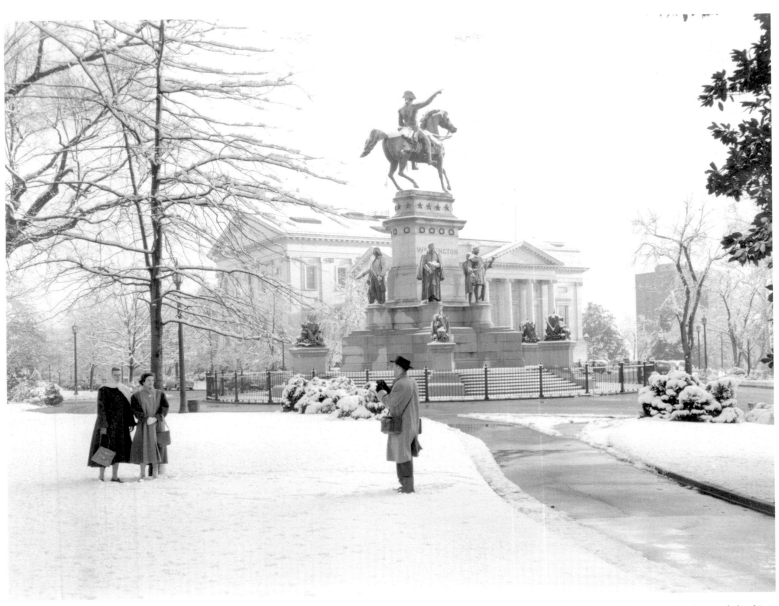

This image shows the bronze equestrian statue of George Washington at the western end of Capitol Square in Richmond, looking east toward the Virginia State Capitol. Thomas Crawford, a Philadelphia artist, sculpted the statue, which was cast in Europe and unveiled on February 22, 1858. The series of statues of famous Virginians around the base was not completed until August 1868.

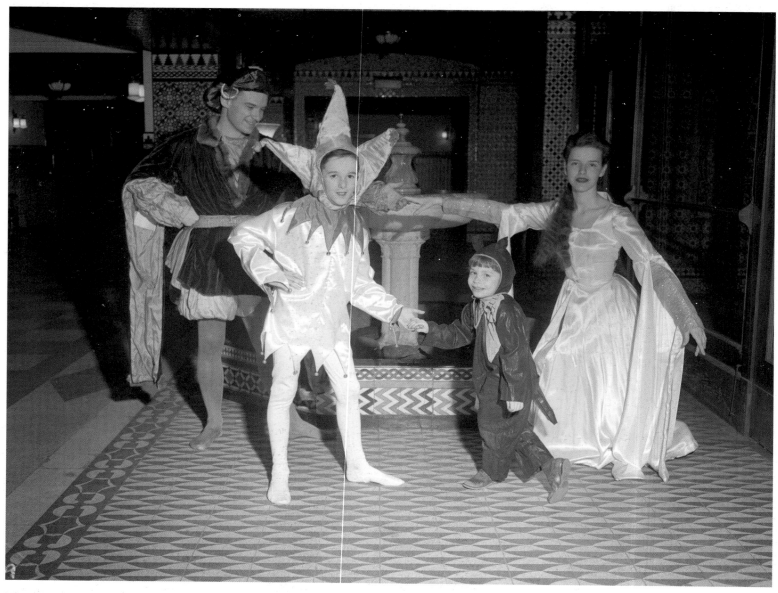

The Mosque, which has been renamed Richmond Landmark Theatre, has been a venue for professional actors and singers since it was completed in 1928. It has also served as a community theater, as shown here on March 10, 1954, at a performance of *Beauty and the Beast*.

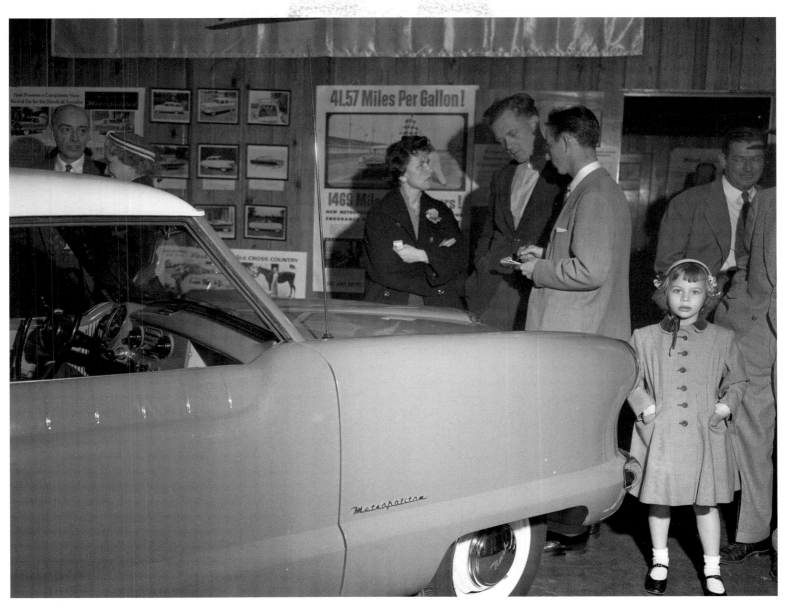

A family is discussing the possible purchase of a new Nash in this photograph taken on March 20, 1954, in the Lauritzen Motors showroom at 1840 West Broad Street. The Colonial Revival–style building was constructed around 1920 and designed by Albert F. Huntt, a Richmond architect. This was his last commission, as he died later that year. The Atlantic Motor Company first occupied the facility until 1925, and then a commercial laundry operated there for a decade after 1928. Next came an electric-appliance dealership, which moved out in 1946; Lauritzen moved in the same year and operated until 1955. Today the Virginia Community Development Corporation occupies the recently renovated building.

Puss 'n Boots cat food was popular with cats but less so with their owners because of the extremely fishy smell. The food was essentially menhaden, an oily fish caught in Chesapeake Bay, mashed to a paste. This display was photographed on April 11, 1954, at Conrad-Deans, a food-brokerage firm that was located in downtown Richmond.

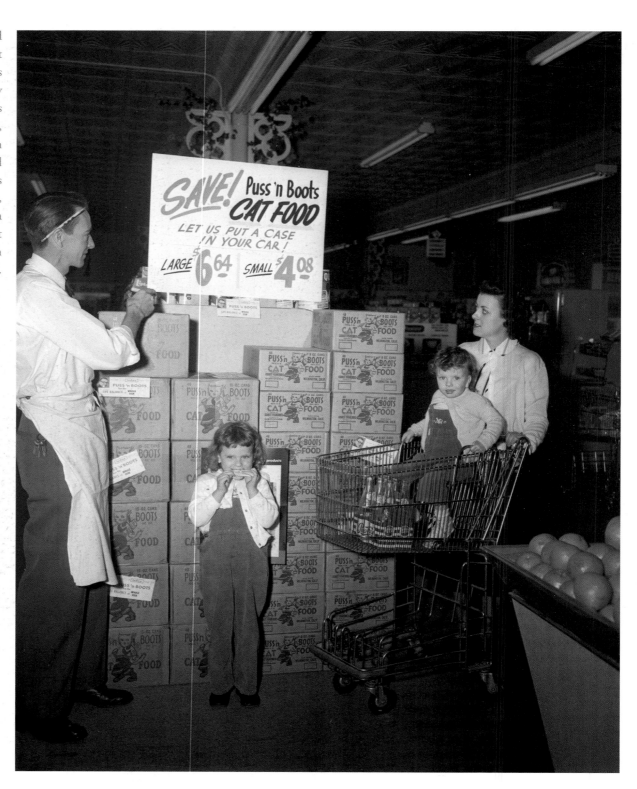

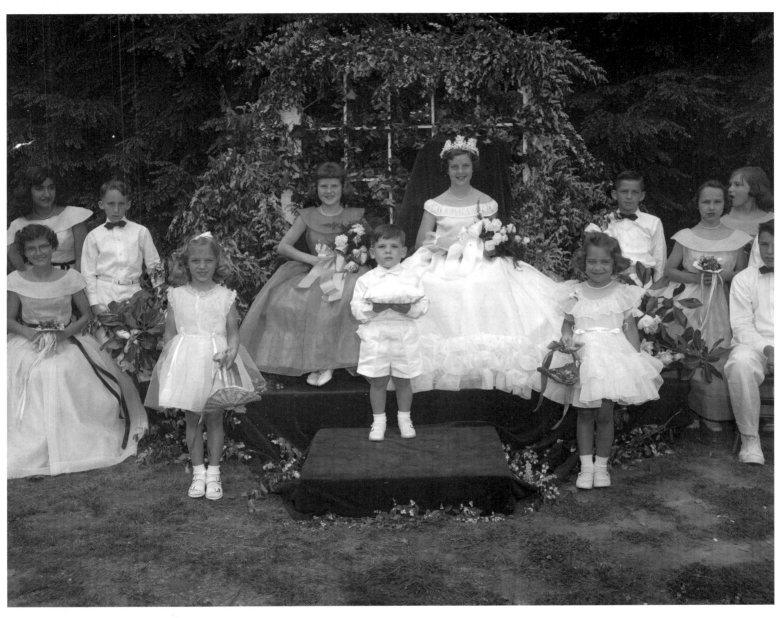

This May Day queen and her court were photographed at Albert H. Hill Middle School on May 11, 1954. City school architect Charles M. Robinson designed this building, located at 3400 Patterson Avenue, in the Mediterranean style. It was completed in 1926 and still serves as a middle school.

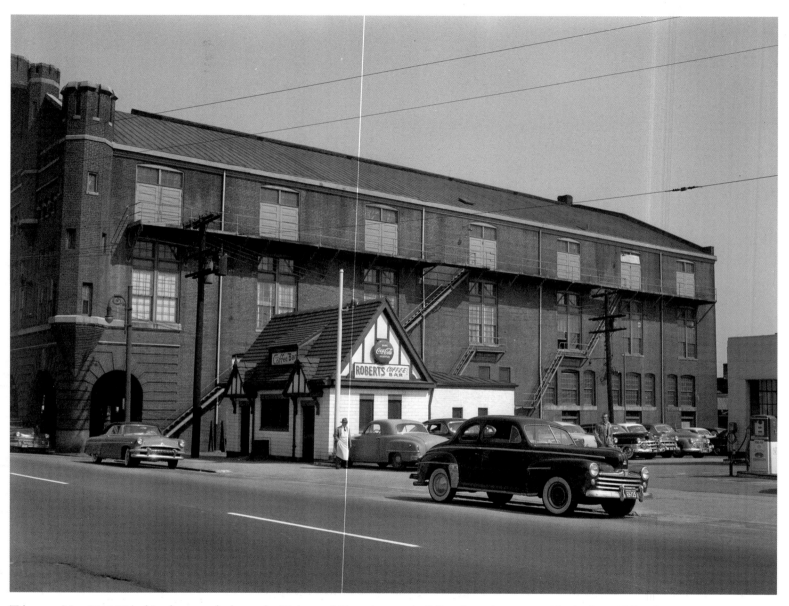

Taken on May 21, 1954, this photograph shows the Richmond Blues Armory building from the eastern side, in the middle of Marshall Street between 5th and 6th streets. The Roberts Coffee Bar, parking lot, and gas station have been replaced by a building that served as a hotel until several years ago. The armory was completed in 1910. In the 1980s, it became part of Sixth Street Marketplace, an urban redevelopment project that has since been mostly disassembled.

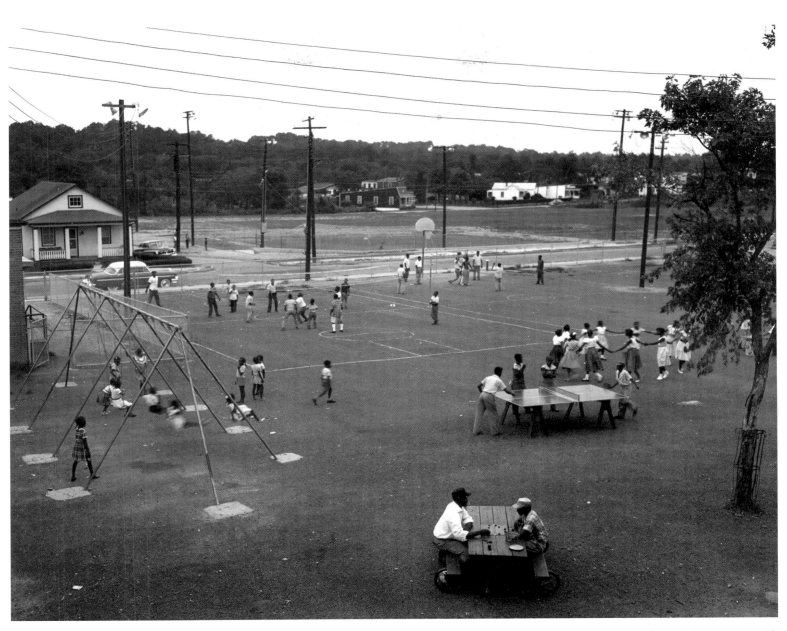

George Mason School is located on Church Hill in the East End of the city at 29th and O streets. Taken on August 30, 1954, from an upper floor of the school building looking southeast, this view shows the playground area, which served the African-American neighborhood as a local park. Today, except for the playground immediately adjacent to the school building, much of the open space south of the school is Ethel Bailey Furman Memorial Park, honoring the first practicing black woman architect in Virginia. The area across the street now contains small houses.

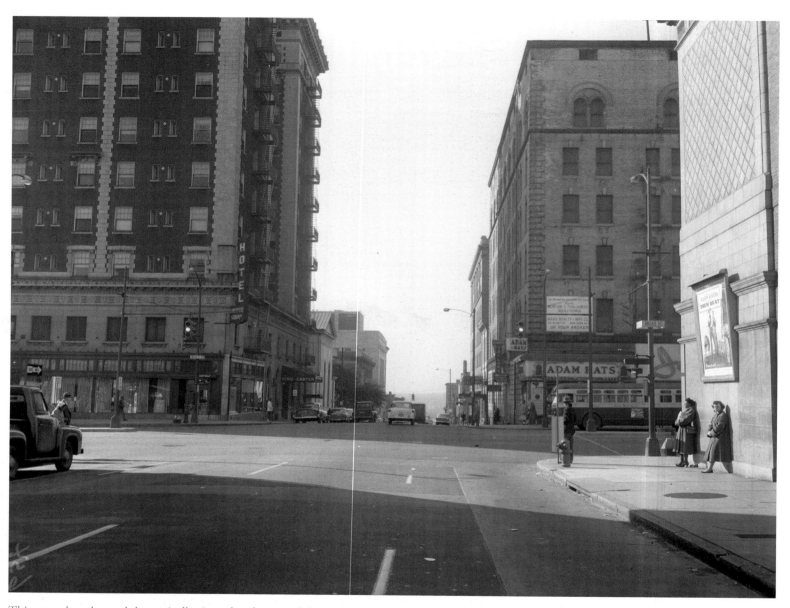

This scene has changed dramatically since the photograph was taken on December 2, 1954. The view is south on 8th Street across Broad Street toward the James River. The entire block on the right, with Adam Hats across Broad on southwestern corner, has been razed, and the new U.S. District Court occupies the space. On the southeastern corner, the former Hotel King Carter also has been demolished, for surface parking.

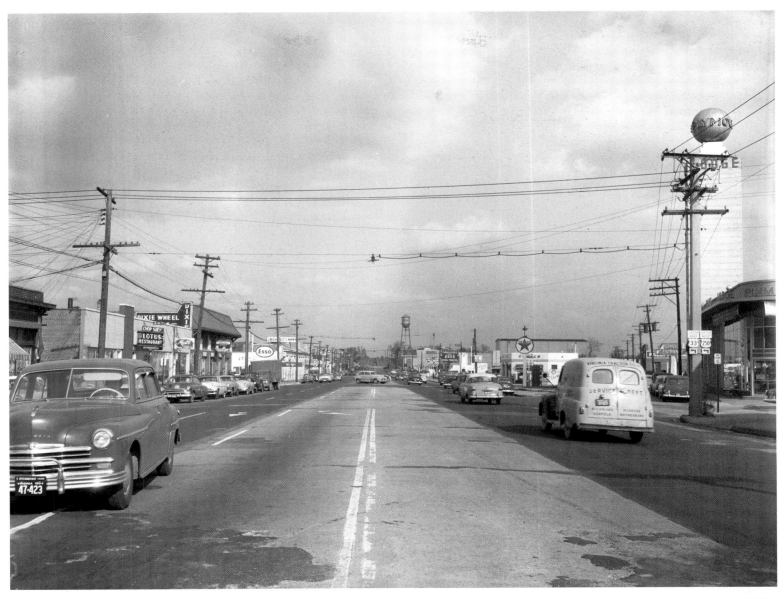

The photographer was facing north on Boulevard looking across Broad Street when he took this picture in December 1954. The tower and building on the right have been demolished, but the line of small stores on the left look much the same today.

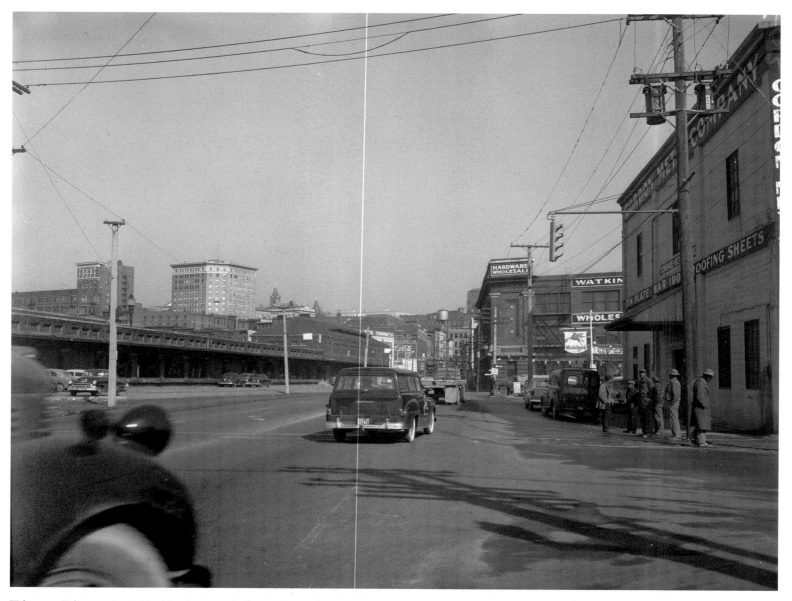

Taken on February 9, 1955, this photograph shows the Watkins-Cottrell Hardware store in the distance. Today it houses La Difference furniture store. The building on the right is gone, but the trestle on the left remains, and the Southern Railway depot at the end of the trestle has been rehabilitated as a restaurant. The view is looking north from just north of the 14th Street Bridge.

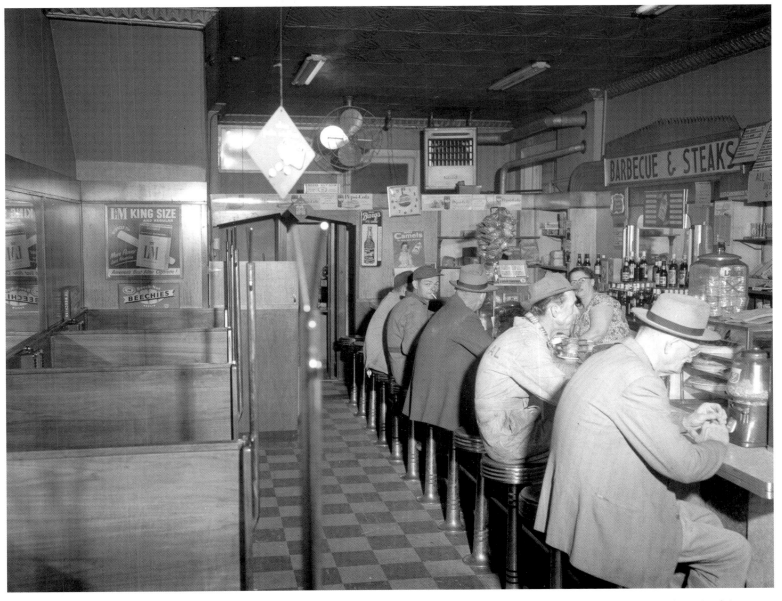

Nick R. George operated Nick's Grill at 802 Hull Street when this picture was taken on April 6, 1955. Located south of the James River, the grill featured "Barbecue & Steaks." The site is now a vacant lot.

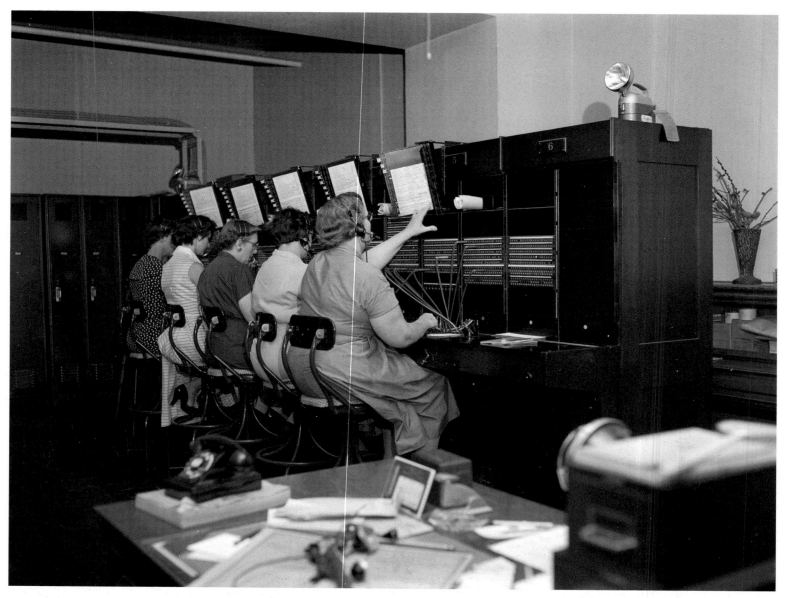

These Chesapeake and Potomac Telephone Company operators were photographed in the Richmond central office on August 17, 1955. The first rudimentary telephone system in Richmond began operations on April 1, 1879, and served 35 downtown customers. In 1930, C&P constructed a new headquarters building at 7th and Grace streets downtown, and also switched from operator-only calls to dialed calls. Operators such as these women (only women were hired for the position) continued to give customers directory assistance as well as help with making long-distance calls, either person-to-person or the less-expensive station-to-station variety.

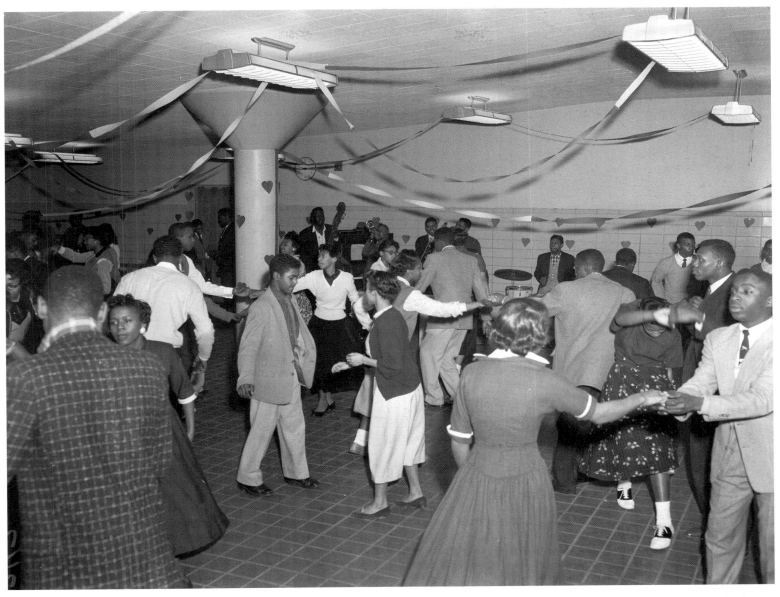

This photograph of a Valentine's dance was taken on February 15, 1956, at Maggie L. Walker High School, one of only two city high schools for African Americans at the time. Walker opened in 1938 almost two decades after Armstrong High School (established 1909), the other city high school for blacks. For 41 years, until Walker closed in 1979, the Armstrong-Walker Football Classic was a Richmond institution on the Saturday after Thanksgiving.

Seen here at its dedication on February 29, 1956, is the Virginia War Memorial located at 621 South Belvidere Street. The memorial was designed to honor Virginians killed in World War II and the Korean War. The names of the dead are engraved on glass panels, and the memorial features a statue representing the Commonwealth mourning her dead. This photograph was taken at the dedication ceremony.

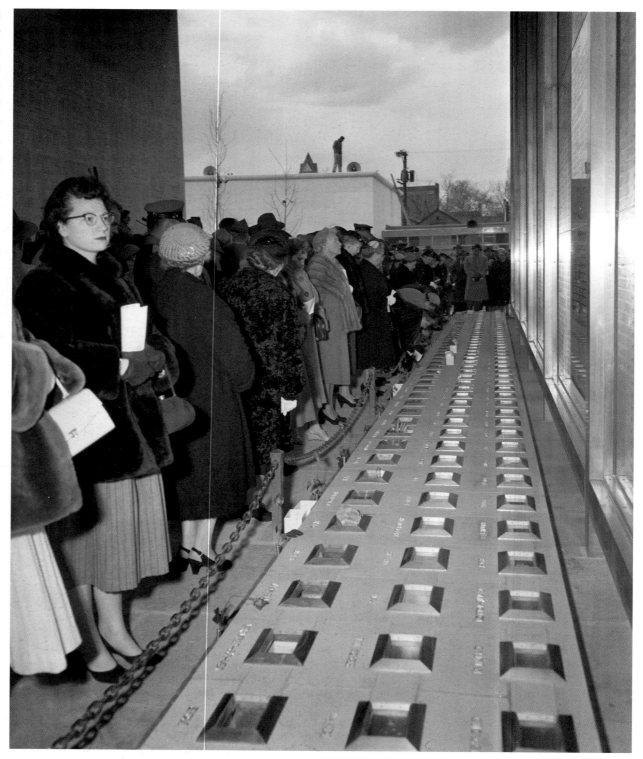

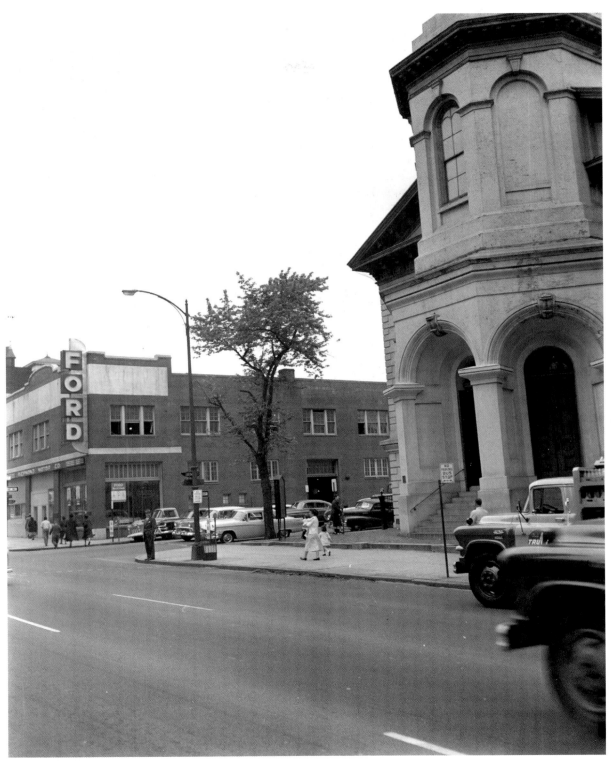

Taken on May 7, 1956, this photograph shows the north side of Broad Street at the intersection with 10th Street. On the northwestern corner is Richmond Ford, which later moved to West Broad Street at Westmoreland Street. This building was demolished and the New Richmond City Hall was erected on the site in 1971. On the right is Broad Street Methodist Church, an Italianate-style house of worship completed in 1859. It was demolished in 1968 for a parking lot for the Richmond Eye and Ear Hospital.

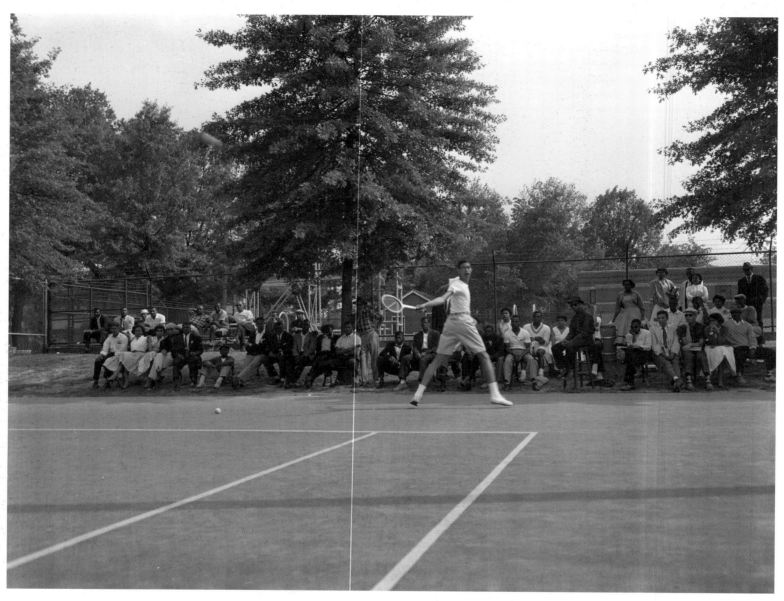

During the era of racial segregation, African Americans were banned from many of Richmond's sports facilities, including the city's Byrd Park tennis courts, which had lighting for night play. Instead, they played on blacks-only courts such as those at Brookfield Park in an African-American section of northern Richmond, the likely site of this photograph taken on May 12, 1956. Fortunately for the future history of tennis, the young Arthur Ashe lived near Brookfield Park and learned the rudiments of the game there.

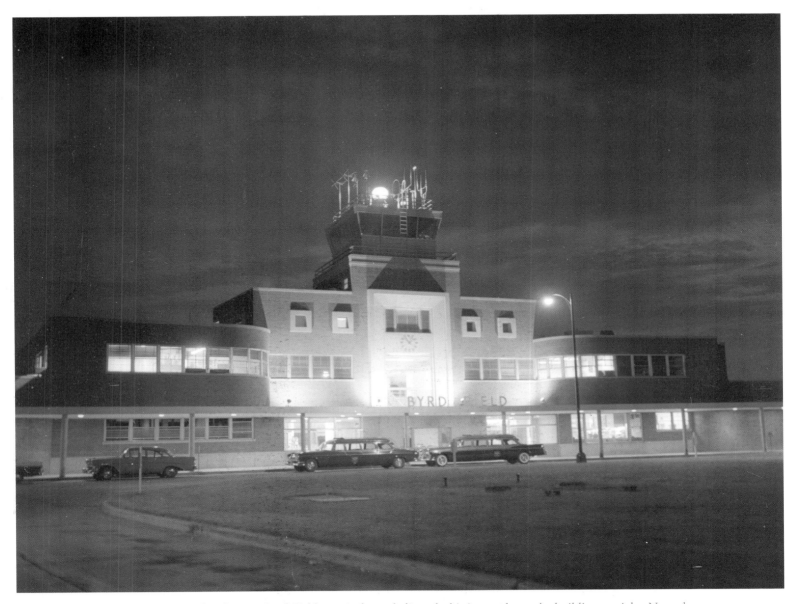

Taken on June 24, 1956, six years after the new Byrd Field terminal was dedicated, this image shows the building at night. Named for the explorer Admiral Richard E. Byrd, the airfield opened on October 15, 1927. The first official visitor was Charles Lindbergh, who arrived piloting *The Spirit of St. Louis.*

Following Spread: This appropriately aerial view of Byrd Field, taken sometime in the 1950s, shows an unmarked DC-3 (*left*), an Eastern Air Lines DC-3 (*center*), and a Delta Airlines Douglas DC-4 (*right*). Younger air travelers today may find it hard to believe, but once upon a time, not only did airplanes have roomy and comfortable seats, but also the concept of flying was so exciting that many people went to the airport just to watch the planes take off and land.

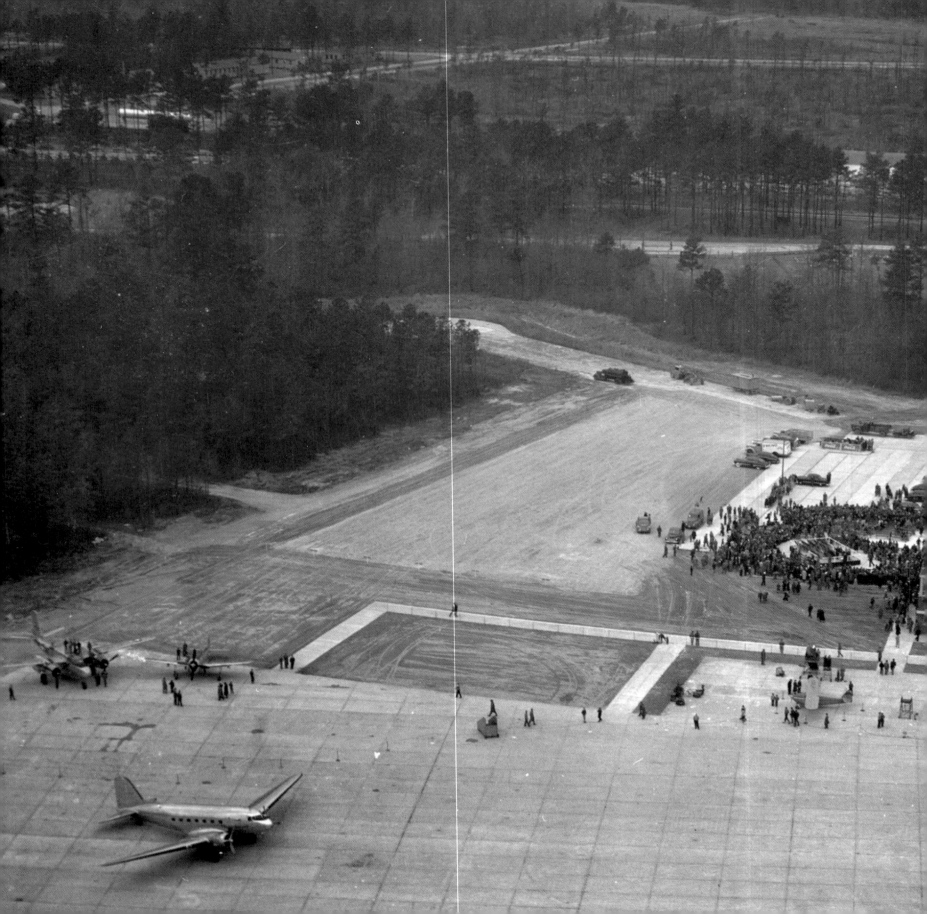

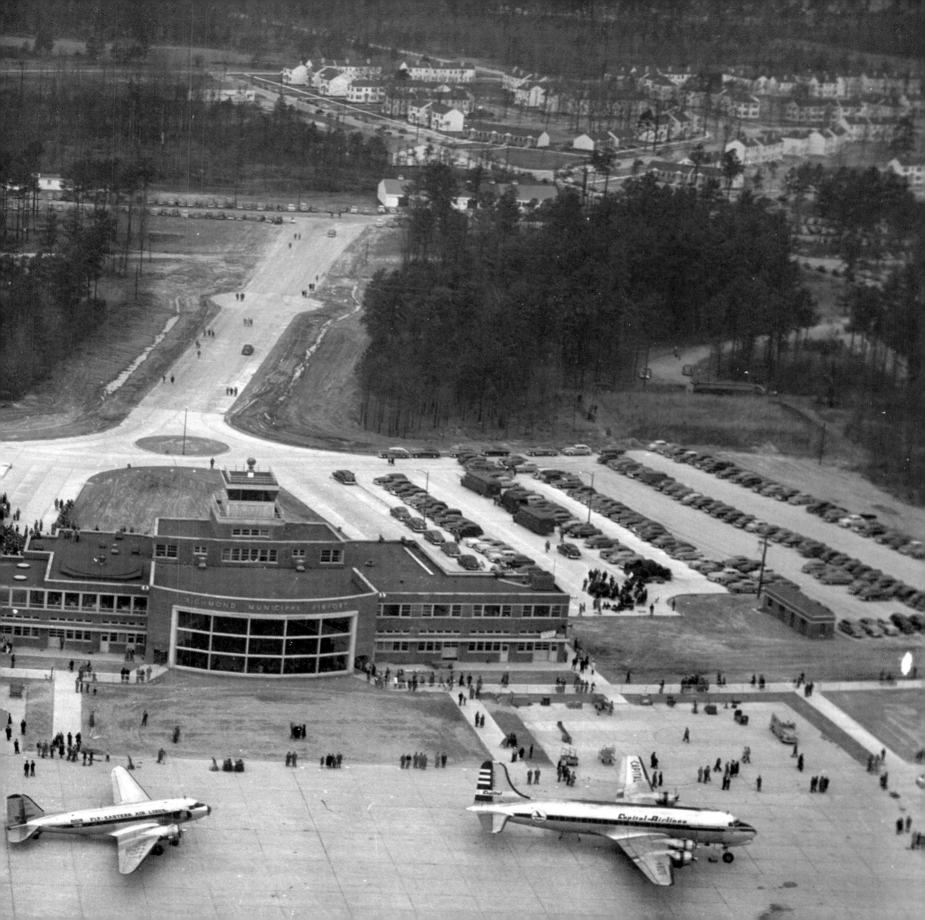

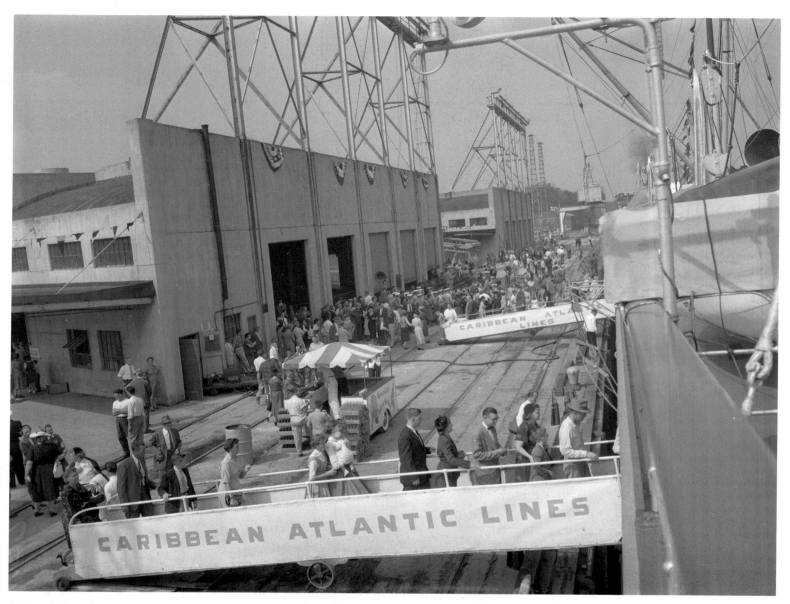

Although this photograph appears to have been taken on the oceanfront since it shows passengers boarding a Caribbean Atlantic Lines cruise ship, in fact it was taken at the Deepwater Terminal, Port of Richmond. The Port is located a couple of miles down the James River below the city proper and the rapids known as the Falls of the James. It can accommodate oceangoing vessels, but today the ships that dock there are freighters and not cruise ships.

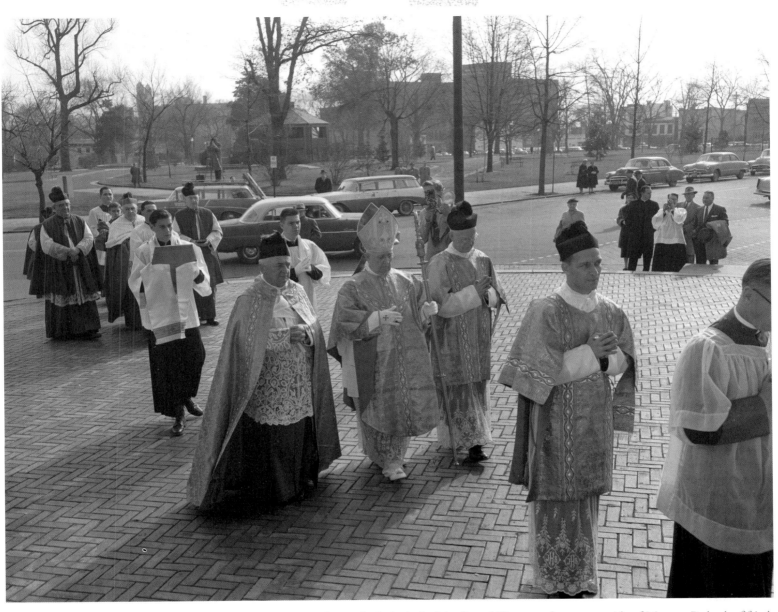

On November 29, 1956, at Richmond's Cathedral of the Sacred Heart on the western side of Monroe Park, the fiftieth anniversary of Bishop Peter Leo Ireton's ordination was celebrated. Born in Baltimore, Maryland, on September 21, 1882, Ireton was ordained a priest on June 20, 1906. He became Bishop of Richmond on April 14, 1945, and died on April 27, 1958. He was particularly interested in education and established 24 schools during his tenure.

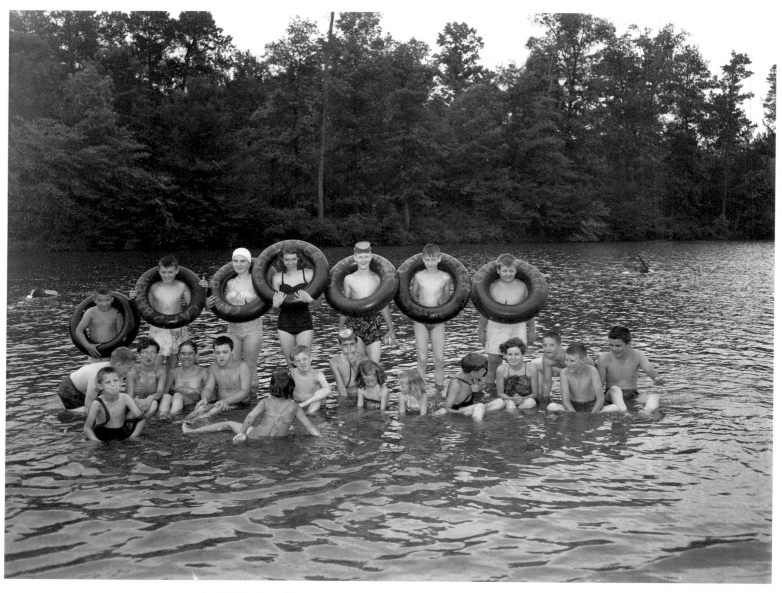

In 1957, when this picture was taken, Richmond-area children with mental and other disabilities were brought for the first time to Camp Baker in nearby Chesterfield County. The summer camp had been established in 1929 to help undernourished children. Located near Pocahontas State Park, Camp Baker still offers the usual summer-camp activities including swimming and horseback riding, and affords both the children and their caregivers a welcome respite.

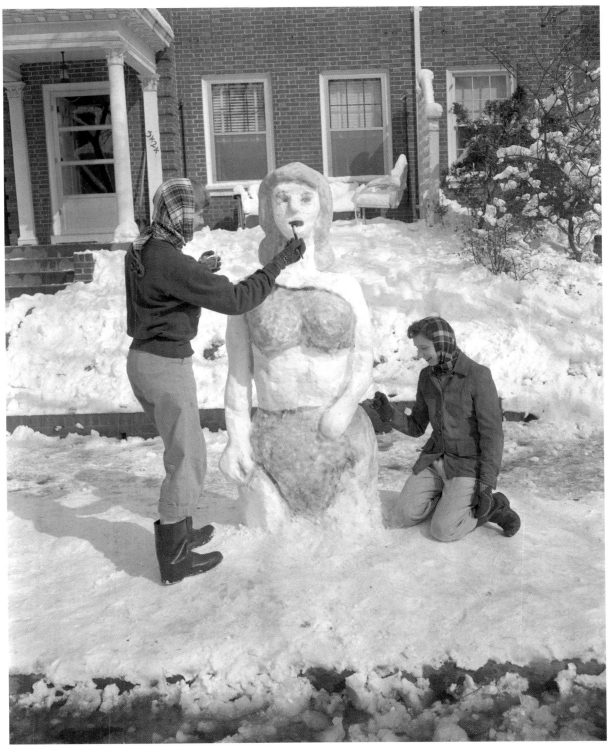

After a snowstorm struck the city in February 1958, two young women made a snow-woman in a two-piece bathing suit instead of the traditional snowman, perhaps to prompt an early summer.

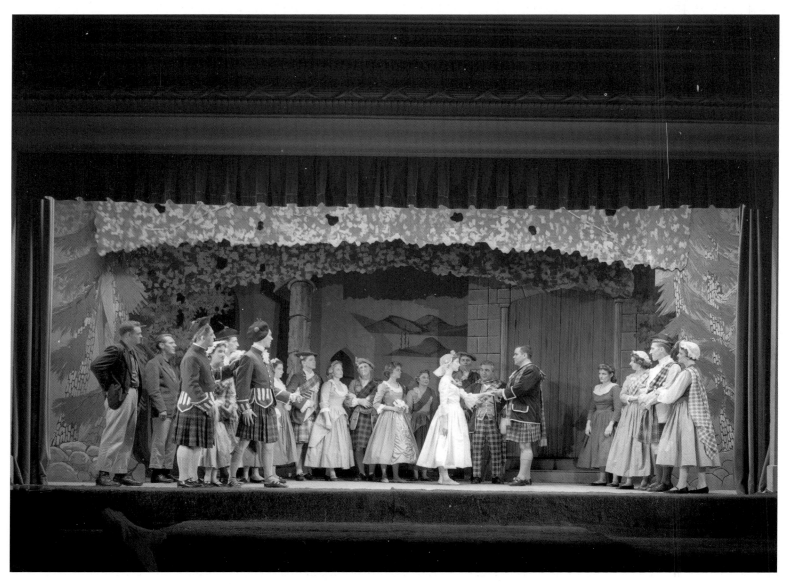

This Catholic Theatre Guild production of the musical play *Brigadoon* was presented in Richmond on May 15, 1958. The Guild, which grew out of the Catholic Theatre Movement of the 1930s, encouraged the presentation of wholesome plays.

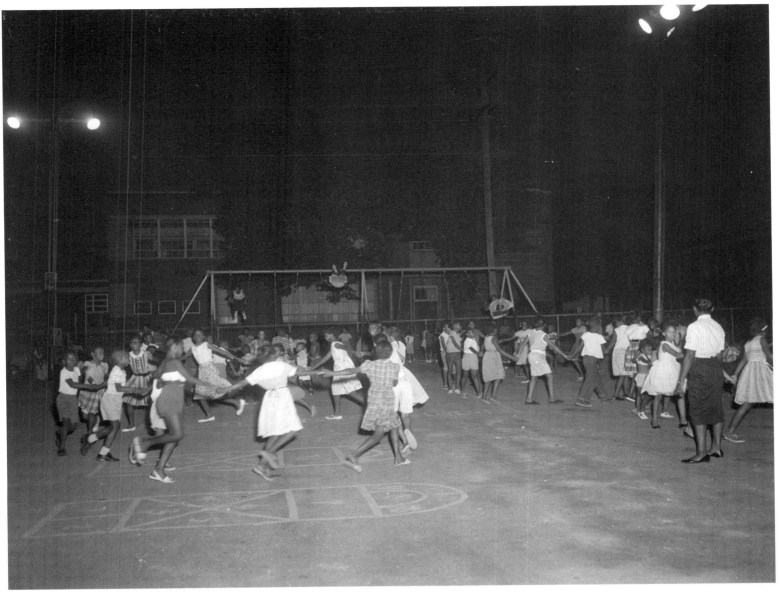

Taken at George Mason School on August 11, 1958, this photograph shows the south end of the school building in the background. City school architect Charles M. Robinson designed the school building, located at 29th and O streets in Church Hill, a predominantly African-American neighborhood. Constructed in 1922 and expanded in 1936, the school replaced two older buildings dating to the 1880s. George Mason School continues to serve the Church Hill community.

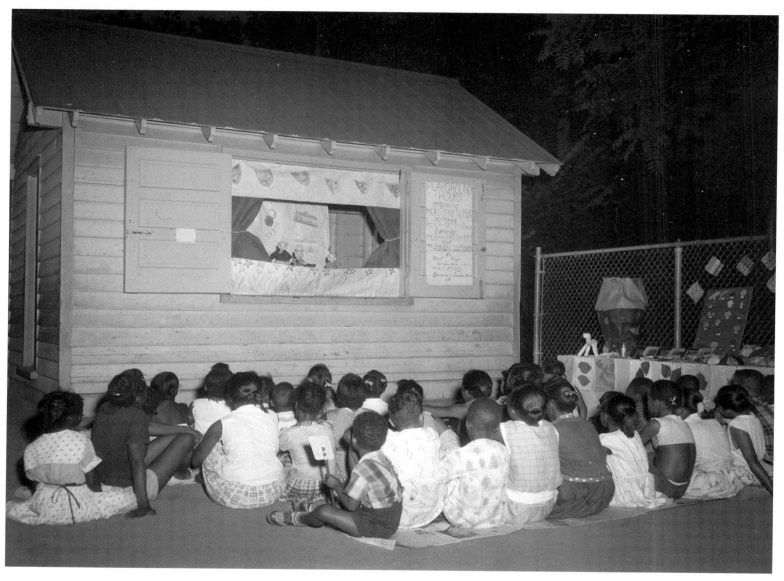

Because of the shortage of city parks open to African Americans in the 1950s, schoolyards such as this one at George Mason School in Church Hill filled the gap, especially when school had adjourned for the summer. The children shown in this photograph were watching a puppet show on the evening of August 11, 1958.

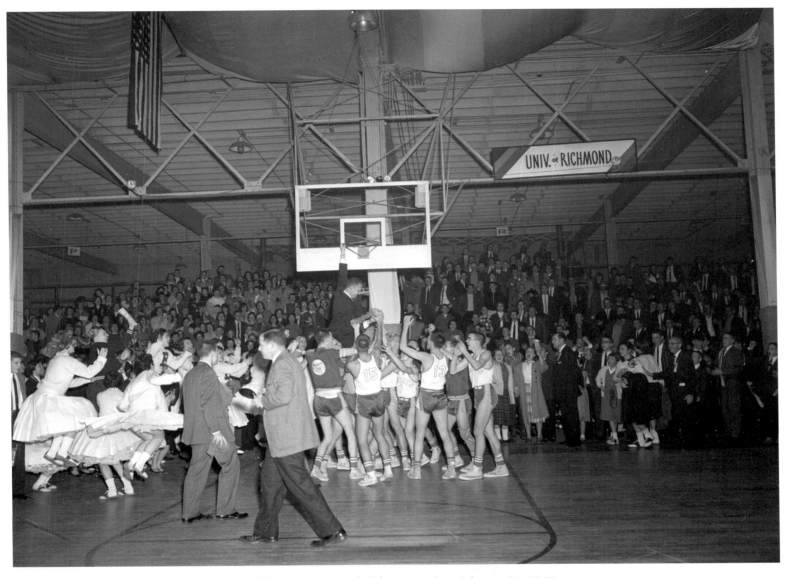

Virginia's Catholic high schools played a basketball tournament each February, and on February 22, 1959, Richmond's Benedictine Cadets defeated the defending champions, the Norfolk Catholic Crusaders, 51–42. The victorious Cadets are seen here cutting down the net in celebration. The game took place in the Richmond Arena, which still stands near Boulevard and remains in use.

Following Spread: Richmond was the first city in the world to have a successful electric streetcar system, which began operating in 1888. By the 1940s, however, buses began to replace the trolleys. In 1949, the streetcar system was closed down and some but not all of the tracks were taken up or paved over. These tracks appear in a photograph of Marshall Street taken on April 1, 1959, near 25th Street in Church Hill, where the Charles J. Billups and Sons Funeral Home and East End Drug Store served the community.

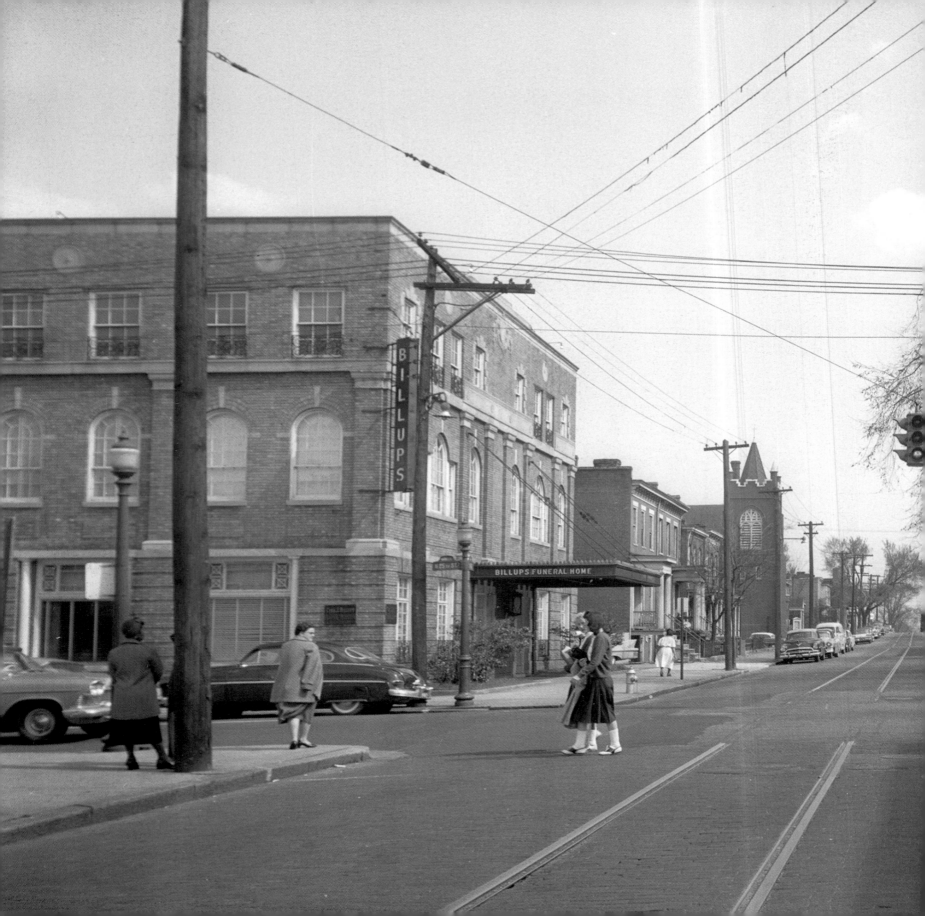

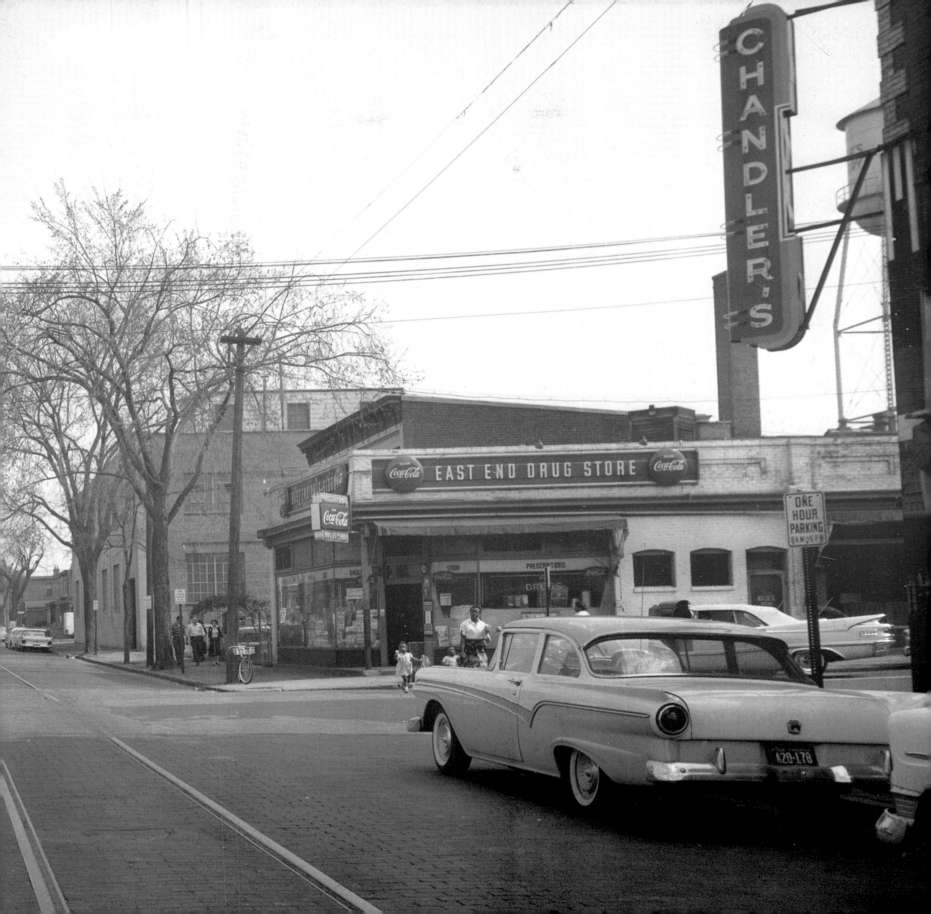

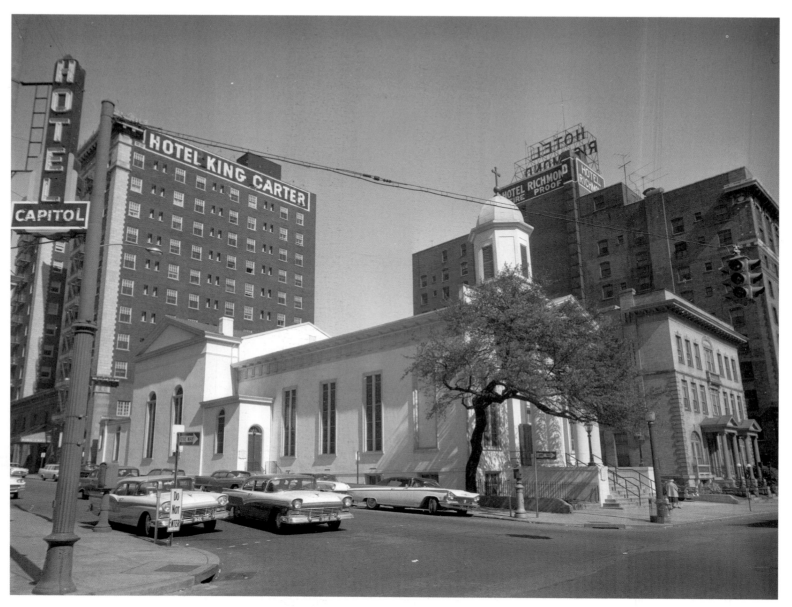

Taken from the southwestern corner of Grace and 8th streets, this photograph shows St. Peter's Roman Catholic Church with the hotels King Carter and Richmond in the background. The church was Richmond's first cathedral and oldest Catholic church, completed in 1834. The two hotels eventually became state office buildings. King Carter became the 8th Street Office Building; it was demolished in 2009. The Richmond Hotel still serves as the 9th Street Office Building, facing Capitol Square.

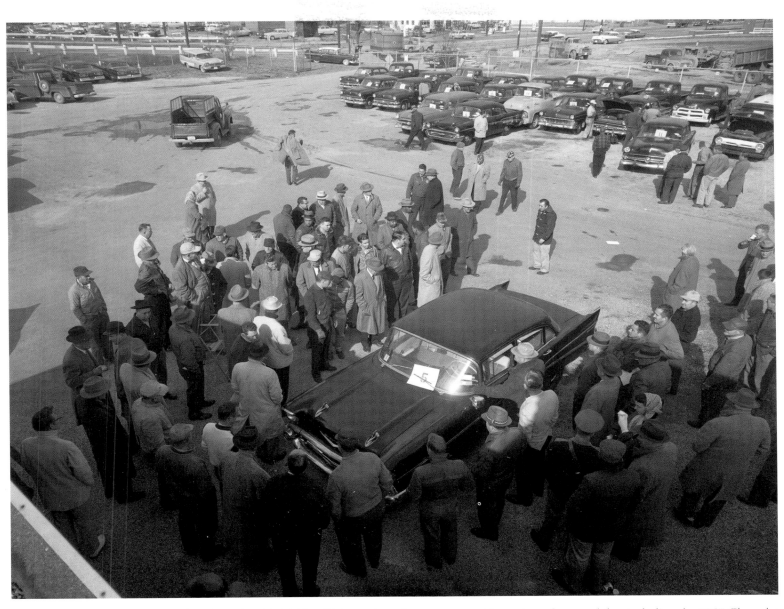

On November 20, 1959, a Richmond auction company sold a variety of automobiles, including the 1957 Chevrolet Bel Air in the foreground.

The Swift Ice Cream plant was located at 308 N. Laurel Street between Grace and Broad streets. It was one of several ice cream manufacturing companies in Richmond. The plant closed a few years after this photograph was taken on September 7, 1955.

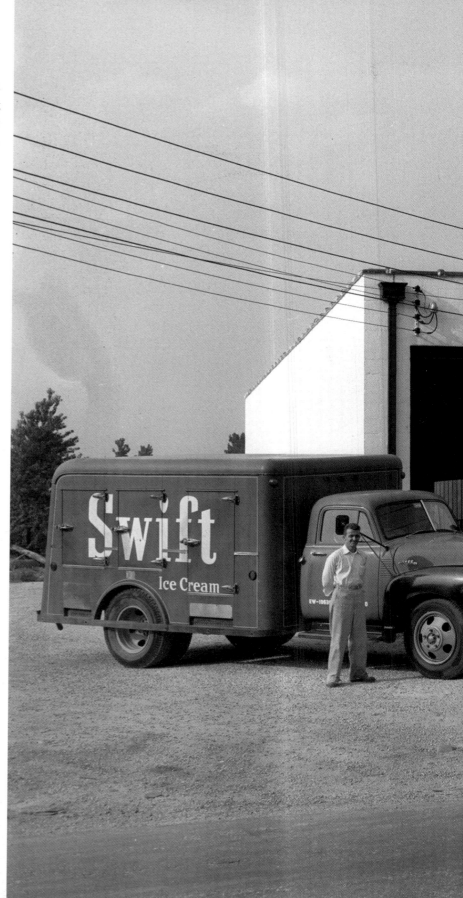

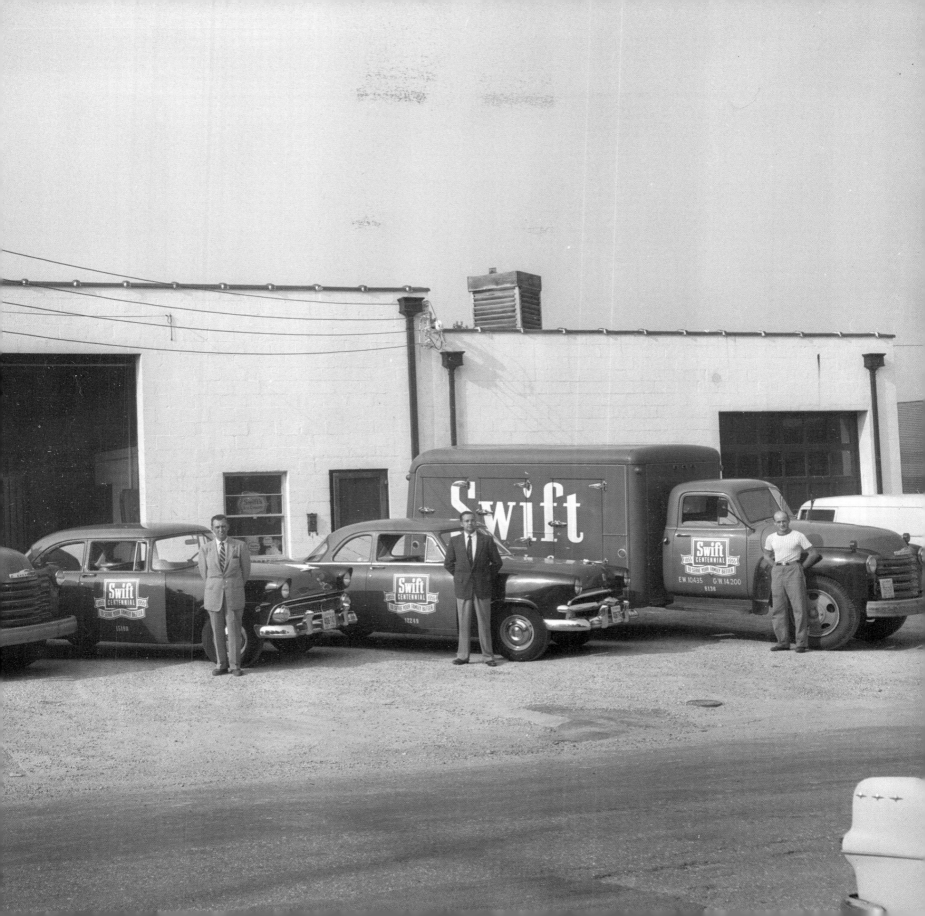

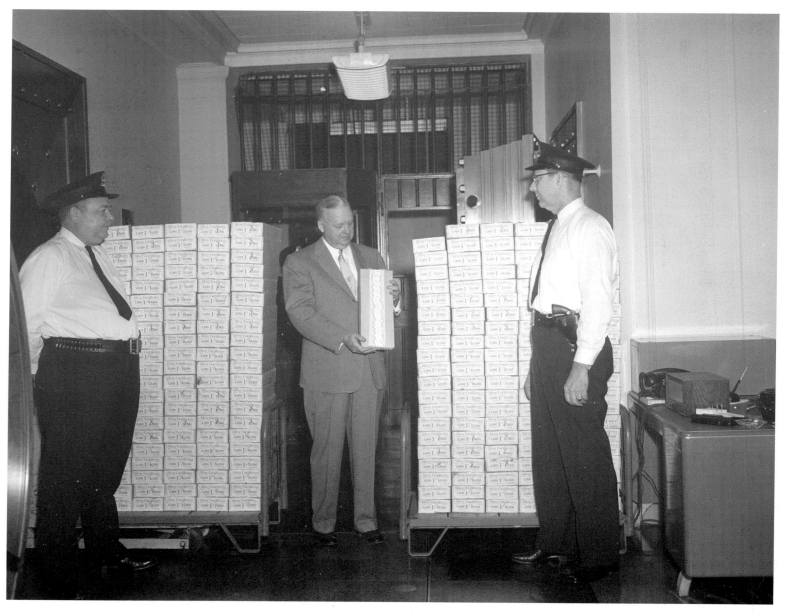

This photograph, taken in 1956, shows the Federal Reserve Bank vault located in the federal bank building at 9th and Franklin streets. In 1980, the Federal Reserve moved to a new headquarters close to the James River, and this building was renovated to serve the Supreme Court of Virginia.

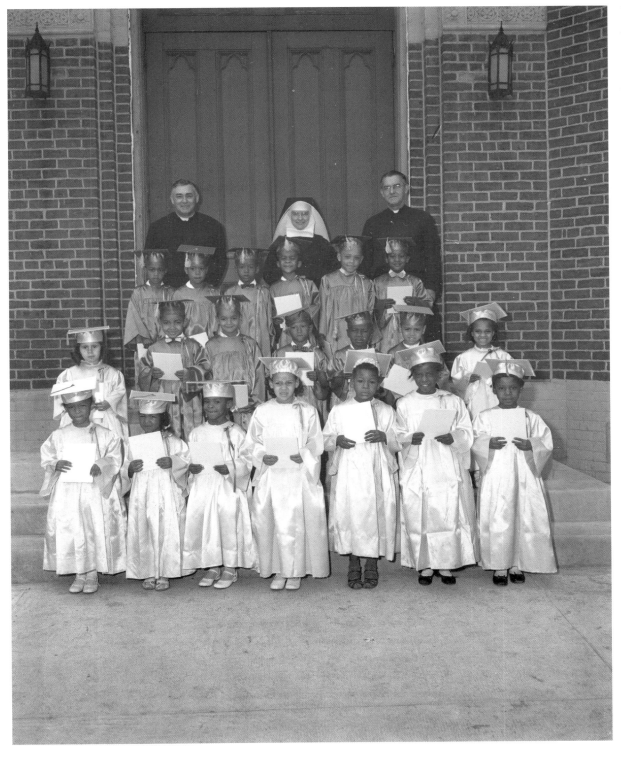

The first-known African-American Roman Catholic congregation in Richmond was formed in 1884 as St. Joseph's Roman Catholic Church. Located in the 700 block of North 1st Street in Jackson Ward, the church soon established a two-room school for grades K–12, and eventually expanded its operations to include a parish house, a trade school, and a two-year business college. The church and school closed in 1969. Today, all that remains is the Franciscan Convent building at 717 North 1st Street. This graduation photograph was taken on June 11, 1955.

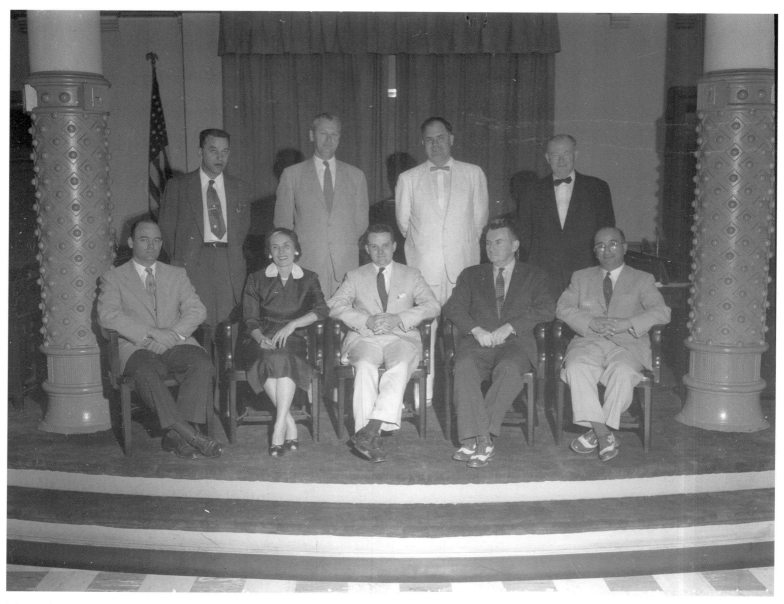

The Richmond City Council was photographed in Old City Hall on July 1, 1954. The sole woman in the picture is Eleanor P. Sheppard, who had just become the first woman elected to the council. In 1960 she became Richmond's first vice-mayor, and two years later she was elected the first woman mayor of an incorporated Virginia city. She served one two-year term and then continued as a council member until 1967, when she resigned and was elected to the Virginia House of Delegates. She served as a delegate until she retired in 1977, having never lost an election. Eleanor Sheppard died in 1991.

PROMISE AND TURMOIL: THE 1960s

If the 1950s were generally an era of peace and tranquility, the next decade was anything but. It did not begin that way, however, and aside from the growing Civil Rights Movement, there was little at first to suggest the violent and divisive future of assassinations, wars hot and cold, protests, and riots that seemed to typify the period. A young president took office in 1961, and although tensions with the Soviet Union continued to escalate during his tenure in office, at the start it seemed that the happier aspects of the previous decade were continuing. Perhaps it could be said that "The Sixties" as we think of them today began with the assassination of John F. Kennedy in 1963 and ended with the resignation of President Richard M. Nixon in 1974, shortly after the end of the Vietnam War.

In Richmond, new construction continued throughout the decade at what seemed like a breakneck pace, dramatically altering the skyline. Many old buildings and neighborhoods fell to the wrecking ball. In the suburbs, newly linked with better roads, residential developments and shopping centers grew where farmers had raised corn only yesterday. Ominously for the future of downtown, office parks began to increase in number. One of the first ones—the Reynolds Metals Company headquarters—had been constructed just west of the city in the mid-1950s. It attracted considerable attention not only for its innovative architecture but also for the tranquility of its setting on more than a hundred acres, in contrast to noisy and crowded downtown Richmond. Instead of an aberration, the new facility was a sign of things to come.

Another sign was the growing impatience among African Americans over the glacial pace of desegregation. Richmond did not experience the violent unrest that erupted in some other cities, but nonetheless, change gradually took place. A young native son, Arthur Ashe, achieved world fame in tennis and broke down many barriers in that sport for other blacks. In an interview with *Sports Illustrated* in 1966, Ashe noted that at many tournaments he was the only nonwhite except for the locker-room attendants, from whom he received especially good treatment. The article questioned whether Ashe had the "killer instinct" necessary to achieve success at the top level of the game, mistaking the young man's politeness (he was a Richmonder and a southerner, after all) for a lack of aggressiveness. Ashe soon proved that he had all the right instincts, becoming one of the world's best players in the 1970s. He went a long way from the segregated tennis courts of his

Richmond childhood. The city has commemorated this sports star and humanitarian with a statue on Monument Avenue, a place formerly the sole province of Confederate icons.

Politically, black Richmonders not only became organized but also succeeded in electing African Americans to offices that only recently had been completely white. In 1948, Oliver Hill, who in the 1950s would become a giant of the legal profession in the Civil Rights Movement, was elected to the Richmond City Council and served one two-year term before being defeated. In 1964, B. A. Cephas, a black insurance executive, was elected to council, and two years later real estate man Wilfred Mundle and attorney Henry L. Marsh III, now a state senator, joined him. In 1966, Dr. W. Ferguson Reid was elected to the Virginia House of Delegates, and in 1969, attorney L. Douglas Wilder was elected to the state senate, beginning a long electoral career that would culminate in 1989 in his becoming the first black governor elected since Reconstruction and the first popularly elected black governor in the United States.

If the racial changes came slowly but dramatically in the 1960s, the physical changes to the city during the same period were likewise startling. They are obvious when the photographs in this section are compared to the downtown scene today. Entire blocks have been replaced with new buildings; in most cases, high-rise office towers soar where two- and three-story structures dating to the nineteenth century once stood. Some sites were leveled merely for surface parking. Happily, however, other buildings shown here not only have survived intact but have also been renovated for other uses.

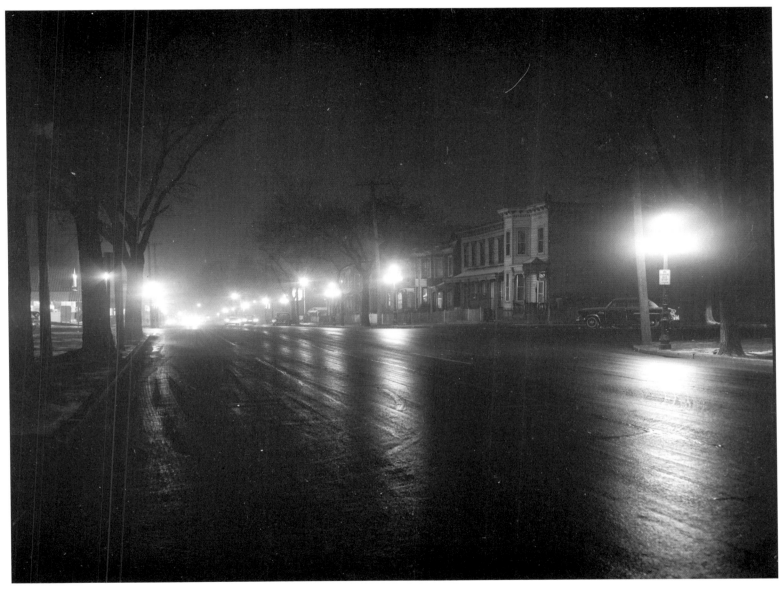

Jefferson Avenue is located on Church Hill in the East End of the city. It runs at an angle north of Broad Street between 21st and 25th streets. This nighttime photograph was taken on March 4, 1960, after a big snowstorm.

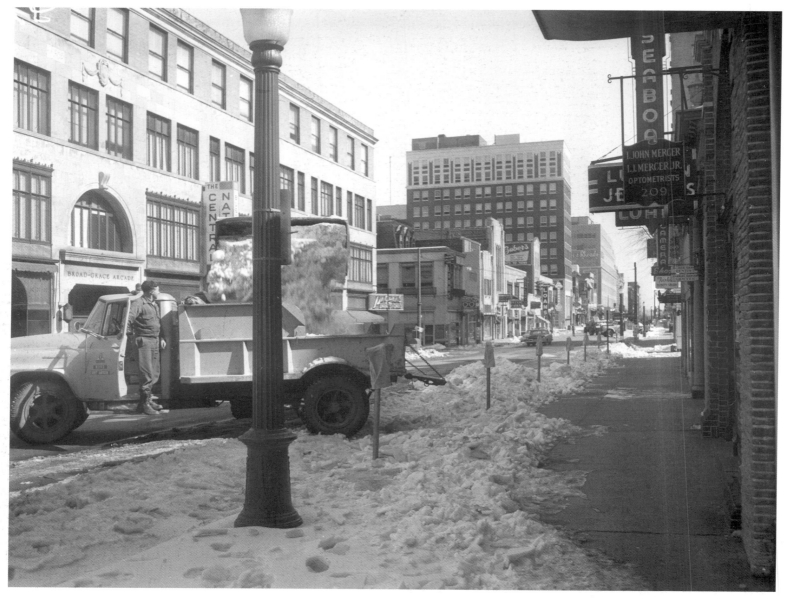

Richmonders spent several days cleaning up after an eight-inch snowfall struck the city on March 2–3, 1960—the deepest ever recorded in March. This photograph was made downtown on March 6; continuing low temperatures had slowed melting.

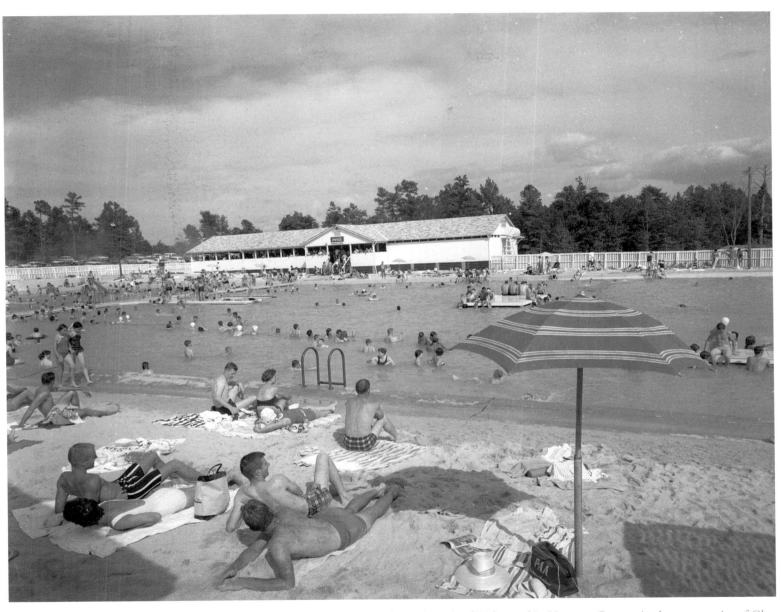

Overhill Lake, photographed on June 5, 1960, is located north of Richmond in Hanover County, in the community of Glen Allen. The lake has been a longtime suburban resort area for city residents.

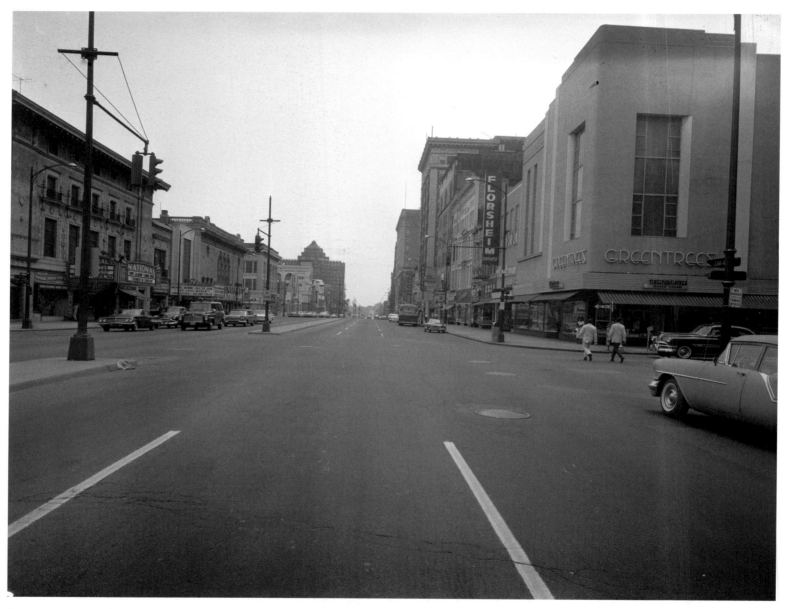

Facing east on Broad Street at 7th Street, this photograph taken on July 31, 1960, shows the National Theatre, which still stands, on the north side of Broad Street (*left*), and Greentree's on the corner of 7th Street (*right*). The new U.S. District Court building has replaced most of the block including Greentree's, a renowned men's clothing store famous for its personal service and high-quality goods. Impeccably dressed salesmen gladly helped male customers cope with the bewildering task of matching shirts, jackets, and ties. On April 18, 1956, at the annual Brand Names Day dinner at the Waldorf-Astoria Hotel in New York, Greentree's was awarded the retailer-of-the-year plaque in the menswear category.

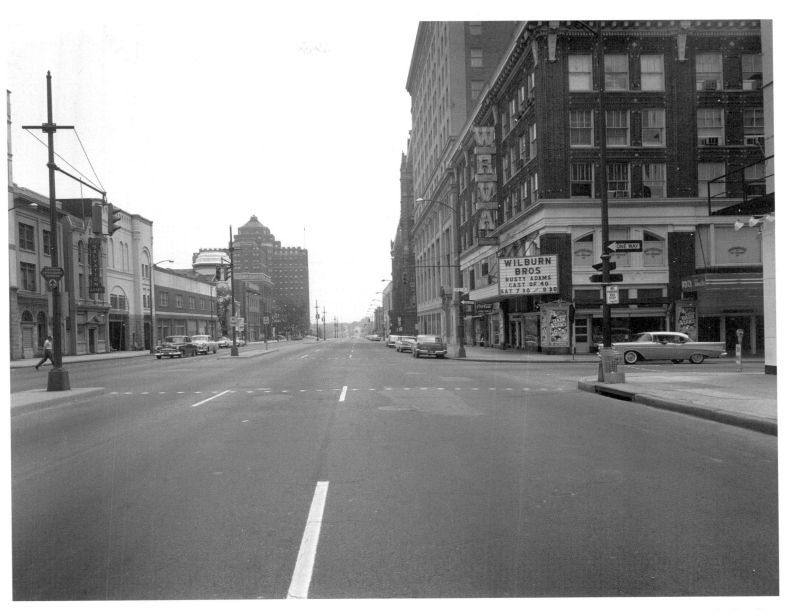

Taken on August 1, 1960, and looking east, this photograph shows the intersection of Broad and 9th streets, with the Medical College of Virginia hospital prominent in the distance on Broad Street at 12th. On the right, in the Hotel Richmond, were located the studios of radio station WRVA, the "Voice of Virginia." The station began broadcasting in 1925 from the Edgeworth Smoking Tobacco Company building downtown and then moved to the hotel in 1933. Six years later, it constructed a 50,000-watt transmitter east of the city, at a time when many stations used only 5,000 watts, thereby greatly increasing its power and range. WRVA moved to a new studio, designed by Modernist architect Philip Johnson, on Church Hill in 1968, and then to new facilities in the West End in 2000.

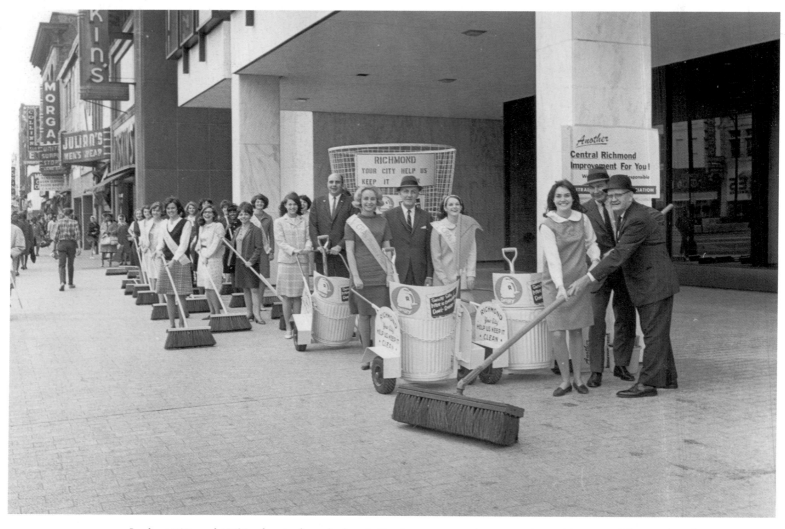

In the 1950s and 1960s, the city launched periodic clean-up campaigns, complete with pretty girls, parades of street-sweeping machines, and giant brooms and trashcans. This campaign photograph was taken in 1960.

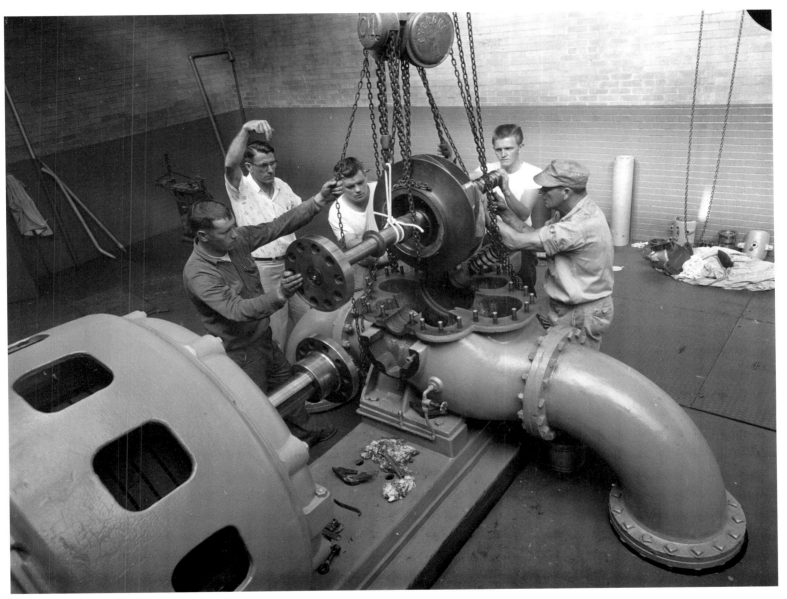

The city water reservoir in Byrd Park dates to 1875. At first it was open, but now it is covered, and a pump distributes the water to Richmond homes and businesses. In this photograph taken on July 21, 1961, city workers are performing maintenance on one of the pumps.

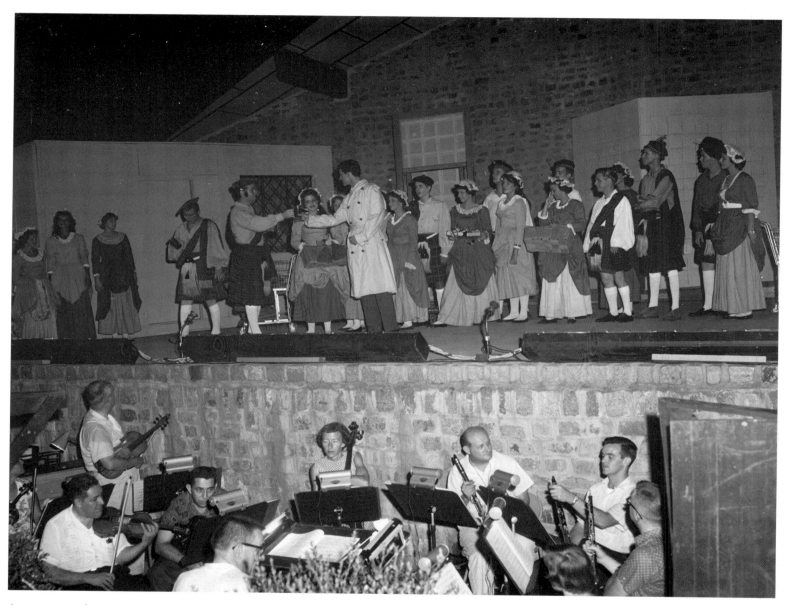

A summer stock company is seen rehearsing the ever-popular musical *Brigadoon* in this July 25, 1961, photograph taken at Dogwood Dell in Byrd Park. The park has been one of Richmond's favorite outdoor summer entertainment venues since it was established late in the nineteenth century. Dozens of festivals, art shows, and plays are held there annually, as well as a spectacular Fourth of July fireworks display.

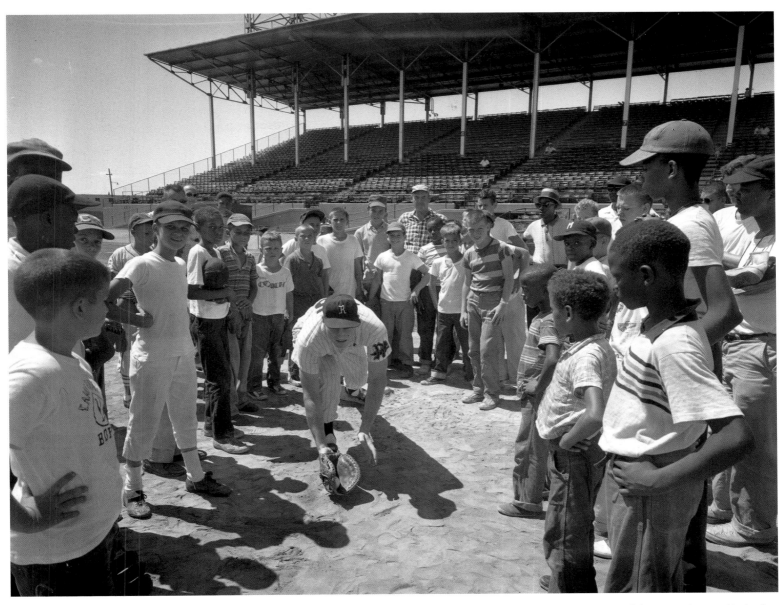

The Richmond Virginians, a AAA minor-league baseball franchise, played in Richmond from 1954 to 1964. At first unaffiliated, the team became part of the New York Yankees system in 1956. The Virginians were transferred to Toledo, Ohio, in 1965, where the team became the Mud Hens. Shown here is Joe Pepitone, a first baseman and outfielder, who played for the Virginians in 1962. He had been called up to the majors that year but was sent down to Richmond briefly before returning to "The Show."

The Henry Coalter Cabell House at 116 South Third Street was constructed in 1847 for William O. George but then leased to Cabell for three decades beginning in the 1850s. It is located on Gamble's Hill, a fashionable nineteenth-century neighborhood, and is the lone survivor of the many elegant houses that once stood there. The Virginia Education Association has had its headquarters there since 1951.

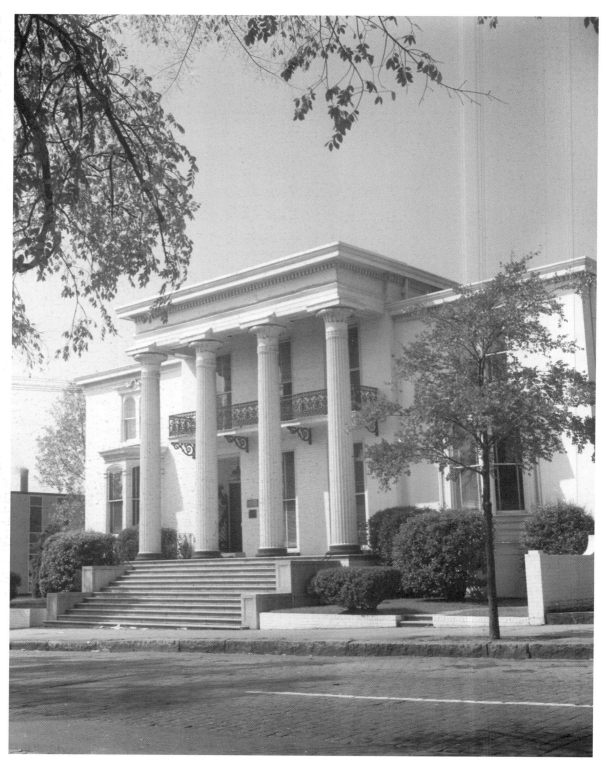

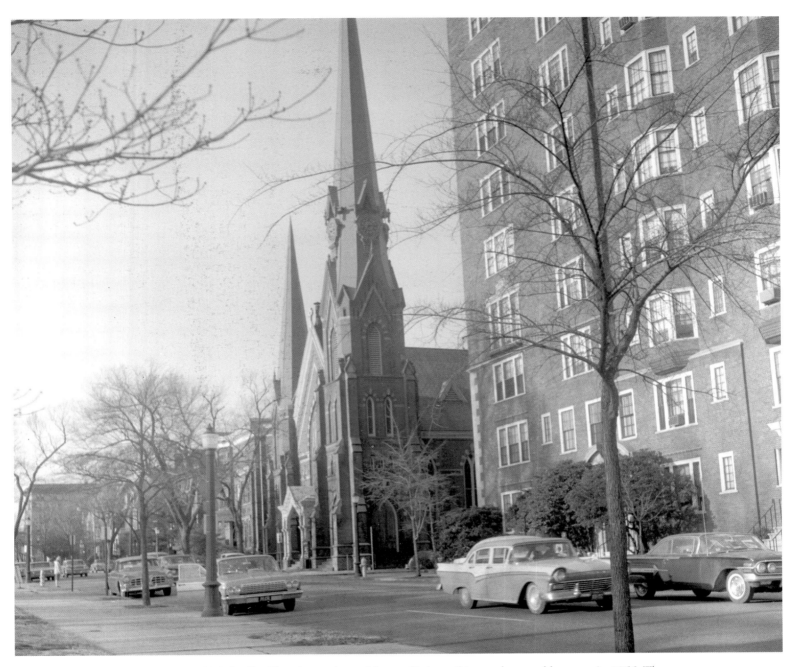

Constructed in 1886, Pace Memorial Methodist Church stood near Monroe Park until it was destroyed by arson in 1966. The exuberant Victorian Gothic church was called Park Place Methodist Episcopal Church South until it was renamed in 1921 for benefactor James B. Pace, who had donated the land on which it stood.

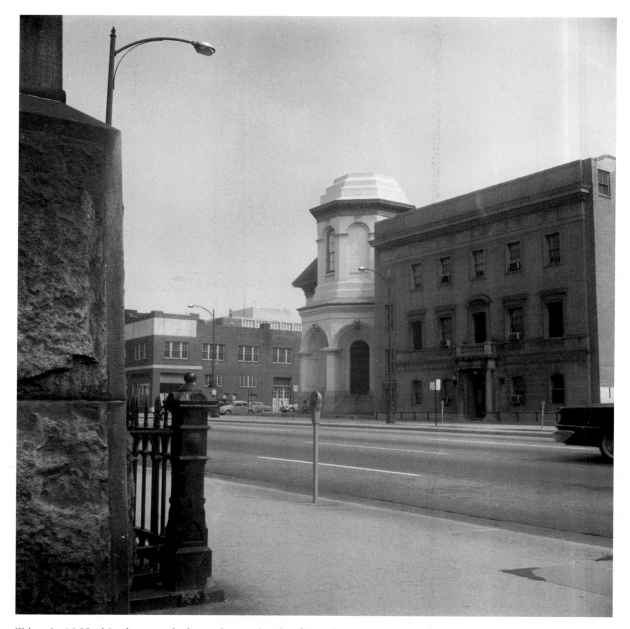

Taken in 1965, this photograph shows the north side of Broad Street at the intersection with 10th Street. The church is Broad Street Methodist, completed in 1859 in the Italianate style. It was demolished a few years after the picture was made to provide parking for the Richmond Eye and Ear Hospital. The building across the street from the church was torn down to make room for New Richmond City Hall, constructed in 1971. The edge of Old City Hall, completed in 1894, is at the left.

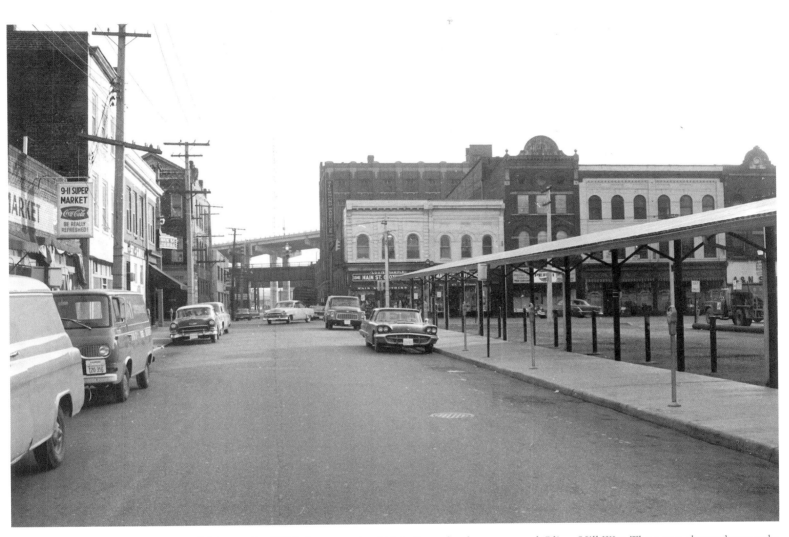

This stretch of 17th Street north of Main Street has been renamed Oliver Hill Way. The name change honors the pioneering African-American civil rights attorney and longtime Richmond resident who was instrumental in the case of *Brown* v. *Board of Education of Topeka, Kansas.* On the right is the Farmer's Market, and an overpass of Interstate 95 can be seen in the distance. Many of the stores on the left are now restaurants. The picture was taken in the 1960s.

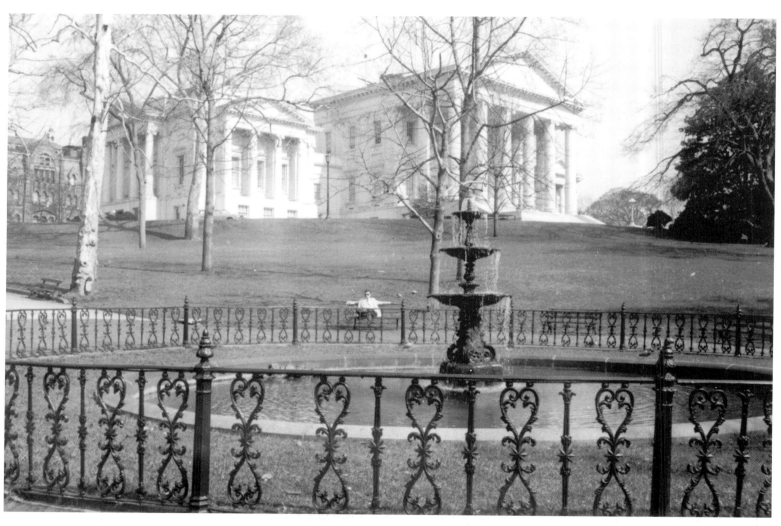

The grounds of Capitol Square have always been a haven for state workers—a place to relax over lunch and soak up the sun, especially on a nice spring day.

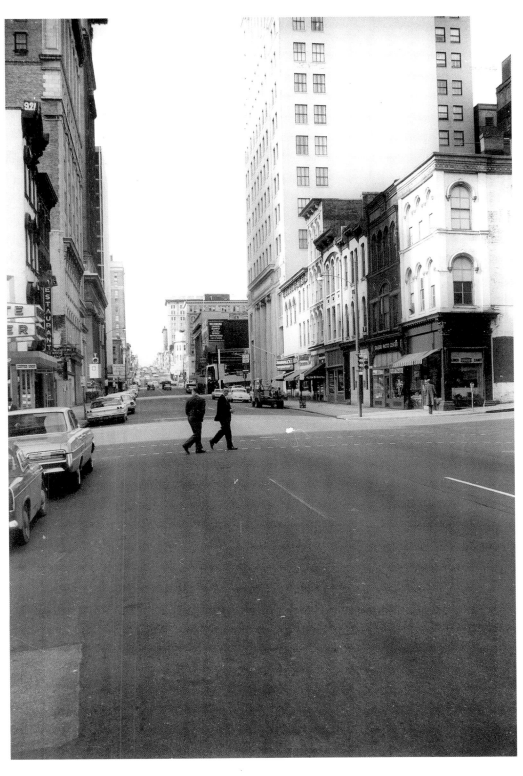

This is the heart of Richmond's downtown financial district, facing west on Main Street from just east of 10th Street. Several of the buildings visible on the left in this 1960s photograph have been demolished for high-rise office towers, as have the smaller buildings on the right.

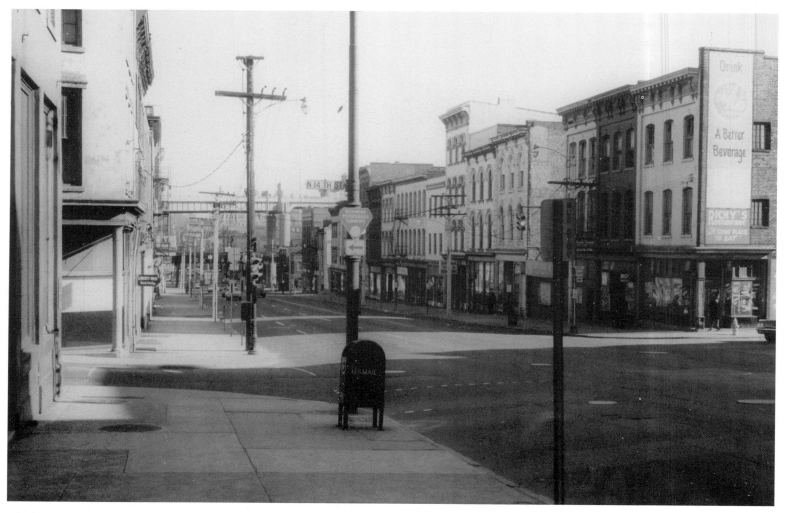

The block of buildings across 14th Street on the right side of Main Street has long since been torn down for surface parking. In the distance, the railroad trestle now runs under the Interstate 95 overpass.

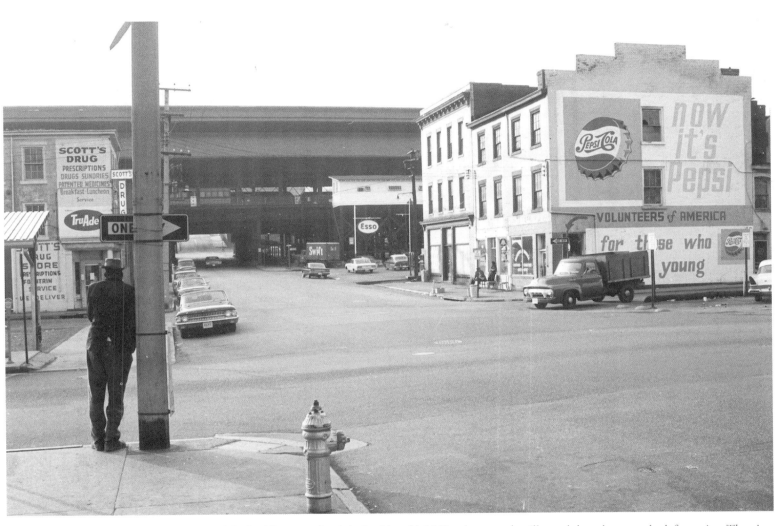

None of the buildings on the right in this mid-1960s photograph still stand, but those on the left survive. The view is west on Franklin Street looking across 17th Street to the train shed and trestle at Main Street Station.

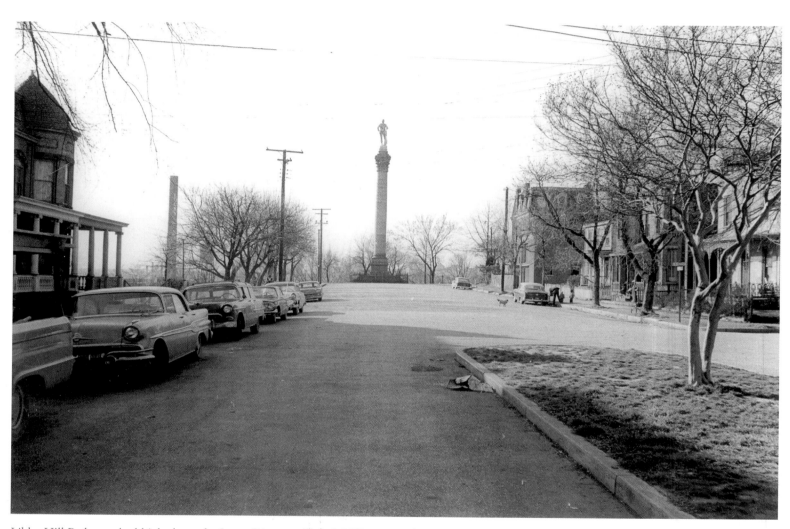

Libby Hill Park, perched high above the James River on Church Hill, is one of Richmond's underappreciated parks. Although the Confederate Soldiers' and Sailors' Monument appears to dominate the park in this 1960s photograph facing south, the view of the James River quickly occupies the visitor's sight and attention. According to local tradition, it was here that city founder William Byrd II decided to name his town Richmond, because of the similarity of the river's bend with that of the Thames at Richmond near London, England.

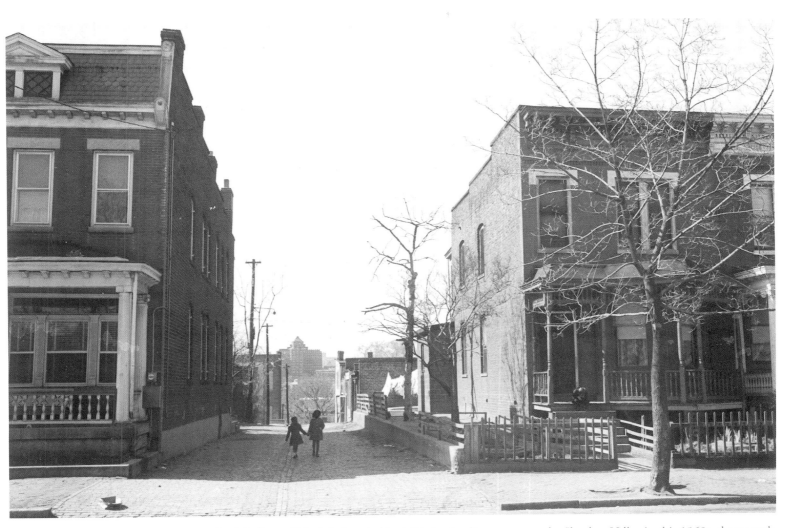

The Medical College of Virginia hospital is visible in the distance across the Shockoe Valley in this 1960s photograph. It was taken facing west from 23rd Street in Church Hill. The hospital was completed in 1940, one of several federally funded buildings in the area constructed in the Art Deco style.

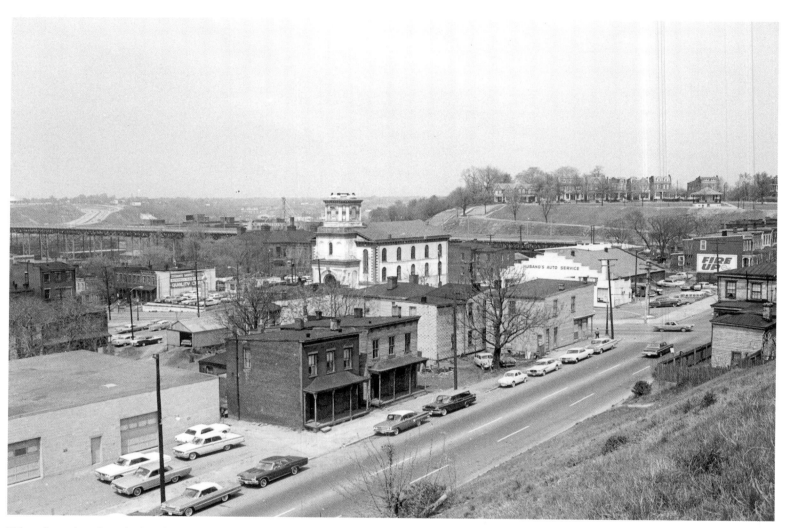

Taken from the edge of Church Hill looking northwest in the 1960s, this photograph shows 21st Street in the foreground running up to East Broad Street. All of the buildings across 21st Street have been torn down except the garage at bottom left. The white building and the church on Broad Street still stand. The church, Old Trinity Methodist, was completed in 1866. It once had a tall spire, but it was damaged in a hurricane in 1955 and taken down.

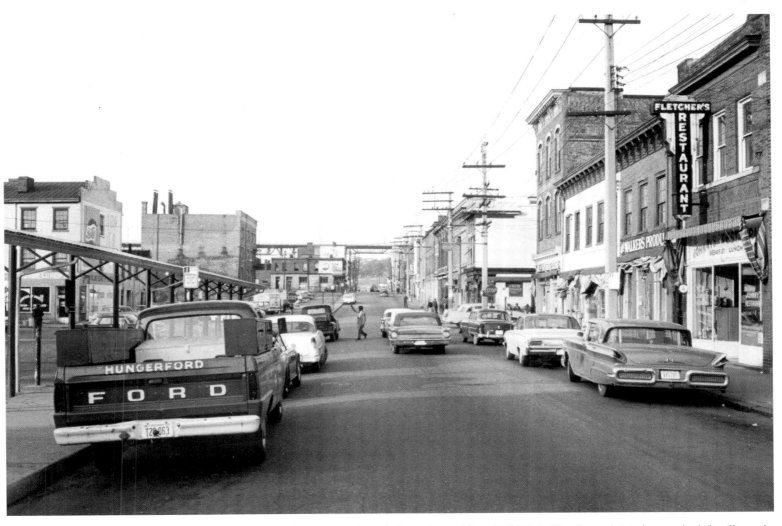

This mid-1960s photograph was taken on North 17th Street (now Oliver Hill Way). The Farmer's Market on the left still stands, but the stalls have been covered. On the right, the buildings have now been renovated for restaurants and small shops.

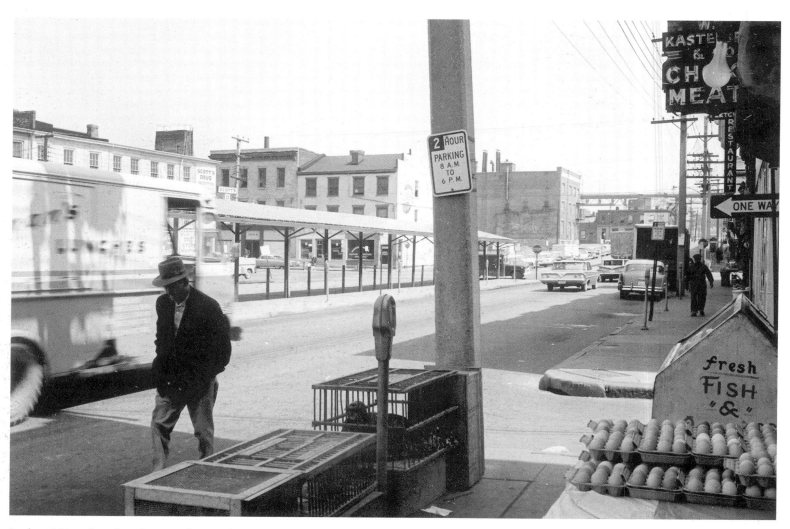

In the 1960s, when this photograph was taken, many of the shops like this small grocery in Shockoe Bottom served neighborhood residents. Now the stores cater to the lunch, dinner, and nightclub crowds. On the left is the Farmer's Market, with the view to the north.

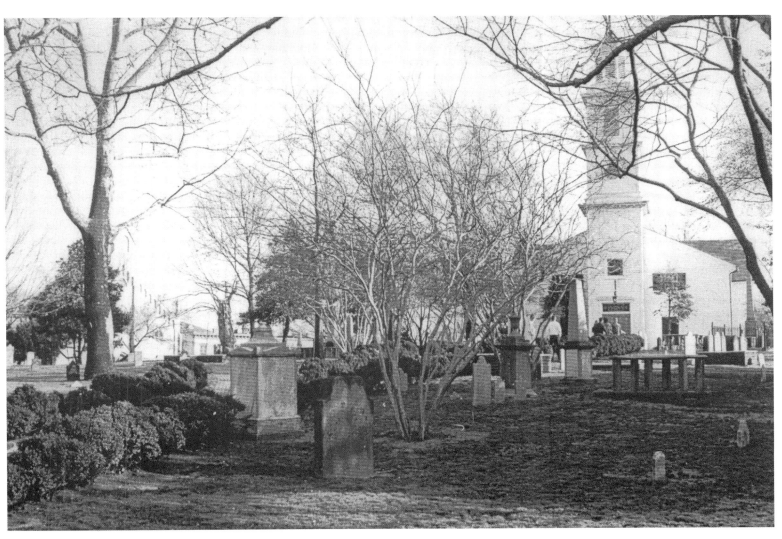

In the colonial period, St. John's Church on Church Hill had the only burial ground in the small community that then constituted Richmond. Many important early Richmonders are buried there, including the mother of poet Edgar Allan Poe.

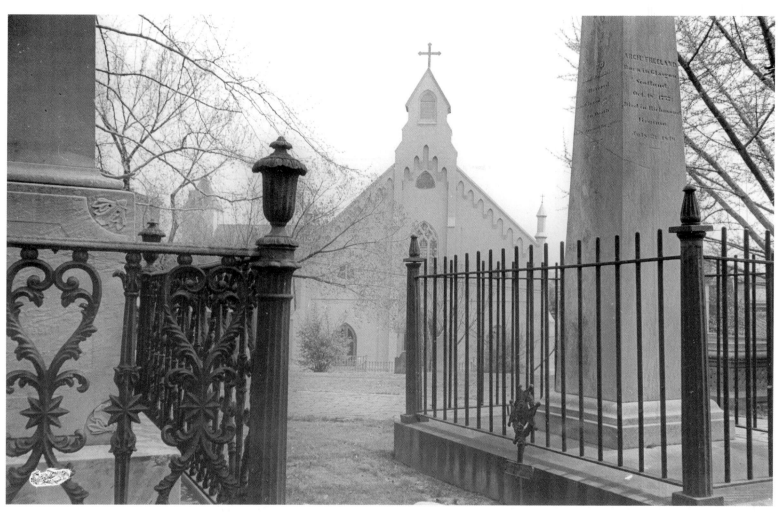

Seen from the St. John's Church cemetery is St. Patrick's Catholic Church, which was erected east of the old Episcopal house of worship across 25th Street in 1859. The Daughters of Charity established a school there in 1866.

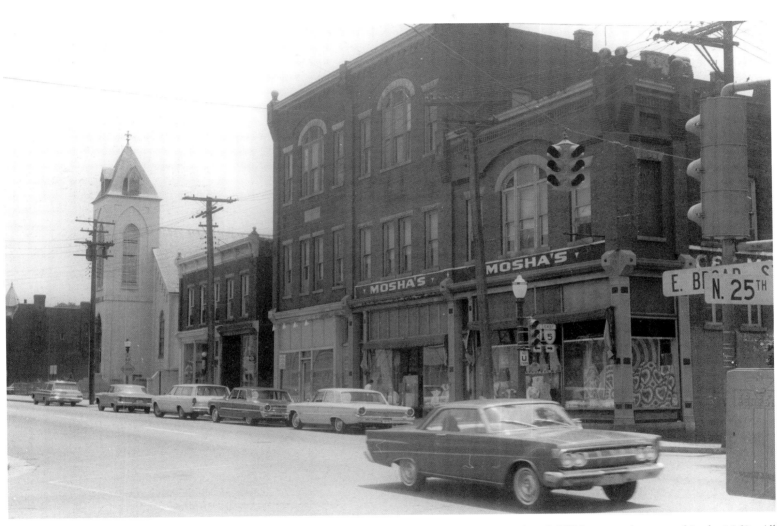

The north side of East Broad Street between 25th and 24th streets in Church Hill is seen as it appeared in the 1960s. All of the buildings are now gone, and in their place is a green space called Patrick Henry Park.

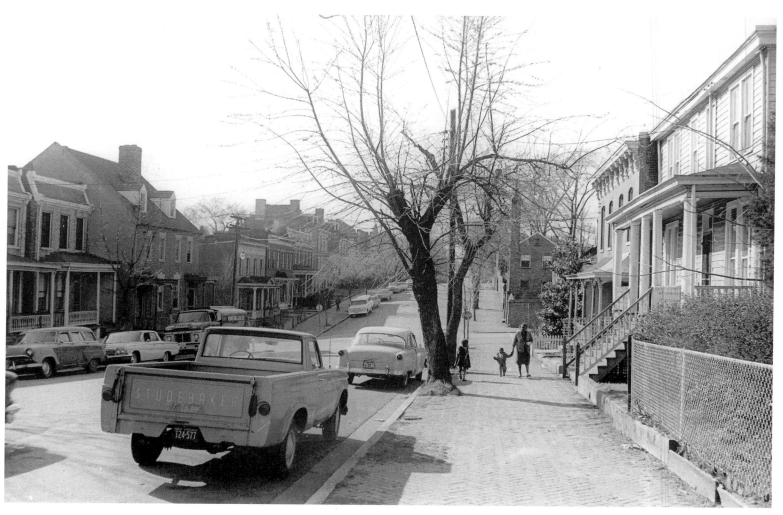

Behind the people on the right can be seen a brick outbuilding on the St. John's Church property across 25th Street.
The view is facing west on East Grace Street, with houses typical of Church Hill on each side.

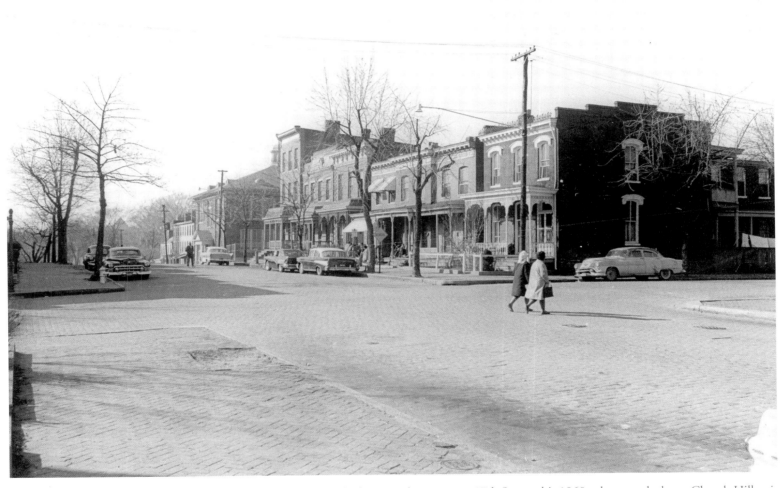

Taken on East Grace Street looking northwest across 27th Street, this 1960s photograph shows Church Hill as it appeared before a major restoration effort was undertaken there. A veritable outdoor museum of nineteenth-century domestic architecture, Church Hill attracted preservationists who carefully renovated many of the houses.

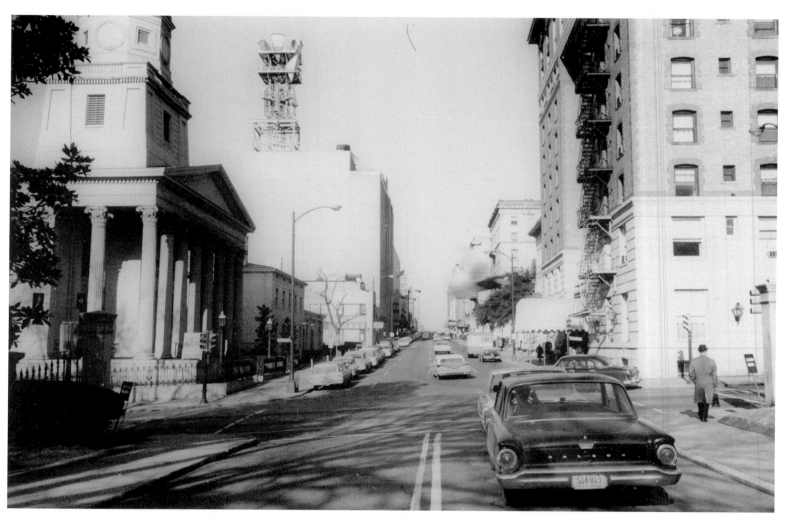

East Grace Street is seen from the western side of Capitol Square in this photograph looking west across 9th Street. St. Paul's Episcopal Church, where Confederate president Jefferson Davis received word from General Robert E. Lee that the army would evacuate the city on April 2, 1865, is on the left. The former Hotel Richmond, now the 9th Street Office Building for state government, is on the right. In the distance, the tower of equipment is atop the Chesapeake and Potomac Telephone Company headquarters.

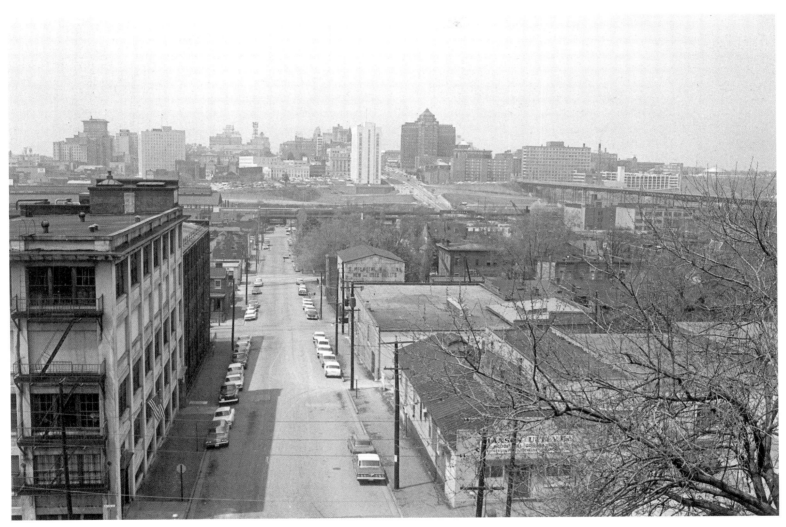

This image essentially replicates a view recorded about a century earlier, after the U.S. Army occupied the city in April 1865. Both pictures show the city looking west from East Grace Street at the western edge of Church Hill. The differences between this picture and the same view today are almost as great as those between this image and the one made at the end of the Civil War. The Medical College of Virginia complex to the right of the MCV hospital tower in the distance, for example, is almost completely hidden behind more recent construction.

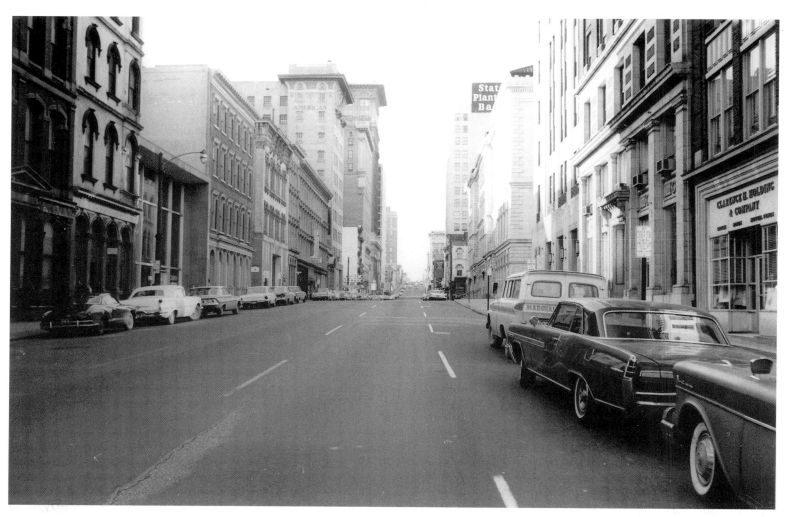

Facing west on Main Street at about 12th Street, this photograph was taken in the 1960s. Although the buildings on the left in the foreground have been demolished for a high-rise office and plaza, those on the right are still standing and in use.

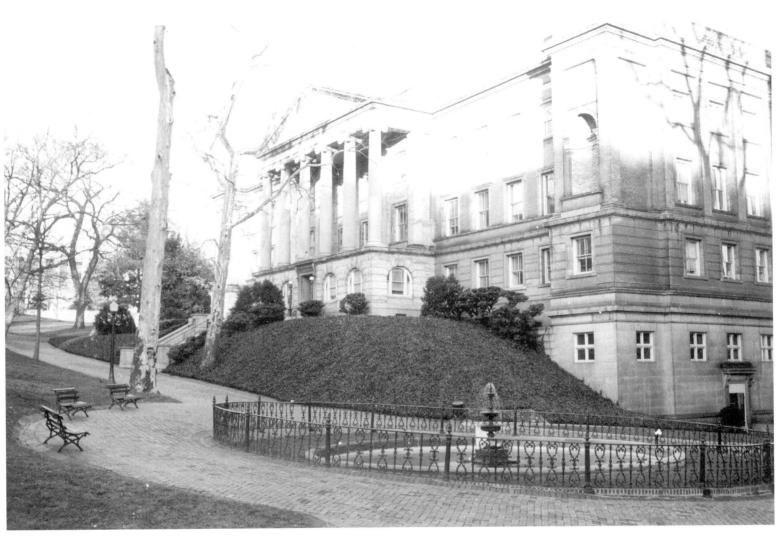

The Virginia State Library was established in 1823 in the Virginia State Capitol primarily to serve as the reference library for government officials. Because it outgrew its quarters as it received deposits of state government records and added to its book collection, the library moved in 1895 into this building. It also contained the offices of the state treasurer, the auditor of public accounts, and the adjutant general, among other state agencies. The library has moved twice more and is now located on the north side of Broad Street between 8th and 9th streets. Mothballed for years, this building is again in use for government offices.

The Bell Tower is visible behind the fountain in this 1960s photograph. Completed in 1824 as a guardhouse and signal tower for the Virginia Public Guard, a forerunner of today's Capitol Police, the Bell Tower is located in the southwestern corner of Capitol Square. In the twentieth century, it served briefly as the office of the lieutenant governor. Today, the Virginia Tourism Corporation maintains a visitor center there.

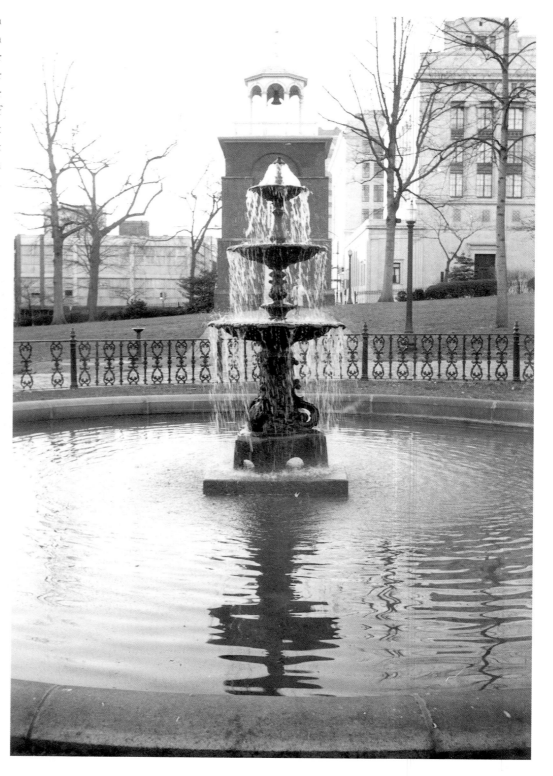

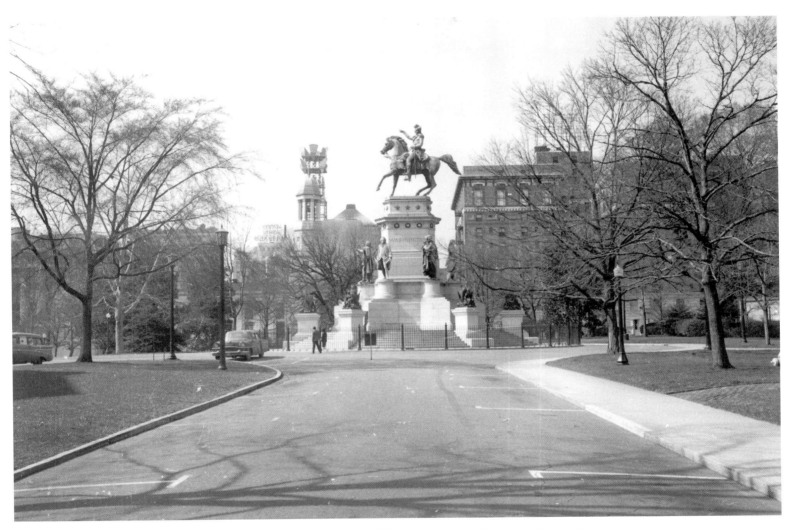

Philadelphia artist Thomas Crawford sculpted the equestrian statue of Washington and had it cast in Europe. It was unveiled on February 22, 1858. The base of the statue includes a crypt intended for Washington's remains, which are entombed at Mount Vernon; his descendants, however, refused permission to transfer them.

The mounting block in the foreground was a remnant of the days of horses, carriages, and buggies. Photographed in the 1960s on Franklin Street between Foushee and First streets, the old block is still there, unlike the building on the far left of the image and its two neighbors. Down the street can be seen the spires of the Jefferson Hotel.

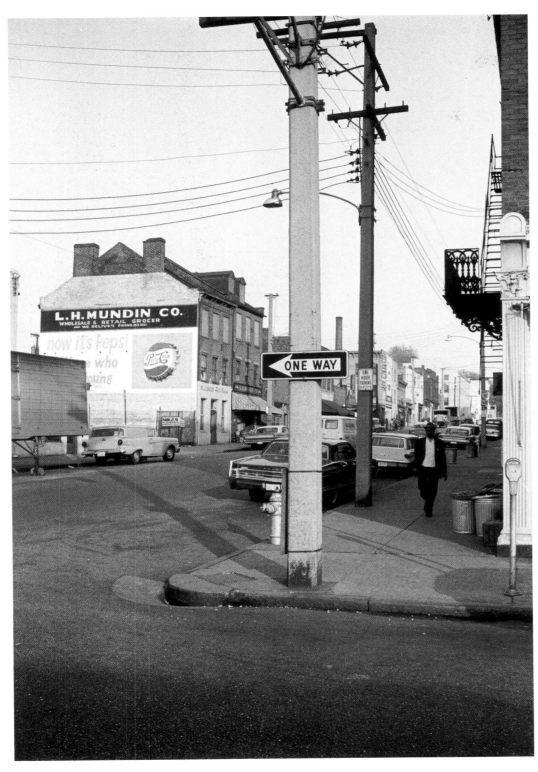

This view shows East Franklin Street looking east from the intersection with North 17th Street. Almost all of the buildings shown here still stand, including the grocery building that Lewis H. Mundin, Jr., occupied in the 1960s.

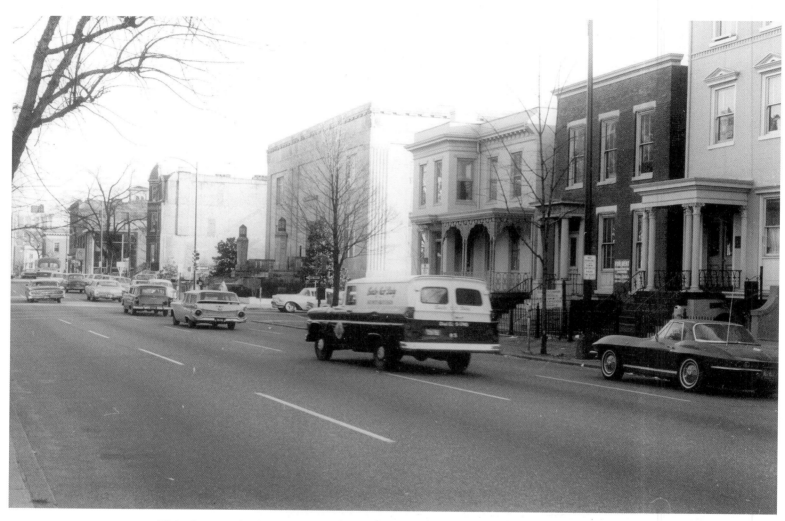

This photograph of East Franklin Street looking east was taken in the 1960s before the Richmond Public Library, visible across 1st Street, was encased in a larger and more modern building that filled the block in 1972. James H. Dooley, the builder of Maymont, endowed the library, which was completed in 1930. The small town houses on the right still stand.

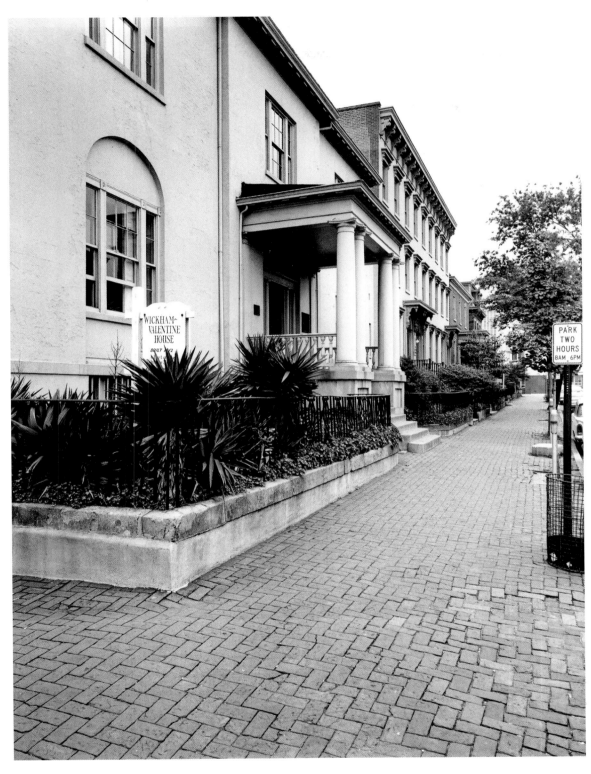

The Wickham-Valentine House, the home of the Valentine Richmond History Center, was completed for lawyer John Wickham in 1812. Later owner Mann S. Valentine, a wealthy industrialist, left his extensive collection of art and Virginia Indian artifacts as well as the house for a museum. Located at 1105 East Clay Street in Richmond's Court End, the mansion shares the street with several other handsome nineteenth-century dwellings.

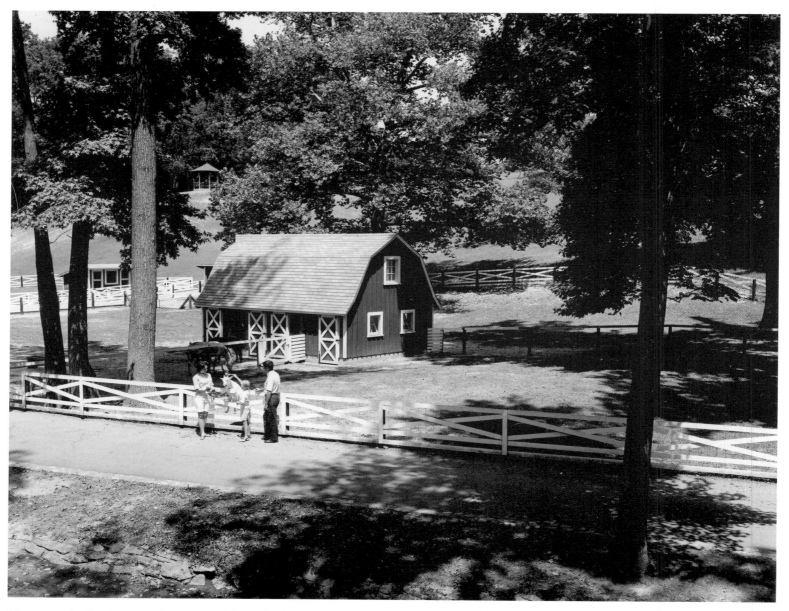

Maymont, the Dooley estate, became a public park after Mrs. Dooley's death in 1925. Besides the mansion, outbuildings, and gardens, the park features a menagerie of domesticated and wild animals. A petting zoo, shown here in 1966, is especially popular with the children.

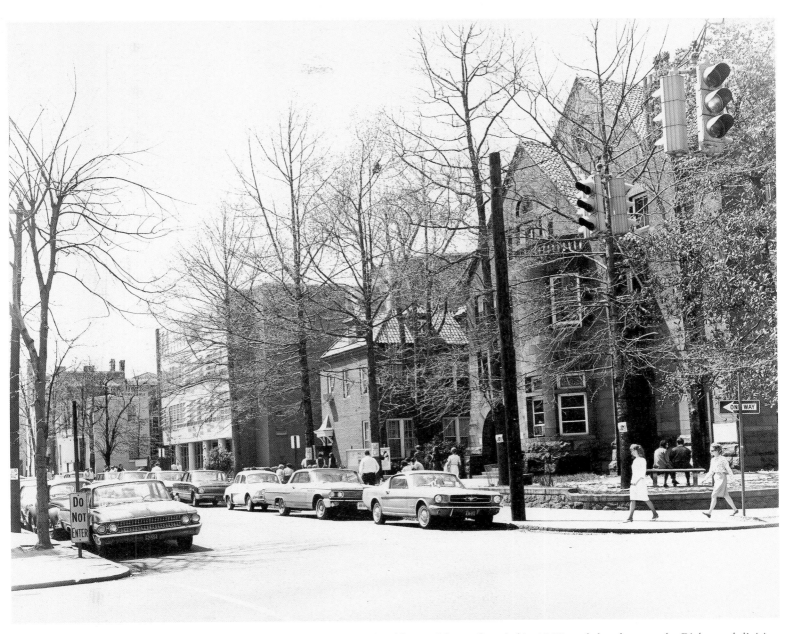

The Richmond School of Social Work and Public Health was founded in 1917, and then became the Richmond division of the College of William and Mary in 1925. It changed its name to Richmond Professional Institute in 1939. RPI, as it was known, separated from William and Mary and became independent in 1962. It merged with the Medical College of Virginia to form Virginia Commonwealth University in 1968. This photograph, taken in 1966, shows part of the university's urban campus in the 800 block of West Franklin Street.

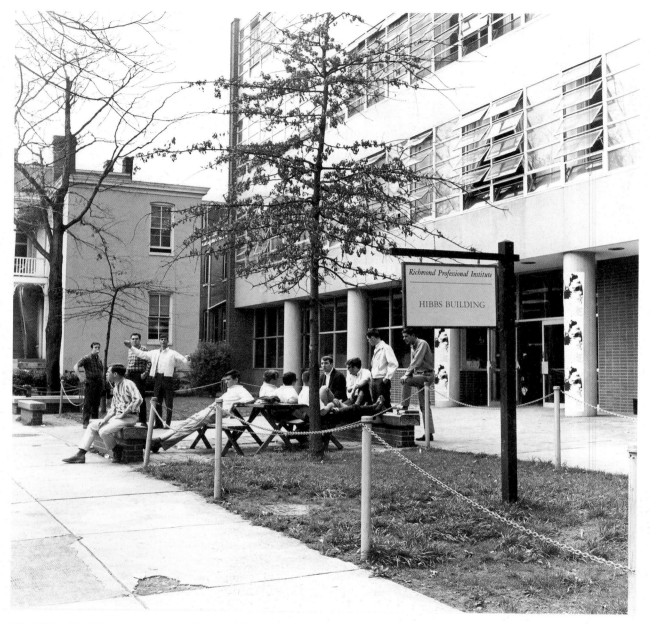

The Hibbs Building, photographed in 1966, is the earliest major academic building and dining hall constructed for Richmond Professional Institute (today's Virginia Commonwealth University). Completed in two sections (1959 and 1965), it was renovated and expanded in 2006. It is named for Dr. Henry Hibbs, who founded the Richmond School of Social Work and Public Health in 1917.

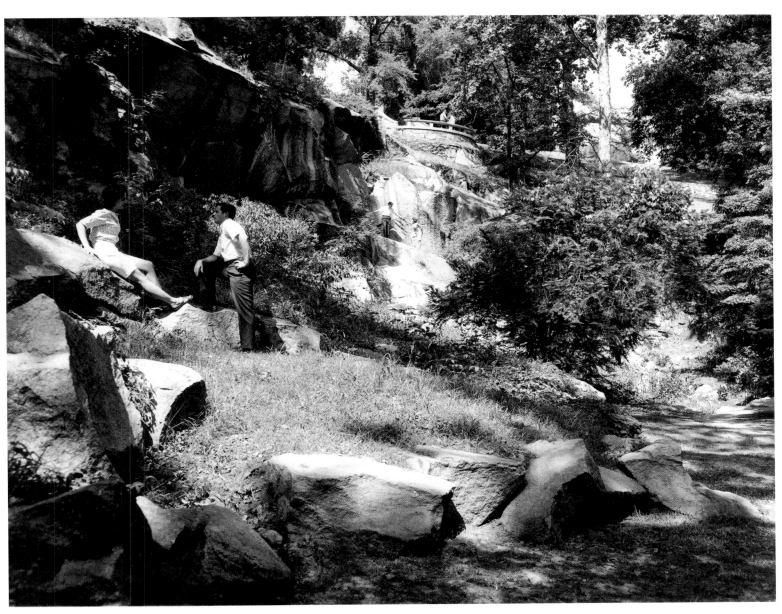

Railroad magnate and philanthropist Major James H. Dooley completed his late-Victorian mansion on the James River west of downtown Richmond in 1893. Besides the great house, which Dooley named Maymont for his wife, Sarah May, the Dooleys also planned extensive gardens overlooking the river. The Italian Garden was completed in 1910, and there is also a Japanese Garden as well as natural areas with walking paths. Today the estate is Richmond's most popular public park.

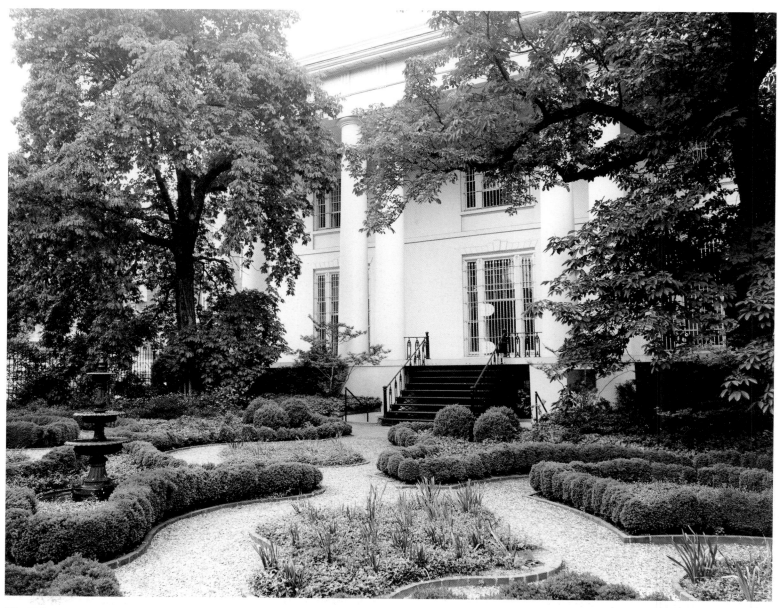

The White House of the Confederacy, completed in 1818 at 1201 East Clay Street for John Brockenbrough, has a two-story rear portico overlooking a garden. It is open to the public as part of the Museum and White House of the Confederacy. Confederate president Jefferson Davis lived there with his family from 1861 to 1865, and it has been restored to its wartime appearance.

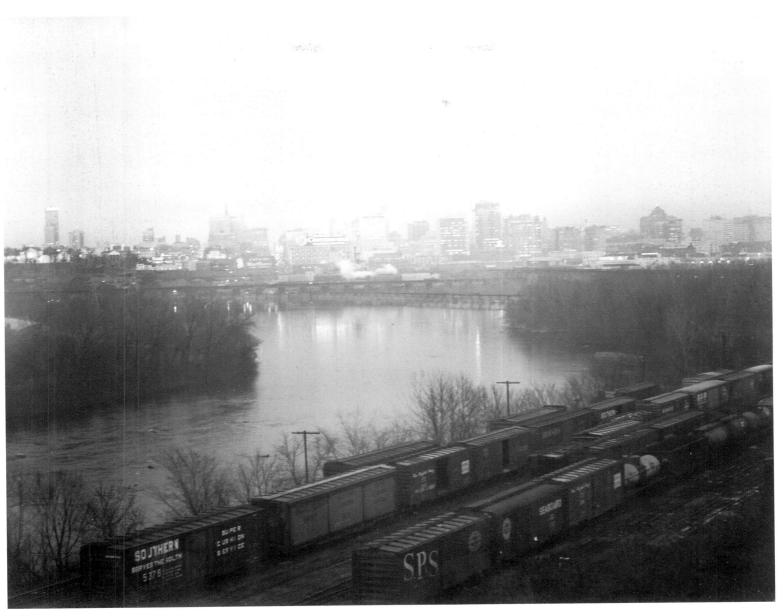

This 1966 photograph of the downtown Richmond skyline at dusk was taken from the south side of the James River. The high-rise building at far right is the Medical College of Virginia hospital; on the far left is the Art Deco Central National Bank skyscraper. The Chesterfield cigarette factory in the middle was rehabilitated for office space in the 1970s.

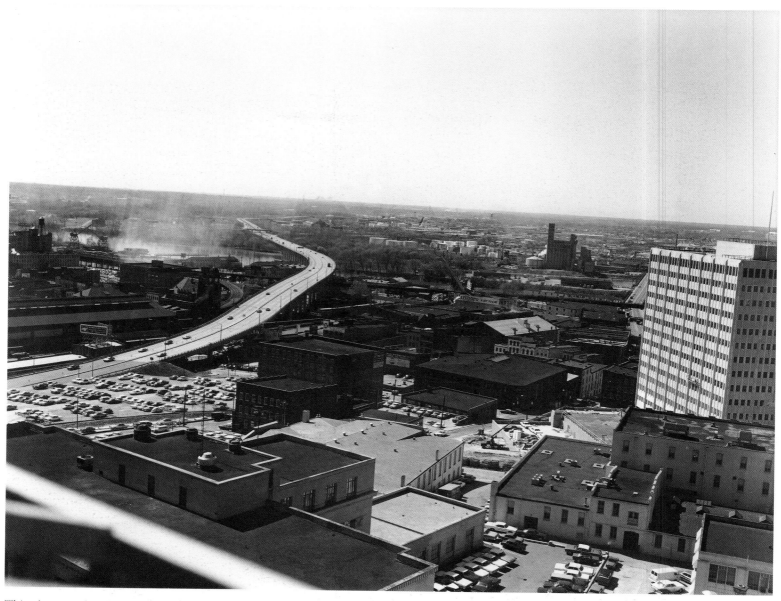

This photograph, taken from atop the Medical College of Virginia hospital in 1967, looks south across the James River into Chesterfield County. Interstate 95 winds around Main Street Station on the left. In the middle ground, between the highway and the 14th Street Bridge barely visible on the right, is Shockoe Bottom. Its buildings have been rehabilitated for shops, restaurants, and apartments.

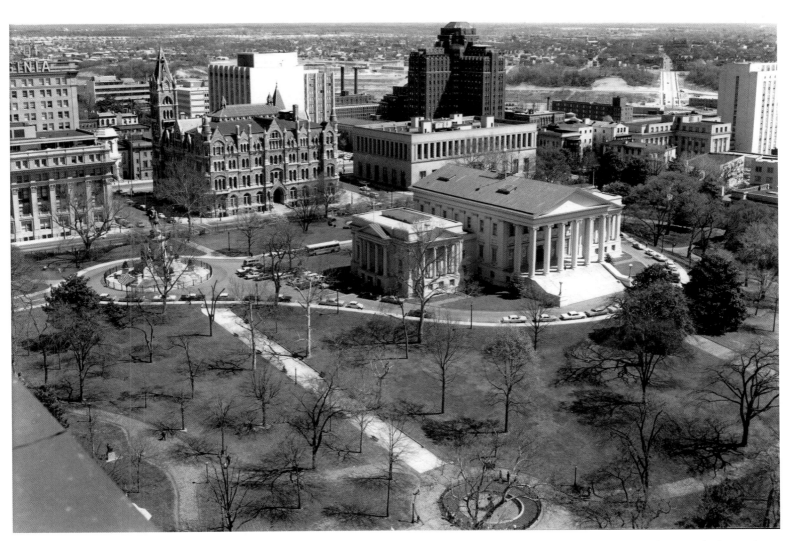

This early spring 1967 photograph, taken from the roof of the Federal Reserve Bank on 9th Street, looks northeast across Capitol Square, with the George Washington equestrian statue and the Capitol in the middle. From left to right behind the Capitol are the Life of Virginia insurance company building (now offices for the Virginia General Assembly), the Old City Hall, and the Virginia State Library building (now containing offices for the governor and several state agencies). The Medical College of Virginia hospital is behind the library.

The Falls of the James River—a series of rapids with water flowing over granite boulders—ebbs in water volume in the summer, when rainfall declines. As a result, fishers and sunbathers can walk across the boulders far into the river, sometimes all the way across. Several small dams afford good fishing spots.

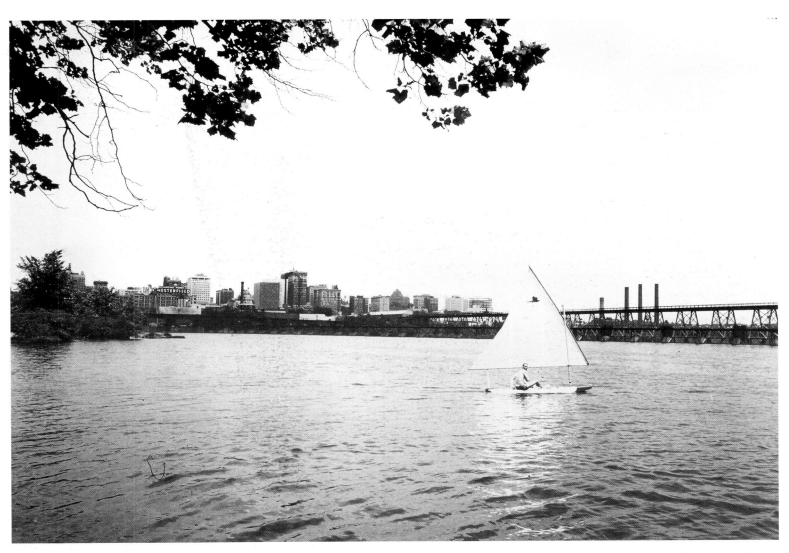

Sailboats such as this example photographed in 1967 are seldom seen on the James River at Richmond. Kayaks and rubber rafts are more common.

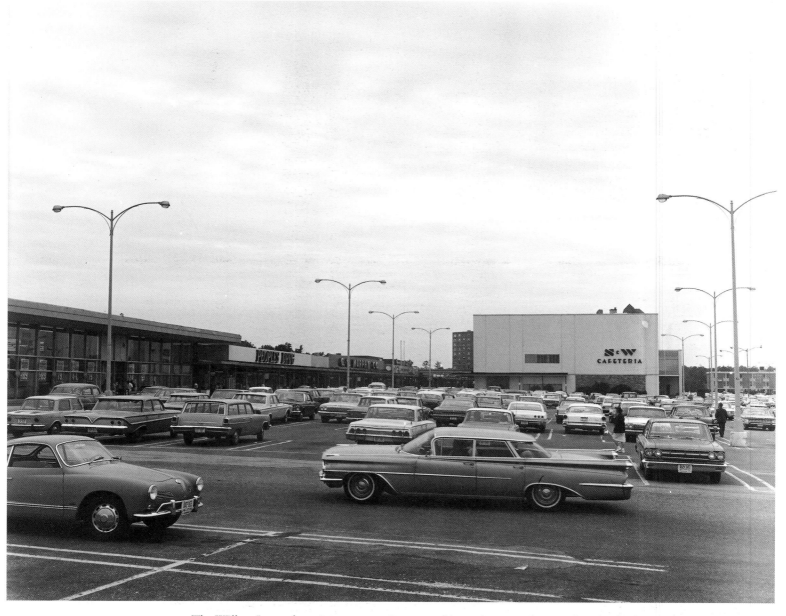

The Willow Lawn shopping center, as it appeared in 1967, opened in 1956 as the first suburban mall constructed in the Richmond area. It is located just west of the city in Henrico County. All of the stores shown here have been replaced in one or another of several makeovers.

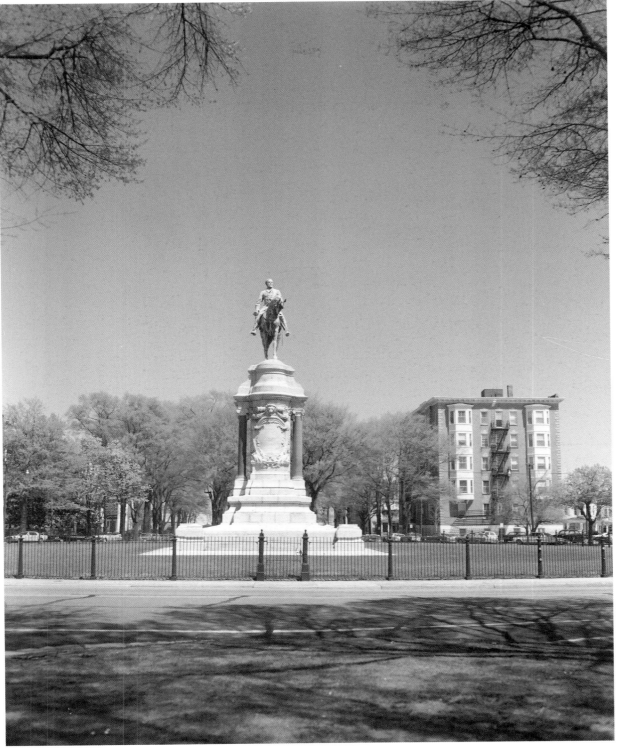

The iconic statue of Confederate general Robert E. Lee on Monument Avenue was photographed in 1966. Efforts to commemorate Lee began soon after his death in 1870, but the project moved slowly as proponents debated various designs and locations for the monument. In May 1890, it finally was erected on what is now Monument Avenue, a new residential neighborhood under construction west of the city. On the right, the front of the Shenandoah Apartments, now an assisted-living facility, faces Allen Avenue behind the statue.

The famous dogwoods of Dogwood Dell in Byrd Park were photographed in the 1960s putting on their annual show. Located primarily on the north side of the Carillon, the Dell is a recessed area of the park popular with Frisbee-throwers and visitors who prefer to lounge on the embankments.

For many years, the WRVA radio station operated the "Traffic Copter" during evening rush hour, and many commuters tuned in to avoid backups. The helicopter shown here was photographed about 1967. In 1974, the copter crashed into a house during a broadcast while flying at low altitude over the Woodland Heights neighborhood on the south side of the James River, killing reporter Howard Bloom, the pilot, and a small child in the house. Although the flights soon continued, the Traffic Copter reports ceased in 2001.

Traditionally, "mews" was a British term applied to a courtyard or alley with stables and small dwellings. The Mews in Richmond's Church Hill may once have contained stables and carriage houses, but by 1967 when this photograph was taken, it had become a secluded residential alleyway.

In 1967, the office of the Virginia Employment Commission was demolished and this building was constructed. The agency still operates there, gathering labor-market information, serving as a statewide labor exchange for employers and job-seekers, and disbursing unemployment benefits.

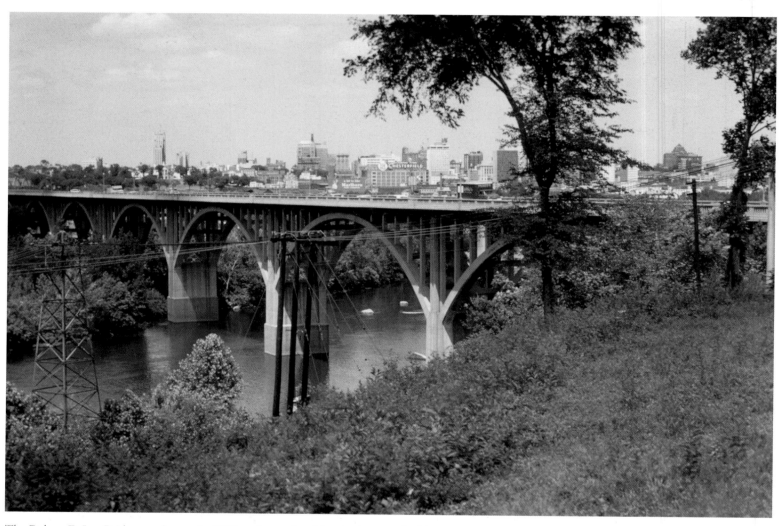

The Robert E. Lee Bridge was begun in 1933 and completed in 1934 at a cost of $1.13 million, with funding provided by the federal Reconstruction Finance Corporation. At first, tolls were levied, but they were ended in 1946. The bridge was demolished when a new bridge was completed in 1988.

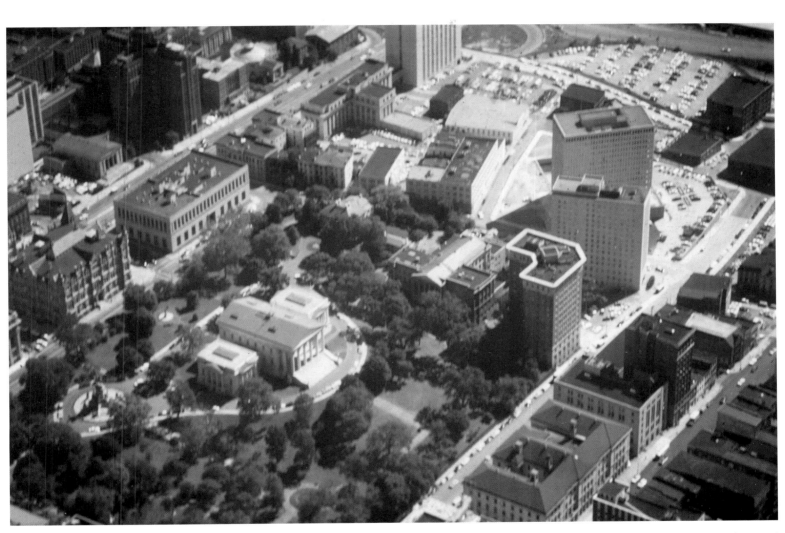

A visitor hovering overhead today would find little changed in Capitol Square itself in comparison to this aerial photograph taken in September 1967. Just north of the square, however, the small church at the upper left across Broad Street from the Virginia State Library was demolished in the 1970s, and new medical buildings were constructed. At the upper right, the Monroe Building has not yet been constructed.

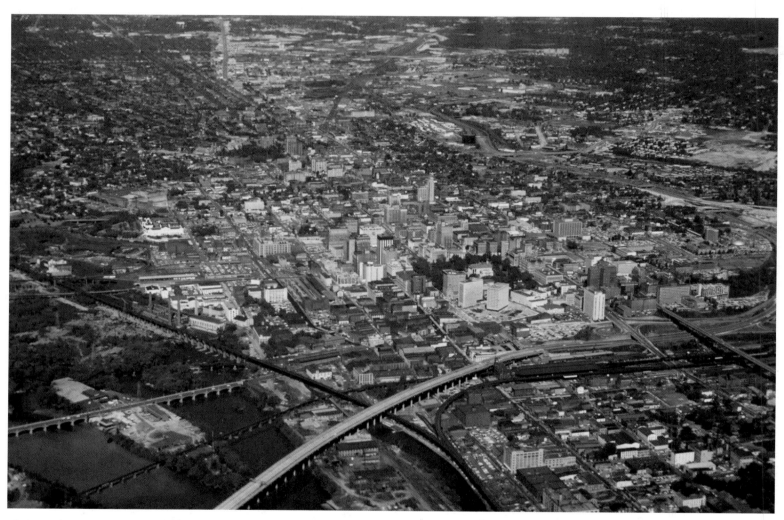

This aerial view of downtown Richmond was taken in September 1967. At the bottom of the image, Interstate 95 intersects with the three-mile-long railroad trestle (allegedly the longest in the world) just north of the James River. Capitol Square is in the middle of the image.

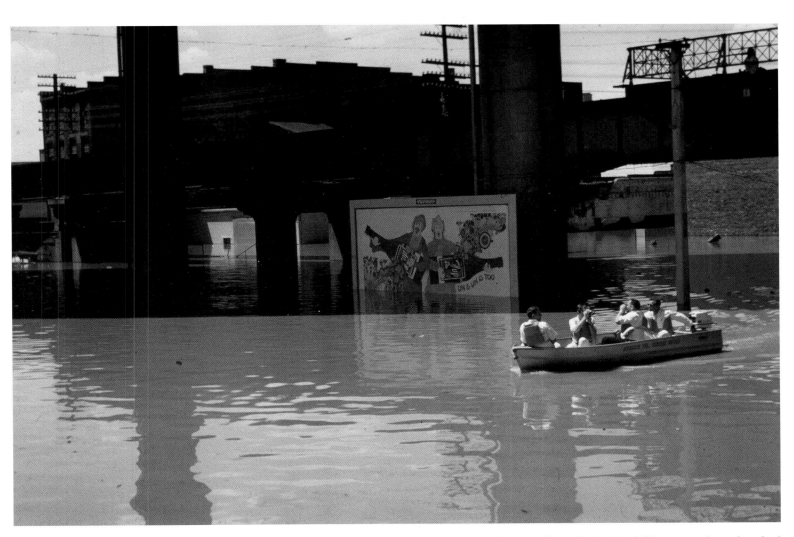

On August 20, 1969, the remnants of Hurricane Camille swept through Virginia, killing more than a hundred people in the flooding that the storm created. Low-lying Shockoe Bottom in Richmond, prone to flooding from even minor storms, was inundated. Here a group tours the area in a boat.

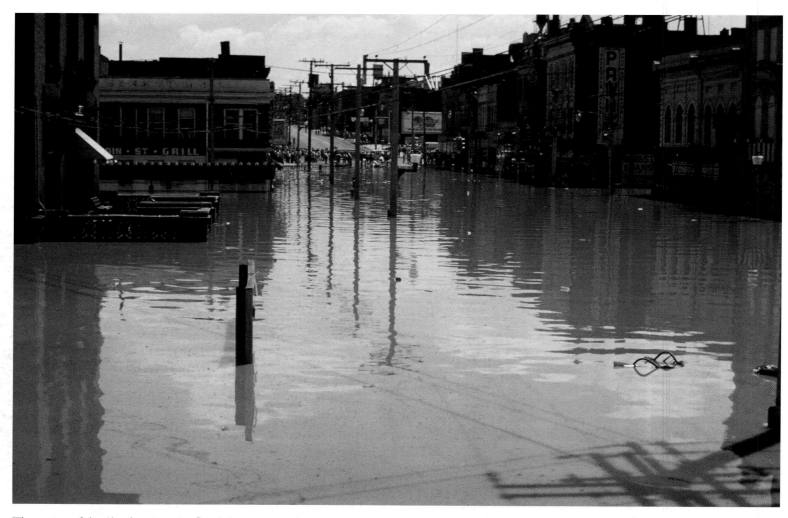

The extent of the Shockoe Bottom flood that Hurricane Camille caused when it struck the state on August 20, 1969, can be seen in this photograph taken from the steps of Main Street Station. The view is east on Main Street.

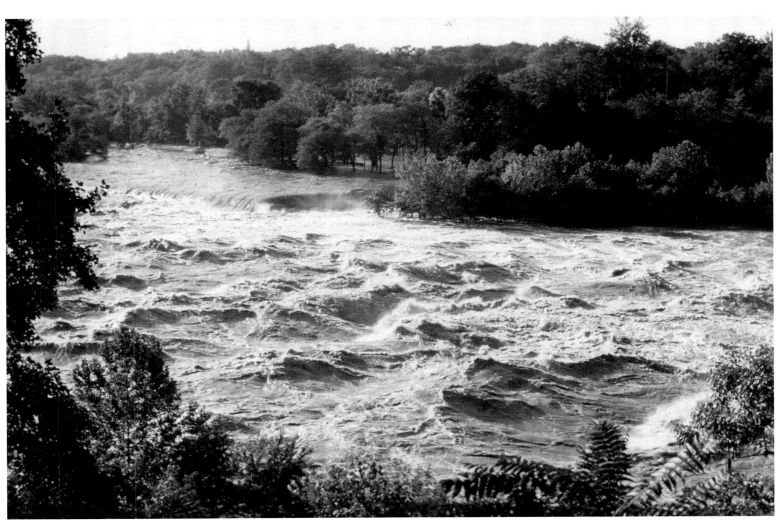

The effects of Hurricane Camille are obvious in this photograph of the rampaging James River at Belle Isle. After the storm struck on August 20, 1969, the river was swollen and the rapids at the Falls of the James rose precipitously to become a churning torrent.

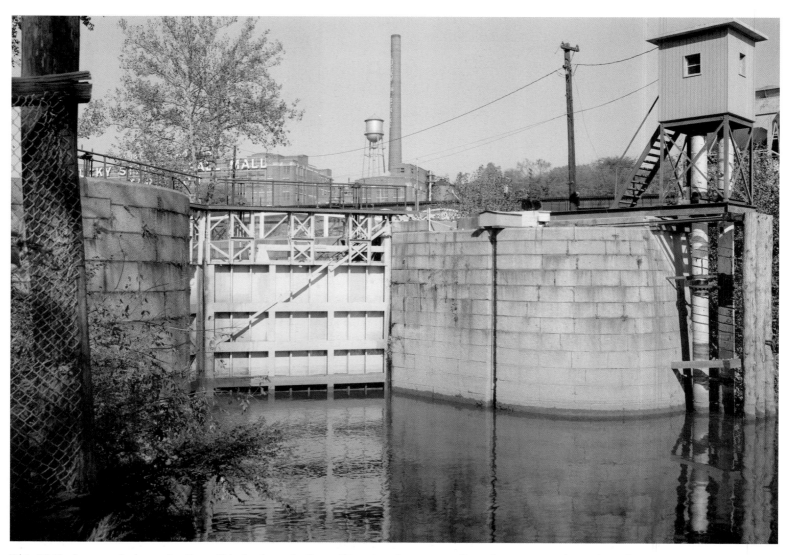

This 1968 photograph shows the Great Ship Lock on the James River just downstream from downtown Richmond. In the background is the Lucky Strike–Pall Mall tobacco factory in a line of such buildings known collectively as Tobacco Row. The James River and Kanawha Company completed the Great Ship Lock in 1854 to connect the navigable part of the James River downstream to the Richmond Dock area upstream.

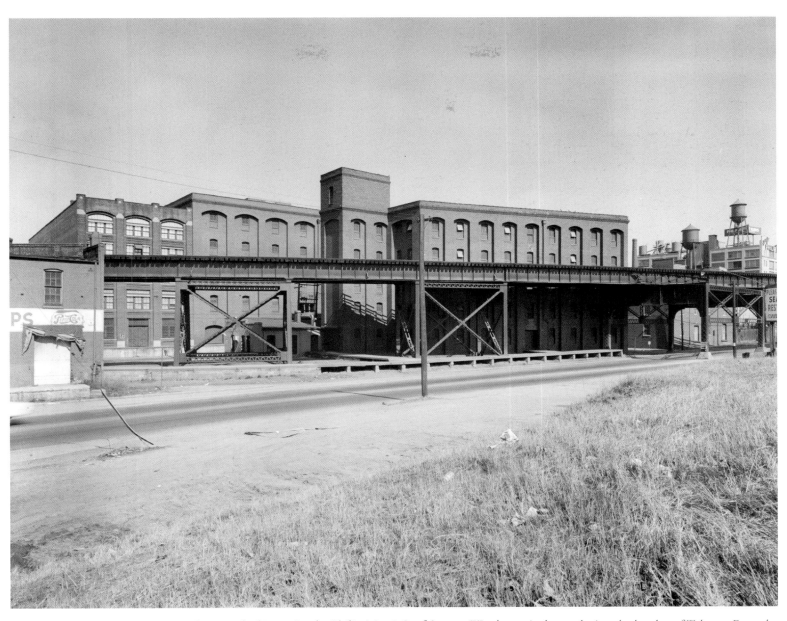

Photographed in 1969, the Philip Morris Leaf Storage Warehouse is shown during the heyday of Tobacco Row, the city's tobacco-manufacturing district that included many such facilities facing the James River. Many of these buildings have been rehabilitated and now contain apartments and restaurants.

Tobacco magnate Lewis Ginter completed the Jefferson Hotel in 1895, taking up most of the block between Franklin and Main streets at Jefferson Street. The Jefferson quickly became one of Richmond society's favorite watering holes. A near-disastrous fire on March 29, 1901, gutted part of the building, but it was repaired and remodeled, and reopened on May 6, 1907. This 1969 photograph of the Franklin Street facade includes a building on the left that was demolished to make way for an entrance drive when the hotel was subsequently renovated in the 1980s.

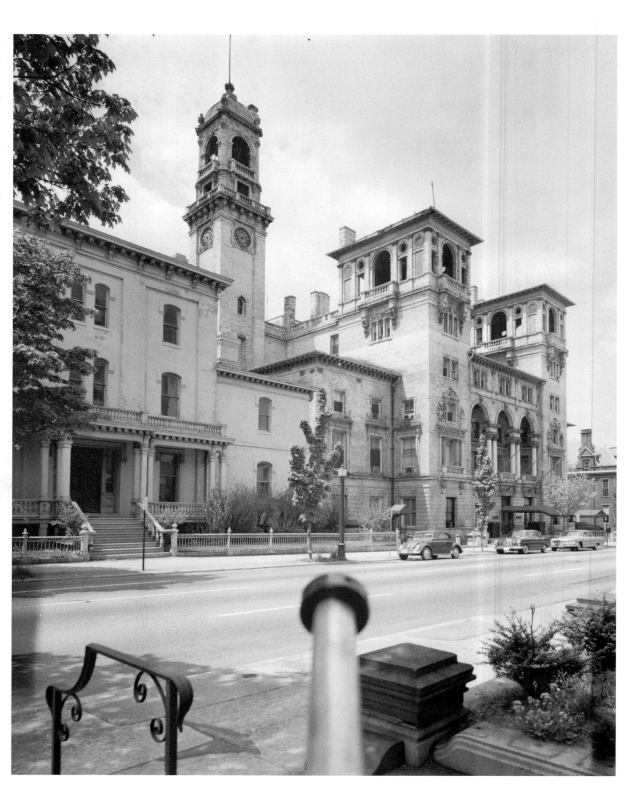

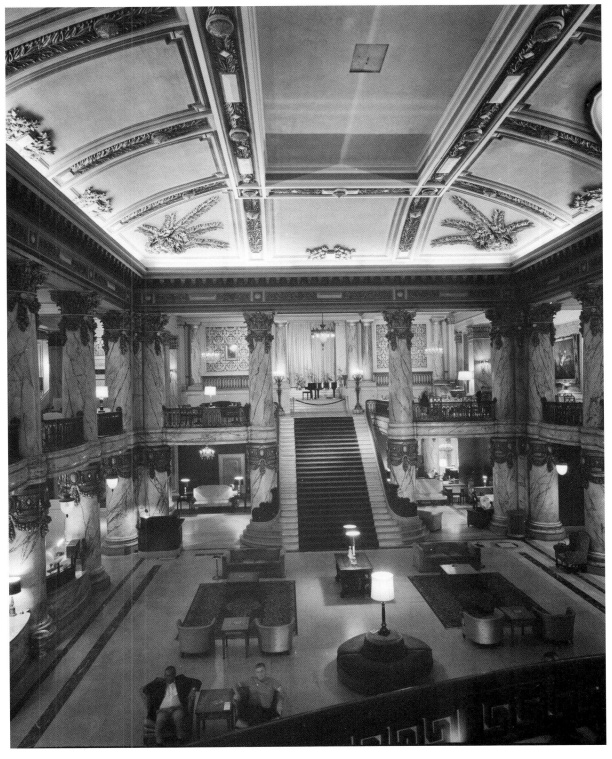

Taken in 1969, this photograph shows the Jefferson Hotel's lower (Main Street) lobby looking north to the staircase and upper (Franklin Street) lobby. At the time, the main entrance was on Main Street, so reception was located at the counters on the left. After a late-twentieth-century rehabilitation created a new main entrance on Franklin Street, reception moved to the upper lobby, and the old reception area became a bar. A charming legend, that this staircase inspired the one in the Butler mansion in the movie *Gone With the Wind*, was exploded when the set designer revealed that he had never seen the hotel.

The Donnan-Asher Iron Front Building was erected in 1866 to replace structures destroyed during the Evacuation Fire of April 3, 1865. It is one of only three completely cast-iron facades remaining in Richmond. After the Civil War, cast iron came to be preferred over the traditional stone or terra-cotta decoration because it was inexpensive to manufacture and could easily be made as elaborate as desired.

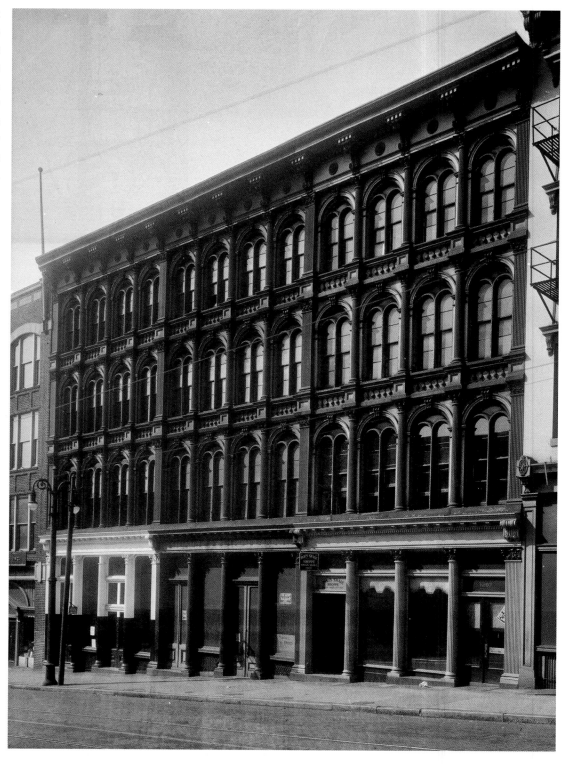

GROWTH AND RENEWAL: THE 1970S

In the 1970s, Richmonders and visitors alike began to exhibit renewed appreciation for the buildings that reflected the city's past. Although the demolition of older buildings did not cease altogether—nor is that the case today—more and more people began to speak out against wholesale destruction. In earlier decades, such people were scoffed at as "little old ladies in tennis shoes," perhaps an oblique reference to local preservationist Mary Wingfield Scott, a "little old lady" with a spine of steel who frequently seemed to be a solitary voice defending the city's historic resources. Today, she is revered as a prophet and a pioneer. Preservation awards are presented in her name, and the city is blessed with several preservation organizations.

Not all of the damage to Richmond's buildings was the result of new construction. Nature played a role as well. In the 1960s, it was Hurricane Camille that flooded the lower parts of the city; in the 1970s it was Hurricane Agnes. On many other occasions, far less severe storms caused flooding in Shockoe Bottom, and before the Flood Wall was constructed in the 1990s, rowboats on East Main Street in the vicinity of 17th Street were not an uncommon sight during floods. The high waters not only damaged buildings and wrecked businesses, they prevented the rehabilitation of those structures, since no one wanted to spend the money and make the effort only to see the work swept away in the next downpour. The Flood Wall, coupled with the rehabilitation tax credits introduced in the 1980s, changed all that. Many of the buildings seen in the pictures in this chapter have been renovated for restaurants and shops, and Shockoe Bottom is now a thriving center of downtown Richmond nightlife.

Beginning in the 1970s as well, the urban institution of higher learning known as Virginia Commonwealth University, which had grown from humble beginnings west of Monroe Park and expanded to become a major employer and powerful presence in the city. The growth has not come without controversy, however, as the university's expansion plans frequently conflicted with the goals of historic preservationists as well as the school's neighbors in the adjoining area called Oregon Hill. Usually but not always, the issues have been resolved through compromise.

The same spirit has not always prevailed on the local political scene, however, as Richmond City Council's racial majority gradually shifted from white to black, as well as from nearly all-male to more substantially female in composition.

Throughout most of the 1970s, in fact, a nasty annexation battle took place in court as the city sought to absorb several (almost all-white) suburban areas. Council elections were suspended until the case was resolved, and the General Assembly established a moratorium on annexations.

During the same period, the city undertook several civic improvement projects that were clearly beneficial to all residents. The Coliseum, a large venue for entertainment ranging from circuses to concerts and ice shows, opened in 1971 in Jackson Ward. Various enhancements were made to James River Park, a largely natural area that borders the river, including better access to Belle Isle, a remarkable resource amid the rapids. A visitor who walks to the western end of the island hears no urban noises over the roar of the water, and the view is largely of the river, boulders, and the tree-lined shores—scarcely a man-made structure to be seen.

Today, thanks to the preservation movement that began to thrive in the 1970s, and to determined efforts by many residents to improve the quality of life in their city, Richmond has entered the new century with many of its historic and scenic resources not only intact but also enhanced. Tourists as well as local citizens appreciate the mix of old and new that make the city a vibrant place to live, work, and visit.

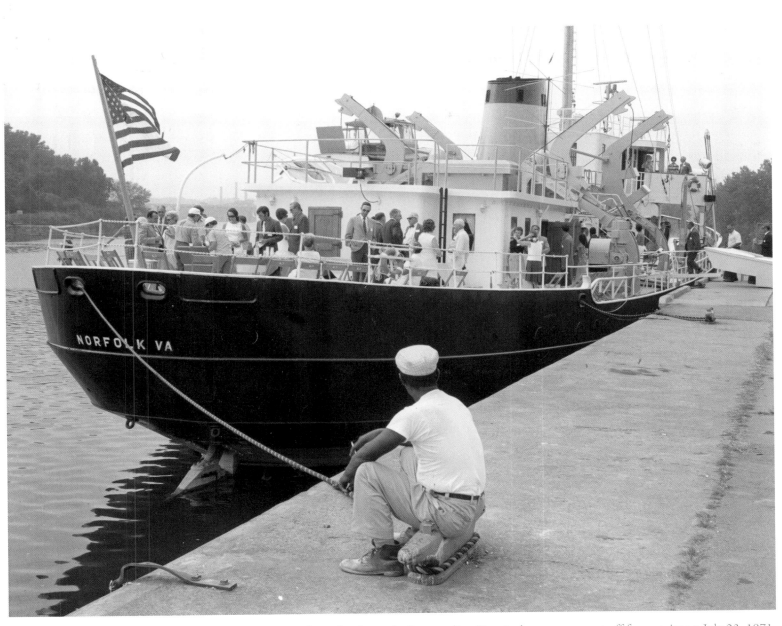

A boat down the James River from the city at the Intermediate Terminal prepares to cast off for a cruise on July 23, 1971.

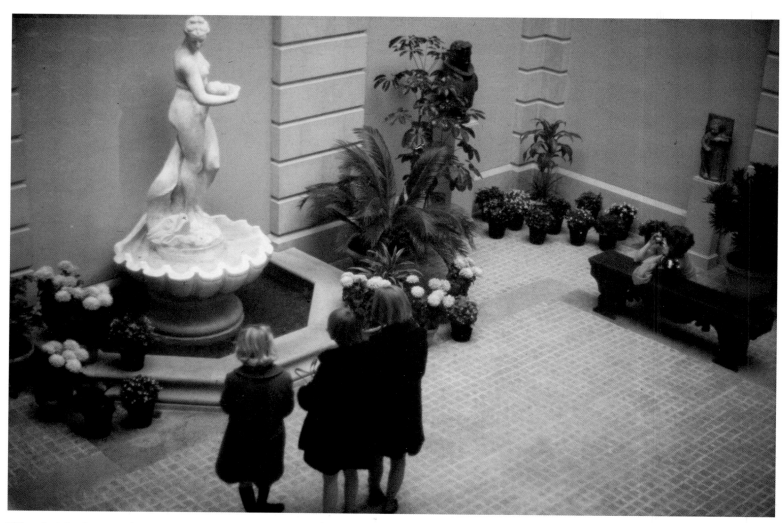

Taken in March 1970, this photograph shows an alcove in the Virginia Museum of Fine Arts.

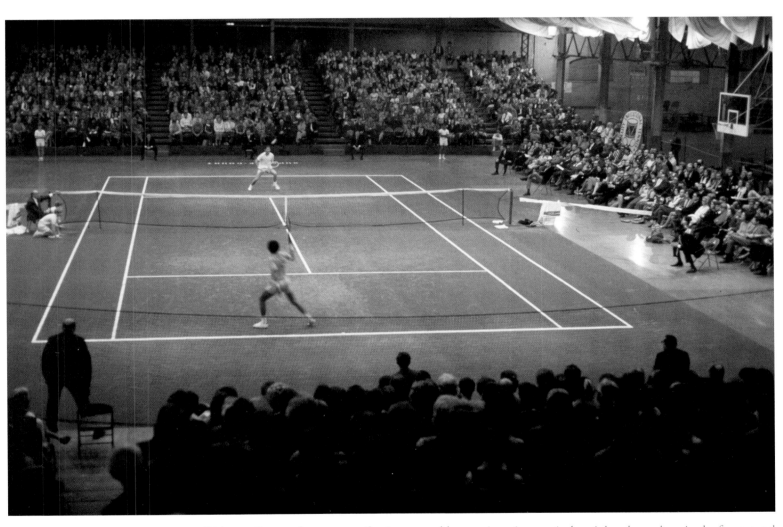

Richmond's most famous contribution to world sports is native son Arthur Ashe, shown here in the foreground returning a shot in the Central Fidelity Bank Invitational Tennis Tournament in February 1971. Although Ashe did not win that tournament, his place in tennis history was already secured. In 1975, he was rated the best tennis player in the world. Today, he is honored in Richmond with a statue on Monument Avenue.

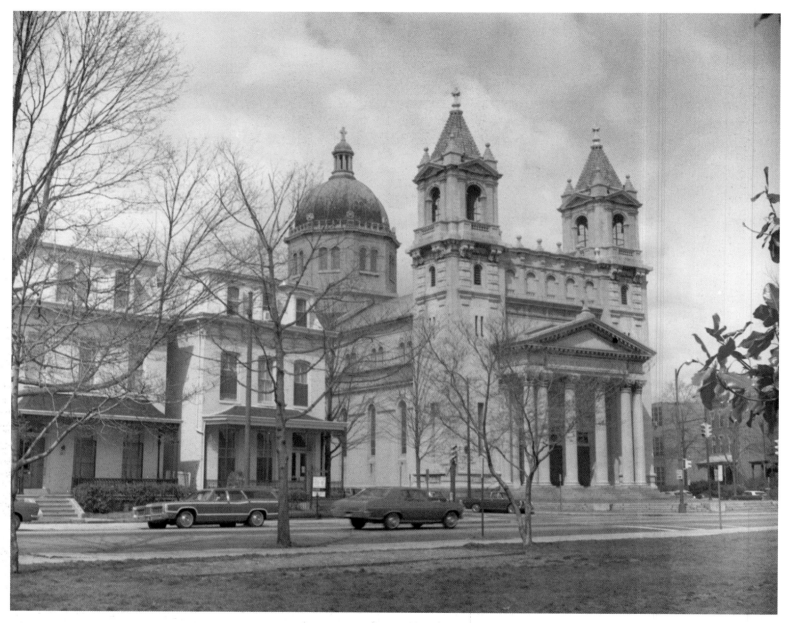

The Cathedral of the Sacred Heart, the cathedral of the Richmond Diocese of the Roman Catholic Church, was constructed on the western side of Monroe Park. It was consecrated on November 29, 1906. Catholic businessman Thomas Fortune Ryan donated $250,000 for its construction after it became obvious that Richmond's Catholics had outgrown their historic downtown cathedral, St. Peter's Church on East Grace Street.

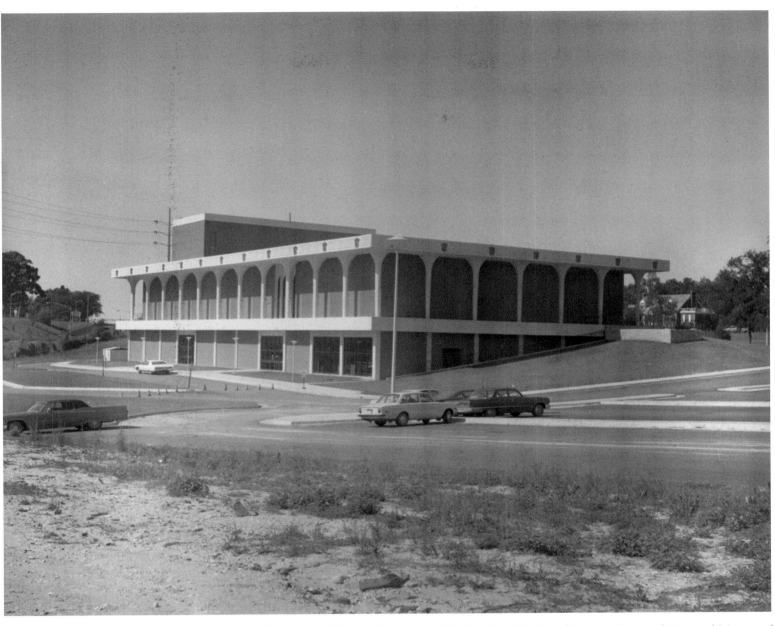

This is a 1971 photograph of Metropolitan Lodge No. 11, Grand Lodge of Ancient, Free, and Accepted Masons of Virginia, located on Hermitage Road in north Richmond. The temple was constructed in 1968.

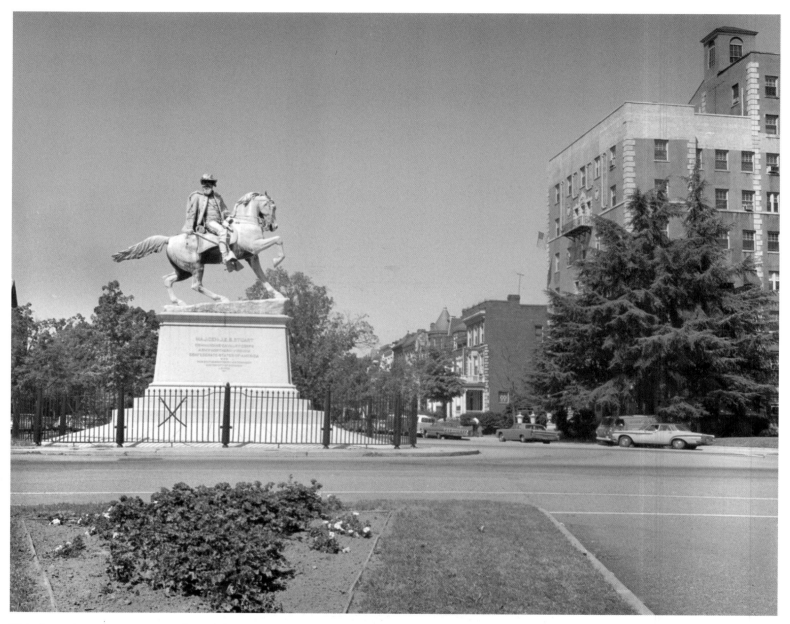

This dramatic equestrian statue of Confederate Major General James Ewell Brown "Jeb" Stuart, which Frederick Moynihan sculpted, was erected on Monument Avenue and unveiled in 1907. It is located in a circle at the eastern end of the avenue, with statues of General Robert E. Lee, Confederate president Jefferson Davis, and Lieutenant General Thomas J. "Stonewall" Jackson placed at intervals to the west as far as the Boulevard. The tall building to the right of the Stuart statue is William Lawrence Bottomley's Stuart Court Apartments, designed in 1924, which sadly has been stripped of some of its architectural decoration.

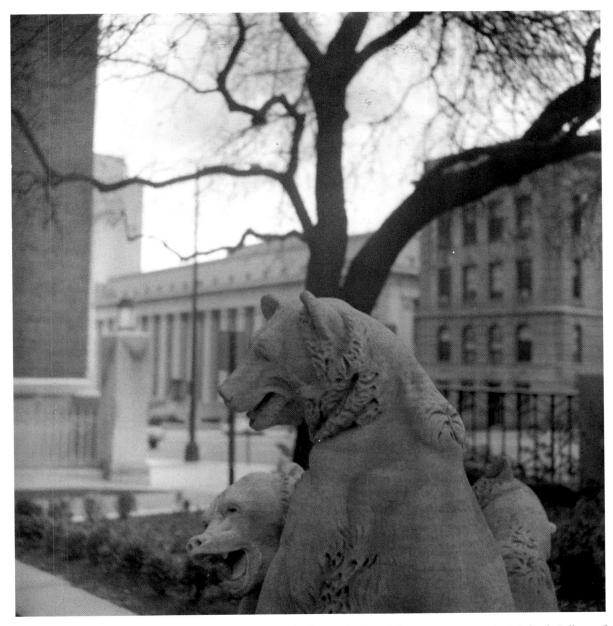

The Three Bears sculpture cast in stone watched over the Broad Street entrance to the Medical College of Virginia West Hospital from 1941 to 1987. The sculptor, Anna Hyatt Huntington, donated them to the hospital. In 1987 they were moved indoors to help preserve them. Since October 2008, they have kept watch on the main concourse of the Critical Care Hospital. Bears are held in esteem in many cultures, especially by Native Americans, for their strength and powers of healing.

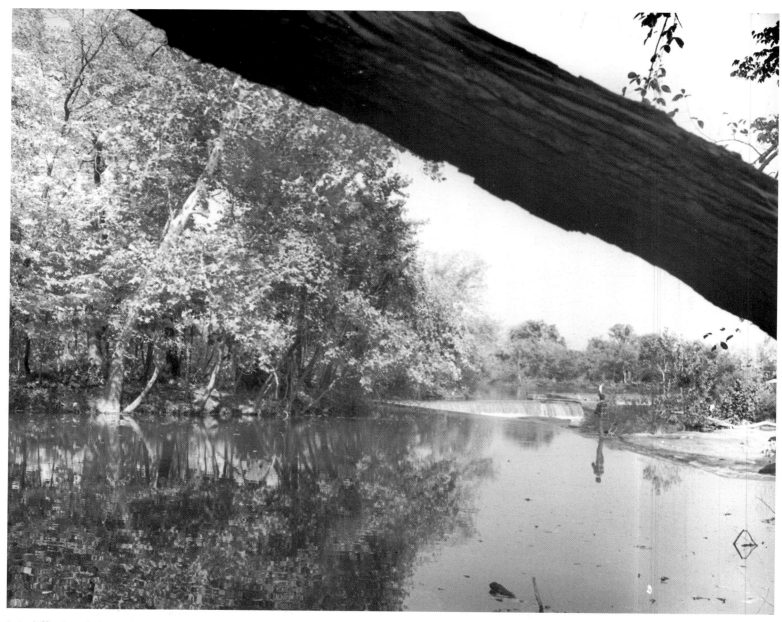

It is difficult to believe, but this scene was photographed in the city. Richmond not only has a great river with the only Class III and IV white-water rapids in the United States running through it, it also has a park bordering that river. James River Park has long been popular with fishermen, hikers, and sunbathers.

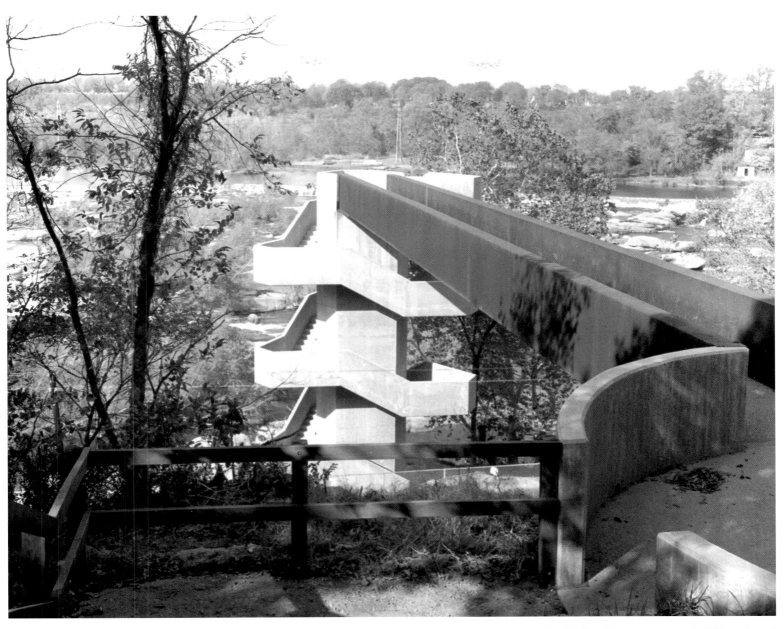

On the south bank of the James River, railroad tracks run between the bluff and James River Park. This stair and pedestrian bridge was completed in about 1970 to enable visitors to get to the park without walking on the tracks.

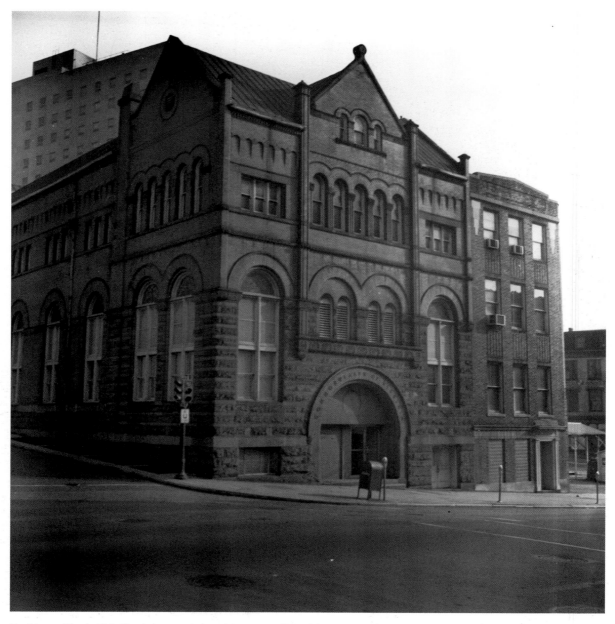

Architect Charles H. Read designed the Planters Bank Building, which was constructed in 1893 at the intersection of 12th and Main streets. It was designed in the Richardsonian Romanesque Revival style characterized by heavy rusticated brownstone, deep windows, and cavernous arched entryways. Read's interpretation of the style, however, produced a less-ponderous result than usual. Few examples of the type were constructed in Richmond, and this is the only downtown example. Threatened with demolition in the 1980s, the building was saved and is now the home of the State Corporation Commission.

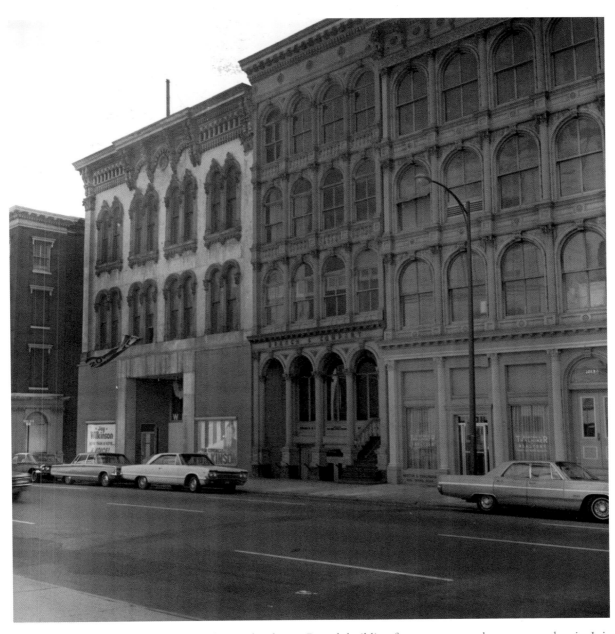

Located at 1015 East Main Street, the elegant Branch building features a recessed entryway or loggia. It is one of a row of iron-front buildings constructed in 1866, shortly after the Evacuation Fire of April 3, 1865, destroyed the city's commercial district. The four-story building was constructed for the Virginia Marine and Fire Insurance Company, and later housed the offices of the Branch Company and its successor, Branch Cabell and Company, a brokerage firm.

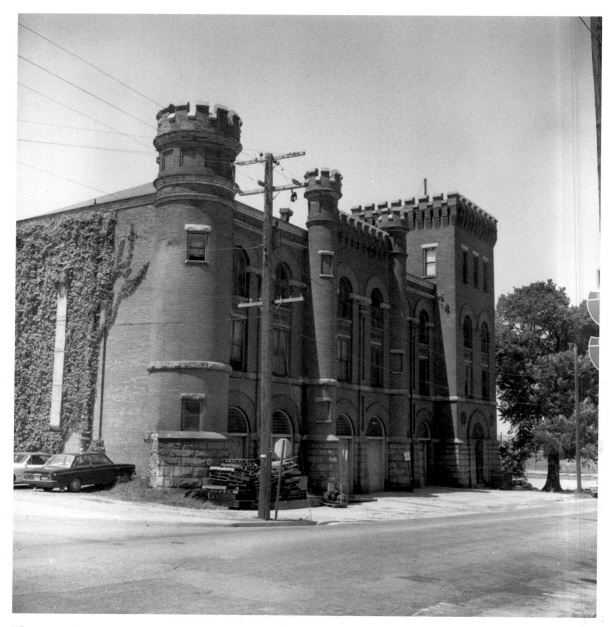

This armory was completed in 1895 in Jackson Ward for the First Battalion Virginia Volunteers, and is the oldest armory standing in Virginia. The all-black unit was organized in 1876, and the construction of the armory by black workers for this African-American battalion was a source of immense pride in the community. Unfortunately, after the Spanish-American War of 1898, the unit was disbanded. The armory was subsequently used as a school, for storage, and as a center for black servicemen during World War II. In the 1980s it was damaged by fire and abandoned by the city. In 2002–2003, the building was stabilized and its preservation assured while the search for a compatible use continues.

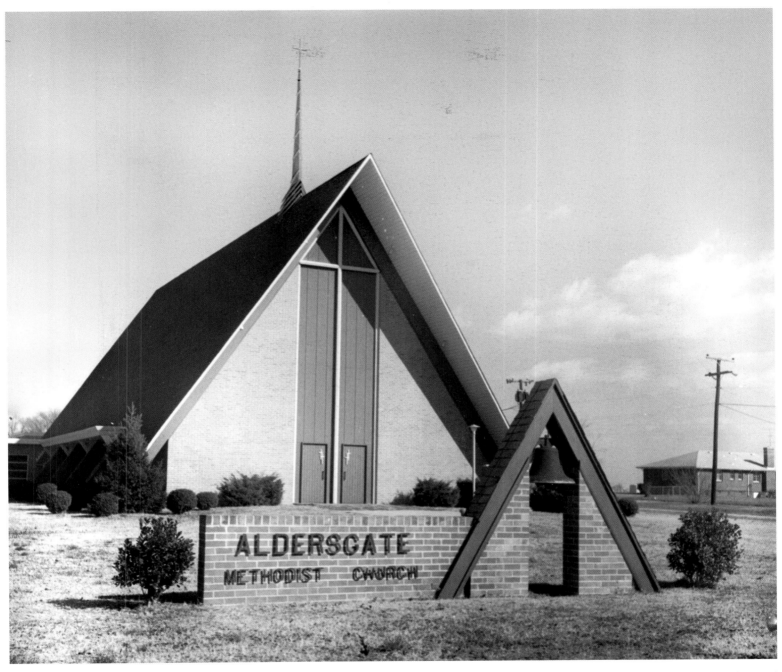

Aldersgate Methodist Church, located at 3006 E. Laburnum Avenue, was photographed in 1971. Leary & Ciucci Architects of Richmond designed the modern A-frame building, and it was completed in 1961. Robert J. Leary and Joseph V. Ciucci, Jr., were the principals of the firm, which designed residential, commercial, religious, public, and educational buildings, as well as health facilities. Although additions have been constructed over the years, the main part of the church and the sign in front remain much as they appeared 50 years ago.

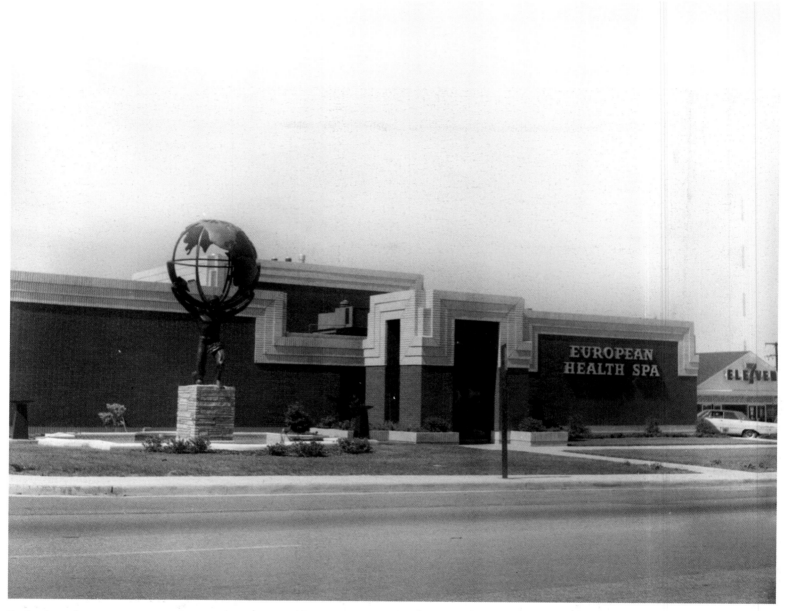

Enthusiasm for exercise waxes and wanes like devotion to keeping New Year's resolutions. Today's "fitness centers" were called "health spas" a few decades ago, and many of them by whatever name have come and gone in the Richmond area. The European Health Spa, shown here in the 1970s, stood on Horsepen Road in the western part of the city. Another fitness club later acquired it but closed in 1989, leaving many members holding expensive "lifetime memberships" that were transferable to only one other club, which was inconveniently located for many members.

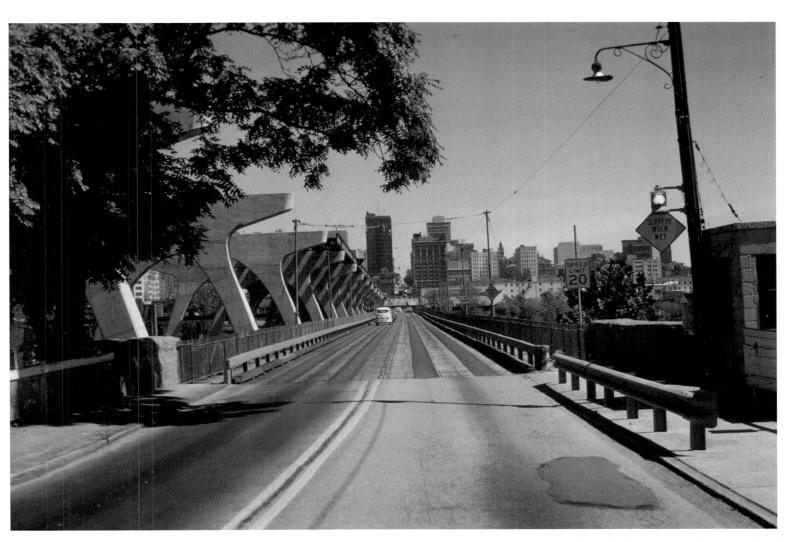

For many years, Richmond had surprisingly few bridges connecting it to Chesterfield County on the south side of the James River. Until after the Civil War, in fact, there was only one bridge that was not a railroad bridge: Mayo's Bridge, a privately owned toll bridge. Eventually the number increased dramatically, and some of the bridges have been replaced with newer spans. This picture shows the new 9th Street Bridge under construction in August 1971.

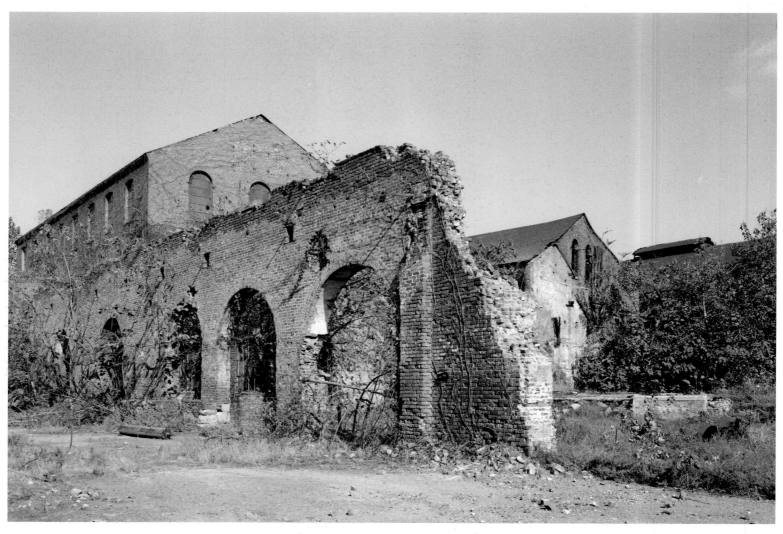

During the Civil War, the Tredegar Iron Works was the largest such facility in the South and produced most of the cannons used by the Confederate armies. The company continued to function for almost a century after the war but eventually closed. By 1971, when this photograph was taken, many of the buildings were virtual ruins. Ethyl Corporation, the owner of the site, subsequently restored the surviving buildings. This National Historic Landmark operates today as the American Civil War Center at Historic Tredegar, devoted to exhibiting the story of the war from Union, Confederate, and African-American perspectives. The Richmond National Battlefield Park visitor center is also located on the grounds in a restored building.

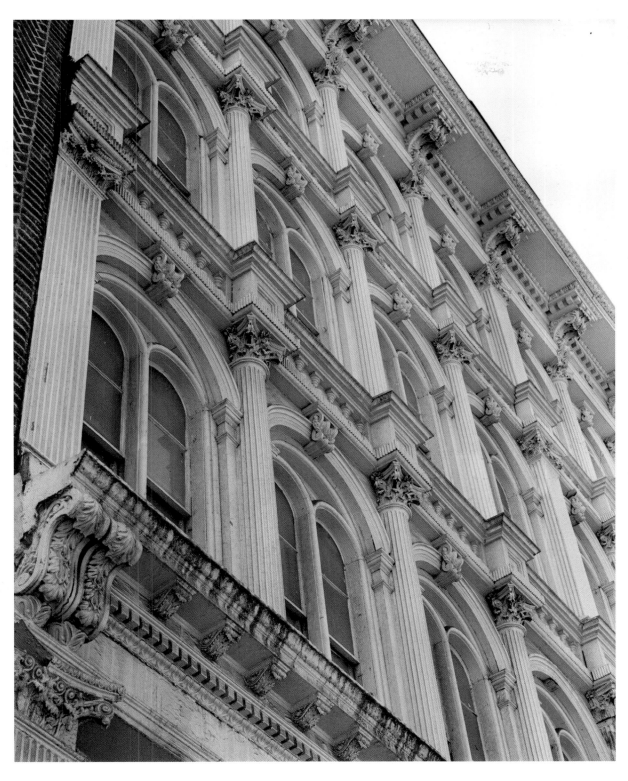

At the end of the Civil War, on the morning of April 3, 1865, Confederate authorities evacuated Richmond and set several tobacco warehouses on fire. A breeze sprang up to spread the flames, and most of the city's commercial district burned down before the U.S. Army entered the city and extinguished the fire. Soon the rubble was cleared, and new store and office buildings were constructed. Many of them had cast-iron ornamentation on their facades, not in hopes of fireproofing but as inexpensive decoration. This building at 1109 East Main Street was being demolished for an office tower early in the 1970s when its cast-iron pilasters and other features were removed.

Both the small building and the high-rise tower behind it are known collectively as Rhoads Hall, a Virginia Commonwealth University dormitory. It was named for Webster S. Rhoads, a member of the Board of Visitors in the 1960s and an owner of the Miller and Rhoads department store. Standing in the 700 block of West Franklin Street, the dormitory was completed in 1968, an interesting contrast to the late-nineteenth-century brownstone mansions on the same street. The photograph was taken in 1971.

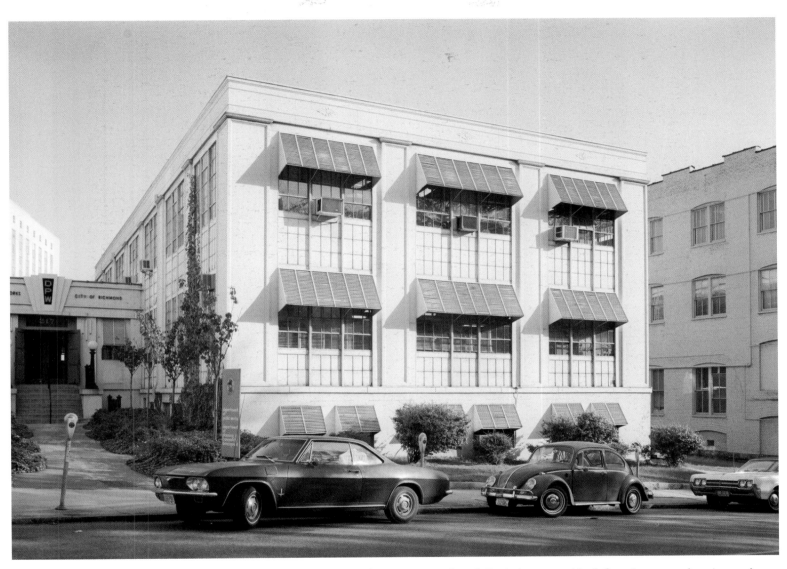

The Aluminum Building was constructed in 1931 at 11th and Capitol streets, a block from its current location, to house Richmond's Department of Public Works. In December 1938, to clear the block for the construction of the Virginia State Library building, the Aluminum Building was rolled down Governor Street and fitted on a lot adjacent to the antebellum Morson's Row of town houses. Today it serves as a state government office building.

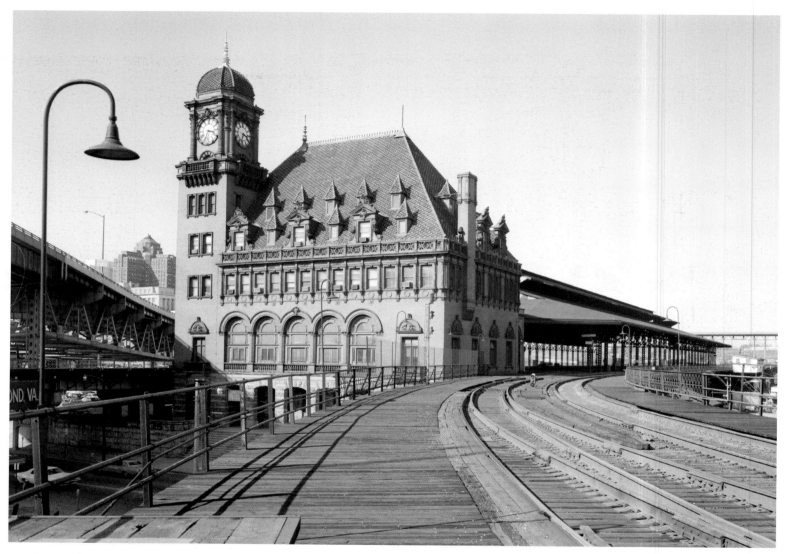

Main Street Station, a National Historic Landmark, was completed at Main and 15th streets in 1901 as Union Station. It served the Chesapeake and Ohio and Seaboard Air Line railroads. Designed in the Renaissance style, the station is richly colored with golden Roman brick, terra-cotta adornments, and a red tile roof. This view taken from the north shows tracks atop a large trestle. Closed for many years beginning in the 1970s, the station has recently resumed passenger service after a multimillion-dollar restoration.

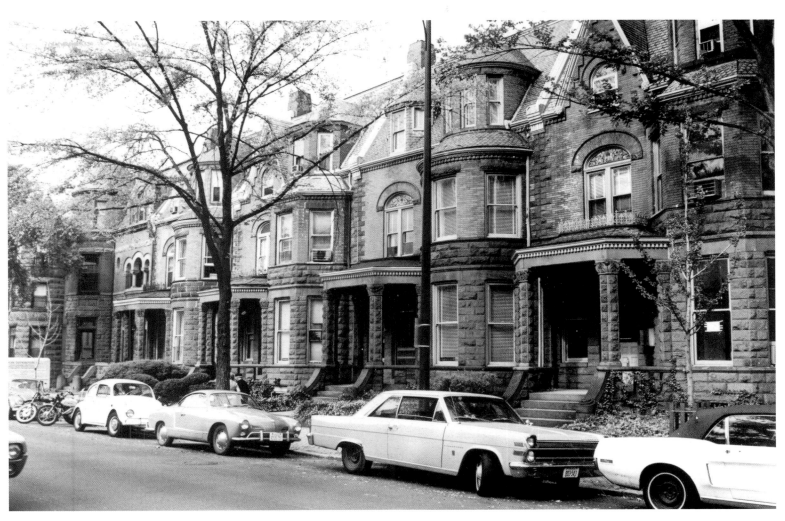

West Franklin Street is a late-nineteenth-century residential neighborhood dominated by brownstone mansions. It extends west from Monroe Park to Monument Avenue. The architectural styles run the gamut of the Victorian era: Second Empire, Italianate, Romanesque, Queen Anne, and Georgian Revival. The styles, despite their wide variety, are united in their similarity of scale and the high quality of the work. Virginia Commonwealth University now owns most of the buildings.

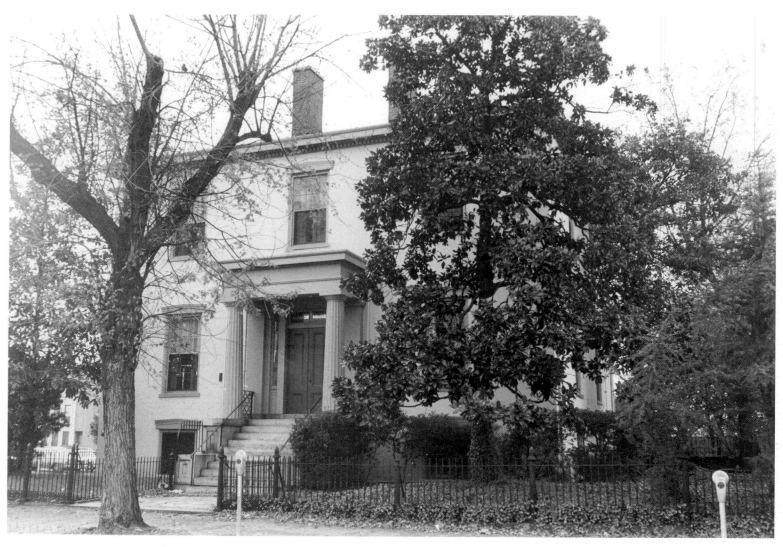

From 1887, when author Ellen Glasgow was 13 years old, until her death in 1945, she made her home in this Greek Revival–style house at 1 West Main Street. It had been constructed in 1841 for tobacco manufacturer David M. Branch. Glasgow's unsentimental novels about the South earned her many awards, culminating in the Pulitzer Prize in 1942 for her last work, *In This Our Life*. Purchased by the Association for the Preservation of Virginia Antiquities in 1947 and then sold with protective covenants, the house is a private residence.

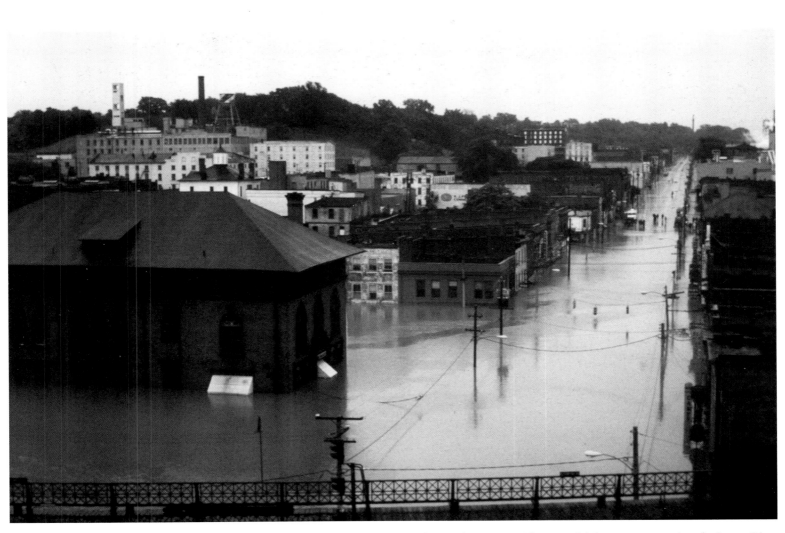

In June 1972, Hurricane Agnes doused western and central Virginia with torrential downpours, causing the James River to pass flood stage and swamp city streets. This photograph looks east on Main Street past the 17th Street Market.

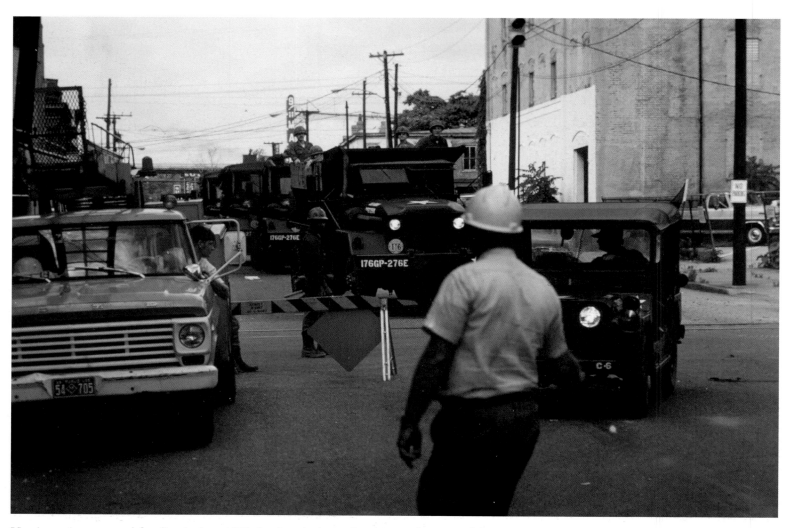

Hurricane Agnes caused flooding in June 1972 that knocked out electricity in the city and damaged water and sewerage services. The National Guard soon arrived, not so much to maintain order as to distribute safe drinking water and set up water purification stations.

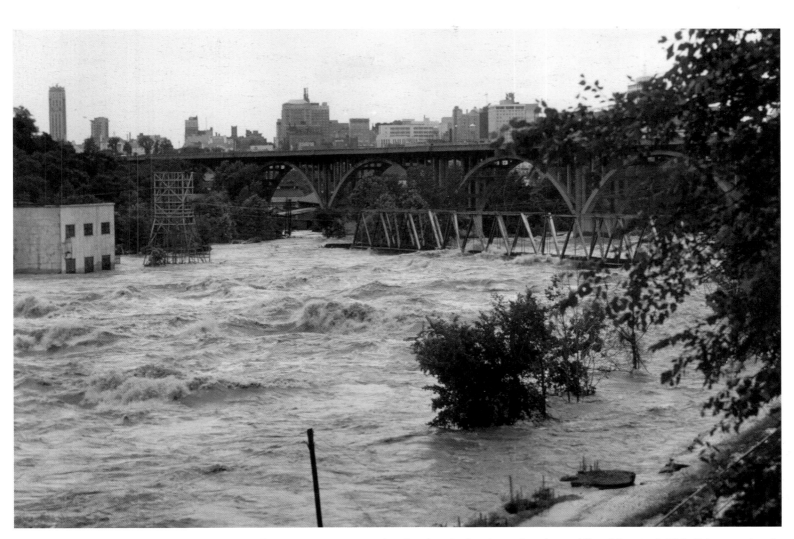

The water level of the James River around Belle Isle, which is located in the middle of the river's "falls," drops so low in the summer that Richmonders can not only walk to and from the island on the rocks—sometimes they can even walk from one riverbank to the other. During a flood, however, the water becomes extremely dangerous and the rapids are spectacular. This stretch of high water on the south side of Belle Isle was photographed during the Hurricane Agnes flood of June 1972. The floor of the little railroad bridge at right is ordinarily a dozen feet above the water.

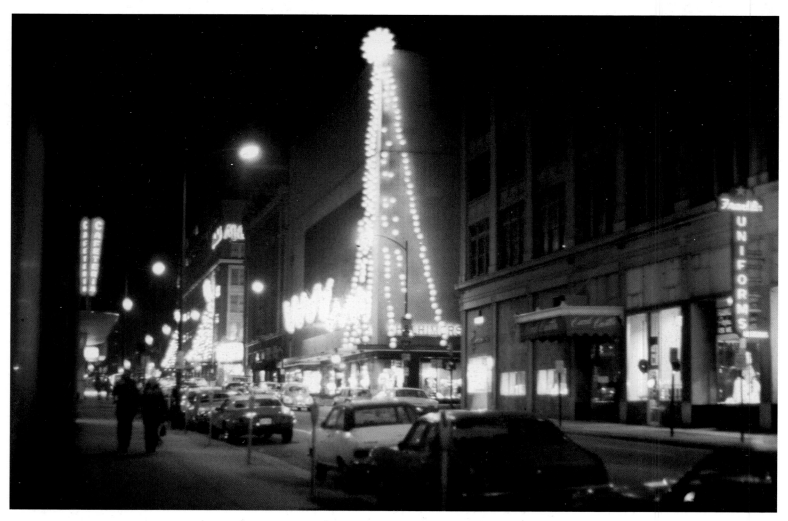

For most of the twentieth century, two locally owned department stores anchored Richmond's downtown shopping area: Thalhimer's and Miller and Rhoads. At Christmastime, each store featured spellbinding window displays, at least for children. Miller and Rhoads had the edge, however: the "Legendary Santa." If he were not actually Santa Claus, generations of children convinced themselves that he was. All other Santas were regarded as mere impersonators. Both stores are now gone, and many Richmonders continue to mourn their passing. Happily, however, the Legendary Santa still makes an annual appearance elsewhere in the city, and when he does, huge crowds of believing children—some of them now gray-haired—turn out to welcome him home.

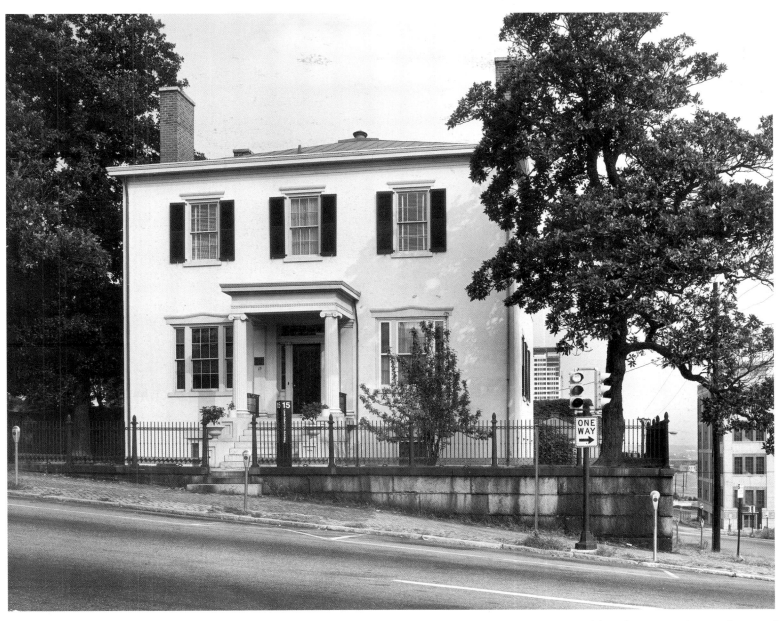

This handsome Greek Revival–style dwelling was completed in 1844 for William Barret, a wealthy tobacconist who was the son of a Richmond mayor. It stands at 15 South 5th Street in a neighborhood that once was thick with such dwellings, of which this is one of the few extant. Mary Wingfield Scott, an indomitable Richmond preservationist, bought the house with her cousin in 1936 to save it from demolition. The property, photographed in 1971, now houses a financial-management firm.

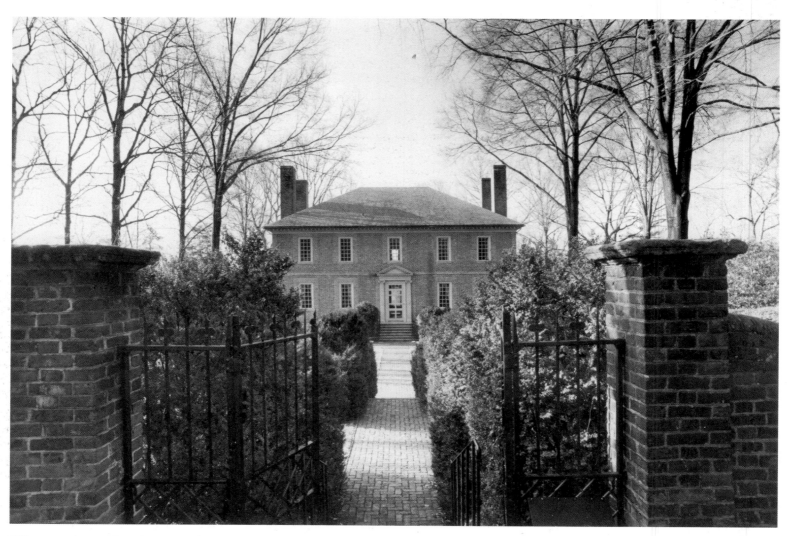

Wilton, an elegant Georgian manor house, was constructed for William Randolph III about 1750–1753. It stood for 180 years on a site overlooking the James River in eastern Henrico County until it was threatened by demolition for industrial facilities. The National Society of Colonial Dames in America bought the house in 1933, carefully dismantled it, and just as carefully reassembled it on a similar site by the river in Richmond's West End. Wilton is known for its spectacular interior paneling and carved main staircase. It is open to the public.

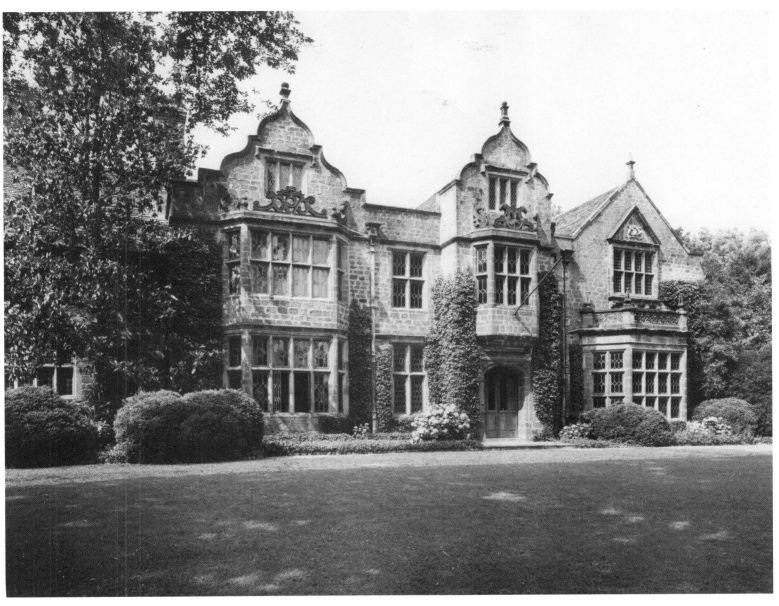

This view of the front facade of Virginia House, constructed of materials from Warwick Priory in England in the 1920s, features the coat of arms of Queen Elizabeth I over the right-hand second-floor window. The sculpture commemorates a visit she made to the Priory in 1572.

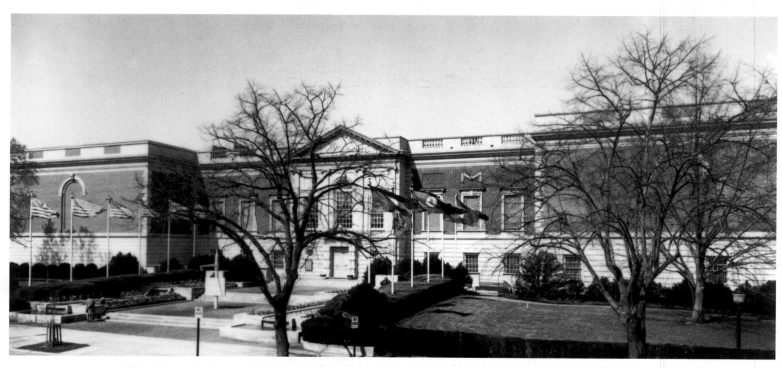

The Virginia Museum of Fine Arts, which is located on Boulevard west of downtown, was established in 1936 as the first such publicly funded institution in the nation. Virginia-born John Barton Payne, a lawyer and chairman of the American Red Cross (1921–1935), donated $100,000 and his own art collection toward the project. Large wings were later added to the Georgian Revival–style building. In 2005, the museum was closed for a major expansion, and it reopened in May 2010.

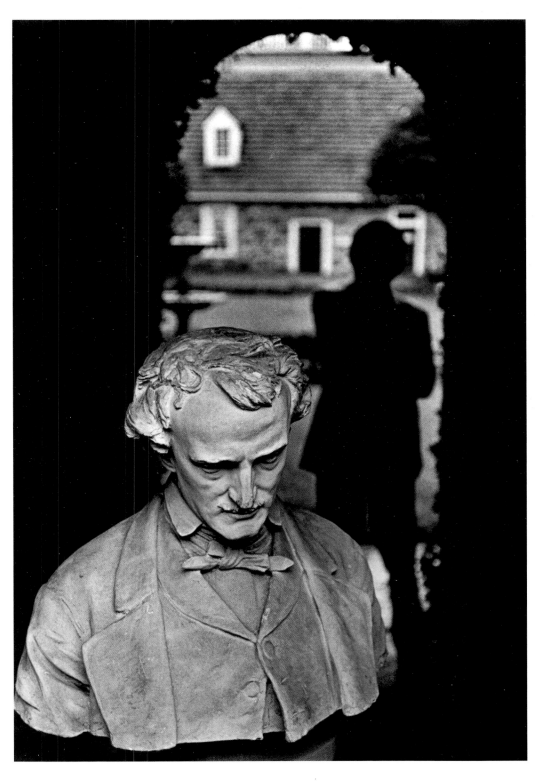

Since 1921, the Old Stone House (in the background), located on Main Street near 19th Street, has been part of a museum honoring Edgar Allan Poe, who spent his youth in Richmond but did not live in the house. The house—there is no other like it in the city—has been the subject of much speculation. It has been called Washington's Headquarters, although there is no evidence linking him to the site. A recent analysis of its structural timbers supports a construction date of about 1754, and the first documented reference to an owner is to Samuel Ege in 1783. It is Richmond's only surviving colonial-era dwelling.

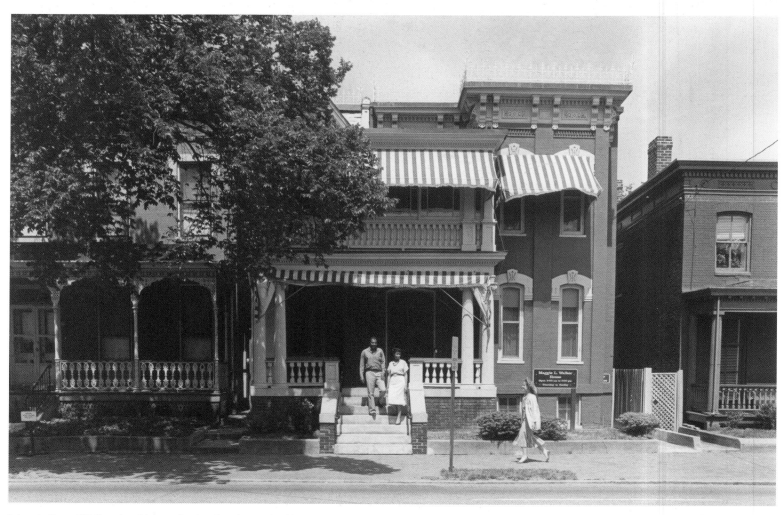

Maggie Lena Walker (1864–1934), the daughter of a former slave, bought this house in 1904. Walker was chief executive of the St. Luke Penny Savings Bank (later the Consolidated Bank and Trust Company), and the nation's first black woman bank president. She was also a founder of the Richmond Council of Colored Women and was active in numerous reform efforts, often taking a leadership role. The National Park Service preserves and interprets the house, which was constructed in the Italianate style about 1883. It was designated a National Historic Landmark in 1975.

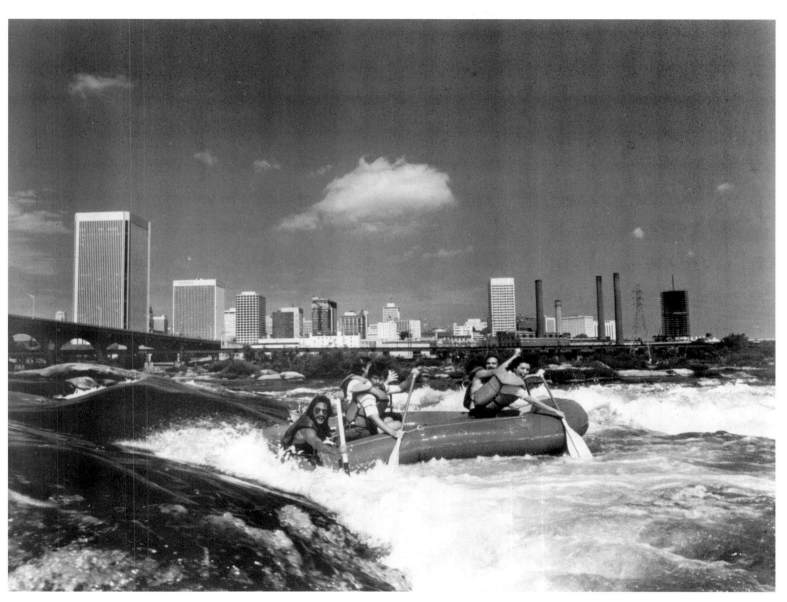

Richmond is located on the "fall line" of the James River—a transitional zone between the rolling Piedmont region to the west and the flatter coastal plain, called Tidewater, to the east. The line itself runs in a southwesterly direction through the state from the Potomac River past the North Carolina border, and each of the rivers through which it passes has "falls" or rapids at the intersection with the line. Richmond is the only large urban area in the country that has white-water rapids in the heart of the city. Kayakers and river runners are familiar sights in Richmond.

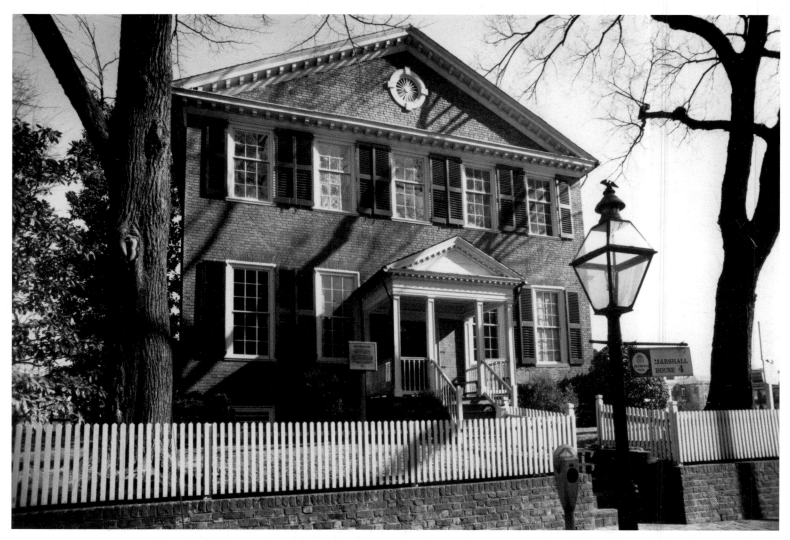

John Marshall, the great chief justice of the United States, built this Georgian house in 1790 and lived there until his death in 1835. Marshall was appointed to the Supreme Court of the United States in 1801 and remained as chief justice for the rest of his life. Although he was frequently in Washington, D.C., during his visits to Richmond, Marshall wrote groundbreaking interpretations of the United States Constitution that still continue to instruct the Court and the United States government. Marshall established the principle of judicial review, which holds that the Supreme Court had the power to invalidate any act of Congress that came into conflict with the Constitution.

John Marshall's descendants owned his house, one of the oldest brick residences in Richmond, until 1907, when the city bought it to save it from demolition. The Association for the Preservation of Virginia Antiquities (now Preservation Virginia) acquired the house in 1911 and interprets it as a museum with many of Marshall's possessions. It was designated a National Historic Landmark in 1966.

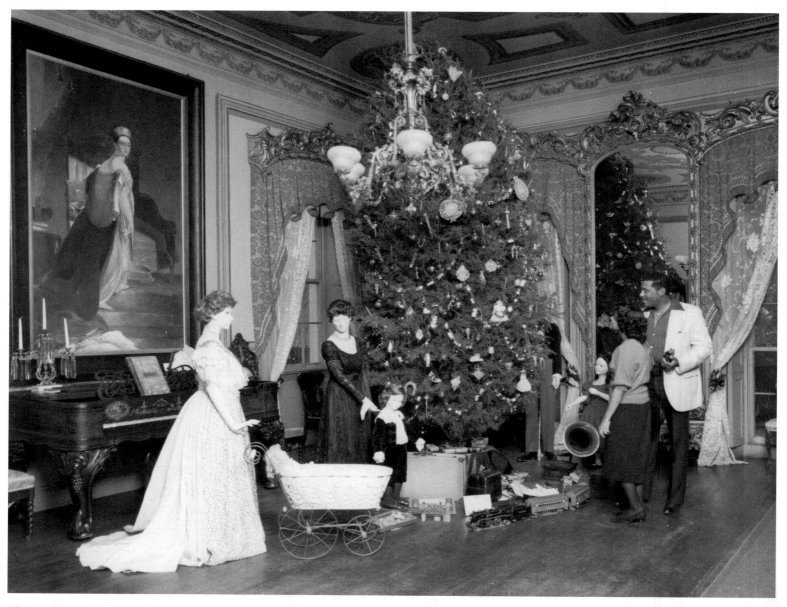

The Wickham-Valentine House, here shown decorated for Christmas, is today home to the Valentine Richmond History Center. Alexander Parris, the Boston architect who designed the Executive Mansion, also designed the Wickham House for local lawyer John Wickham. It was completed in 1812. A later owner, Mann S. Valentine, grew wealthy from his invention of "meat juice," a supposed health tonic. When he died in 1893, he left his extensive collection of art and Virginia Indian artifacts to establish a museum, as well as his mansion in which to house them. The house also includes the remarkable collection of sculptures, papers, and furniture assembled by Mann Valentine's brother, the renowned sculptor Edward V. Valentine. Today, the Valentine Richmond History Center is the city's history museum.

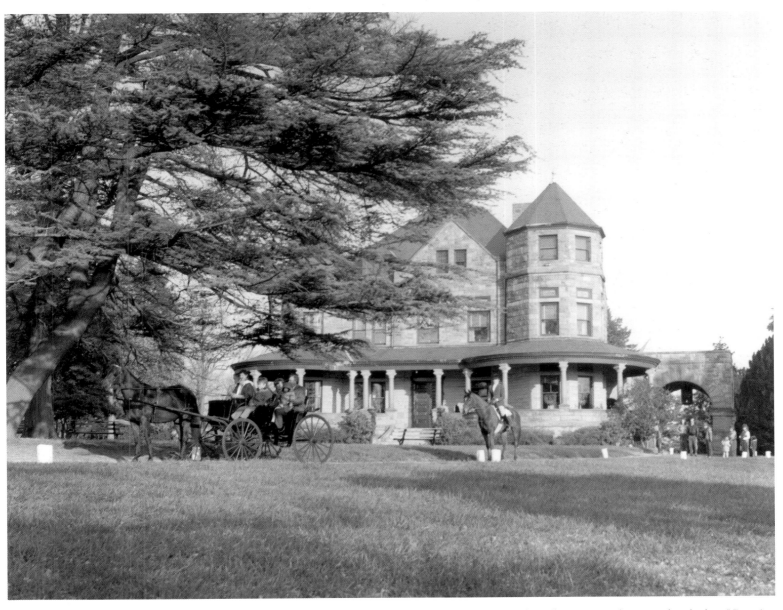

Railroad magnate and philanthropist Major James H. Dooley and his wife, Sallie May Dooley, completed a late-Victorian mansion in 1893 on farmland overlooking the James River west of downtown Richmond. The house featured electric lighting, an elevator, three full bathrooms, and central heat. After the death of Mrs. Dooley in 1925, the estate became a public park adjoining Byrd Park.

This statue of the world-renowned black dancer and actor Bill "Bojangles" Robinson stands at the intersection of Chamberlayne, Leigh, and Adams streets in Jackson Ward, the historic downtown African-American neighborhood. Himself a native of the ward born on North 3rd Street, Robinson had a stoplight installed at the complex intersection to protect children crossing there after a child was injured. Local artist Jack Witt executed the statue, which depicts Robinson tap dancing on a flight of stairs, a scene thankfully preserved for posterity in the movie *The Little Colonel,* filmed in 1935.

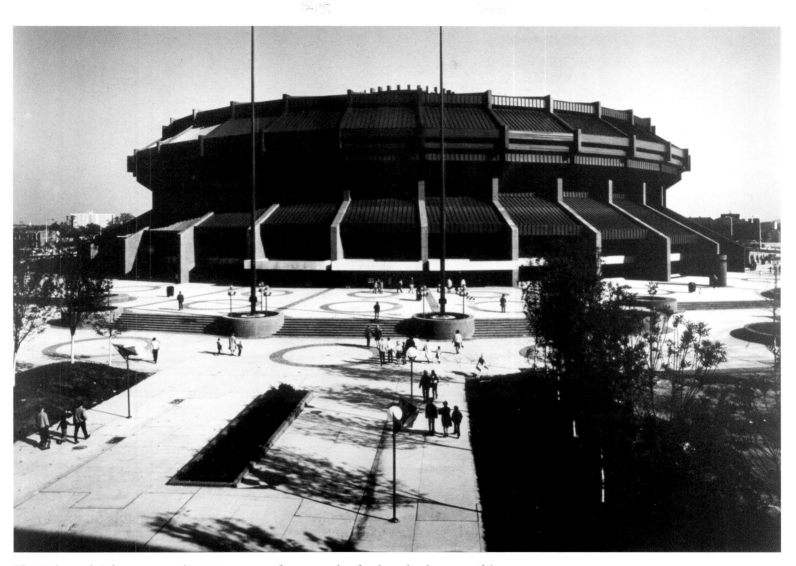

The Richmond Coliseum opened in 1971 as part of a master plan for the redevelopment of downtown Richmond. Since then, the 10,000-seat arena has hosted a vast variety of events, from food festivals to rock concerts to circuses, and also served for a time as the home of a city hockey team.

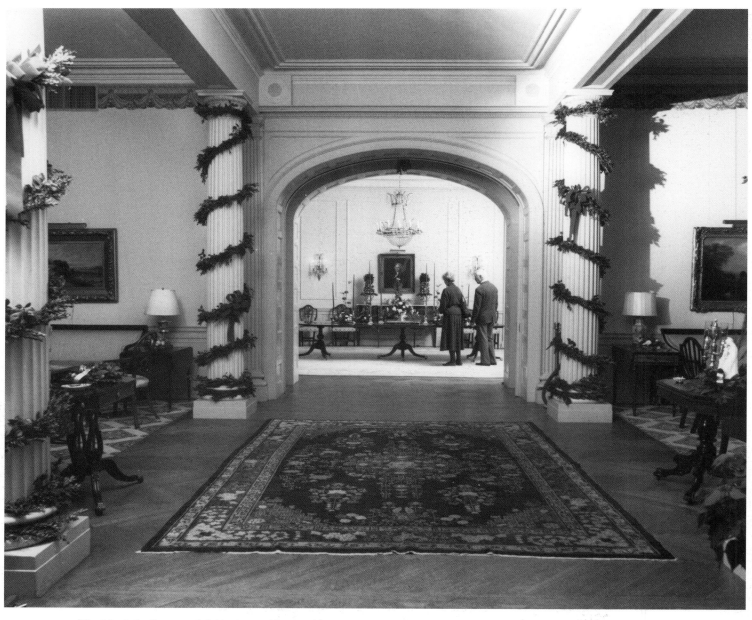

The Virginia Governor's Mansion on the northeastern corner of Capitol Square, shown here decorated for Christmas, is the oldest governor's residence in continuous occupation in the United States. Alexander Parris, a New England architect, designed it, and it was completed in 1813. During the Civil War, the body of General Thomas J. "Stonewall" Jackson lay in repose there, and in 1993, the same honor was extended to tennis great and native son Arthur Ashe. The mansion is a National Historic Landmark.

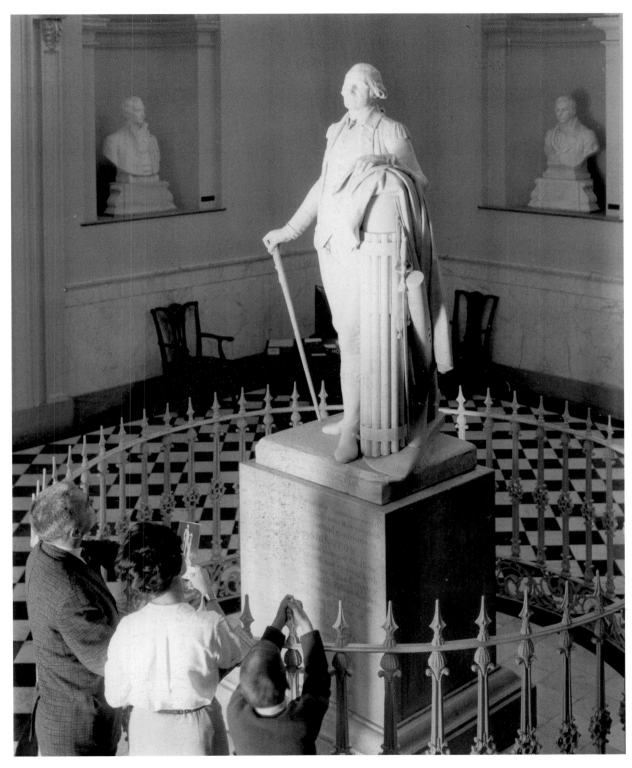

Sculptor Jean-Antoine Houdon carved this statue of George Washington "from life"—from measurements and sketches of the man himself—and Houdon also borrowed parts of the general's Revolutionary War uniform for study. Completed in 1788, the statue has stood in the rotunda of the Virginia State Capitol since 1796 and is probably the most highly esteemed piece of public art in the Commonwealth. Although Washington is not known to have commented on the statue, it was widely admired by those who knew him; they thought it an exact likeness.

The Carillon, located in
Dogwood Dell in Byrd Park,
is Richmond's World War I
memorial. It was completed
about 1928 and stands 240
feet high. John Taylor Bell
Founders of England cast
the original 66 bells that
were at the top and made the
device that played them. The
Carillon now has 53 bells that
are played on veteran-related
holidays and other special
occasions.

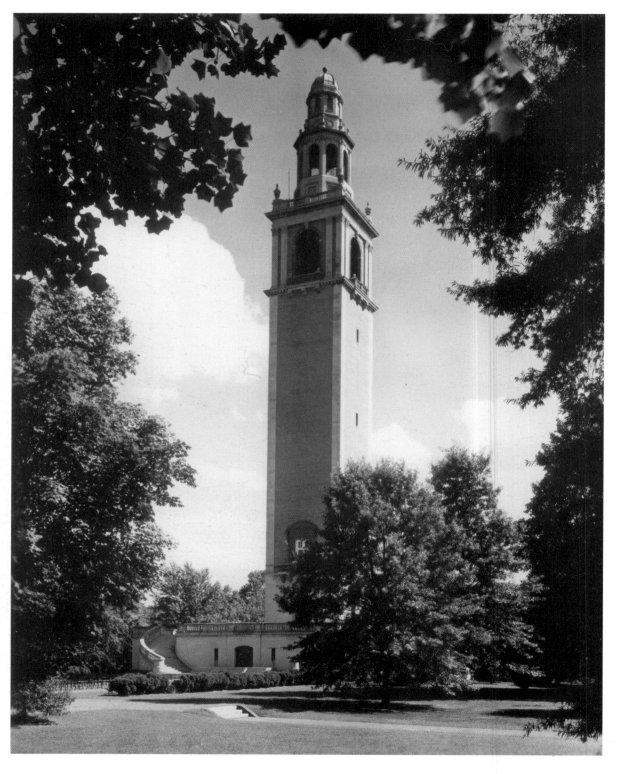

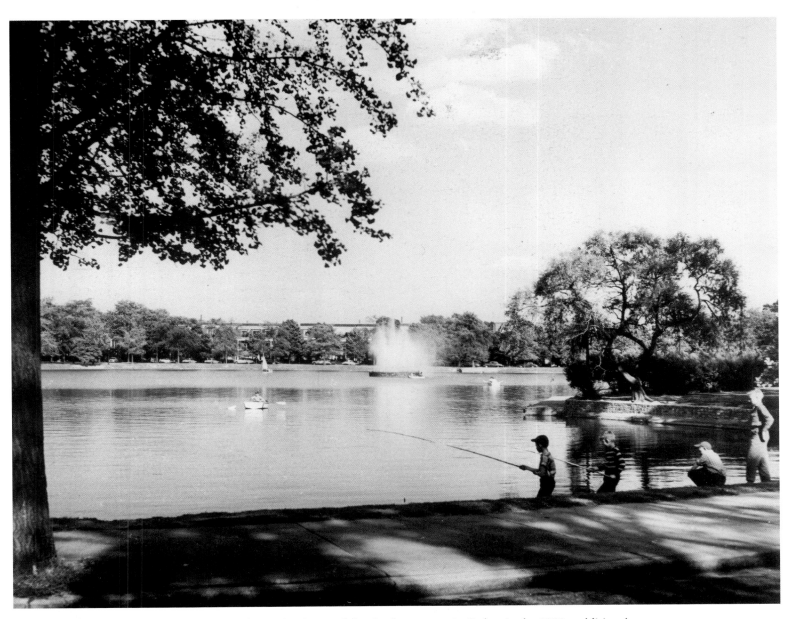

In 1874, Richmond City Council began purchasing land west of the city for a reservoir. By late in the 1880s, additional land had been acquired and Reservoir Park was developed, with a streetcar line nearby. In 1906, the park was renamed to honor William Byrd II, founder of Richmond. Three small lakes—Swan, Shields, and Fountain—lie within the park. The first two were completed by 1915, and Fountain Lake, shown here, was finished in 1925.

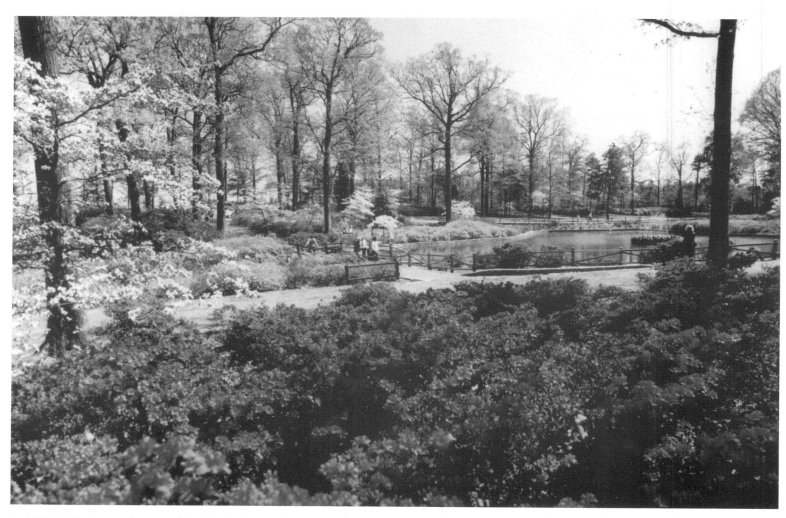

In 1909, Belle Stewart Bryan and her family donated to the city a large tract of land on the north side of Richmond for use as a park in memory of her late husband, newspaper owner Joseph Bryan. Today the park totals 262 acres, with about 175 acres in forest. The remainder has been carefully landscaped and is renowned for its springtime display of blooming dogwoods and azaleas.

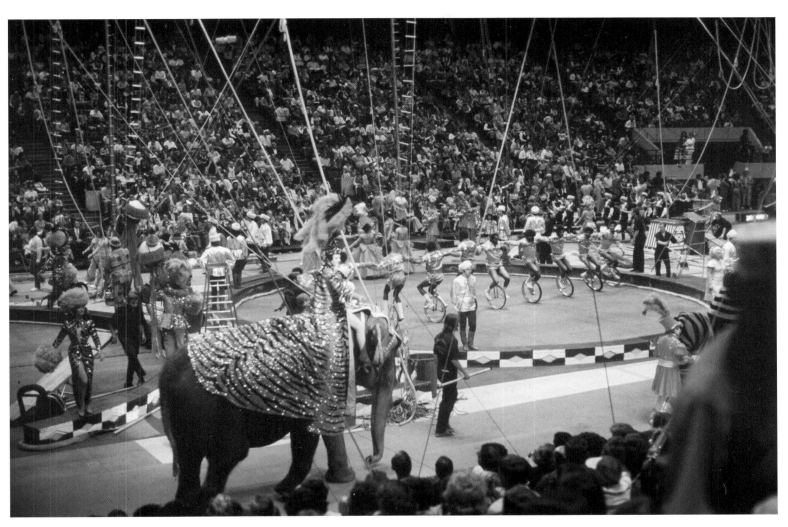

For many years, the Ringling Brothers Barnum and Bailey Circus has appeared in the Richmond Coliseum. Until recently, the circus train parked on the south side of the James River near Belle Isle, and the elephants and other animals marched to the Coliseum in a grand parade. Because of safety concerns and the protests of animal-rights activists, however, the parade no longer takes place.

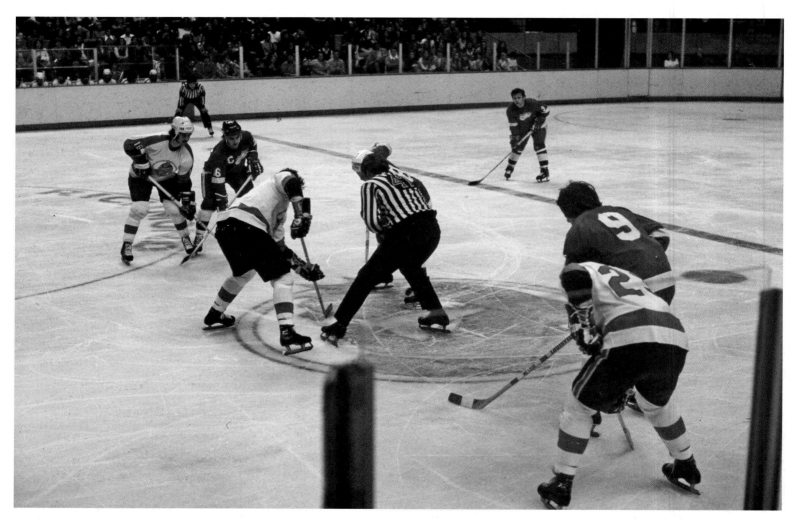

The floor of the Richmond Coliseum can be turned into an ice rink for skating shows and hockey games. From 1971 to 1976, the Richmond Robins played at the venue before the franchise folded. They were followed by two other teams, the Richmond Wildcats and the Richmond Rifles, but neither lasted, and professional hockey disappeared for two decades after 1981.

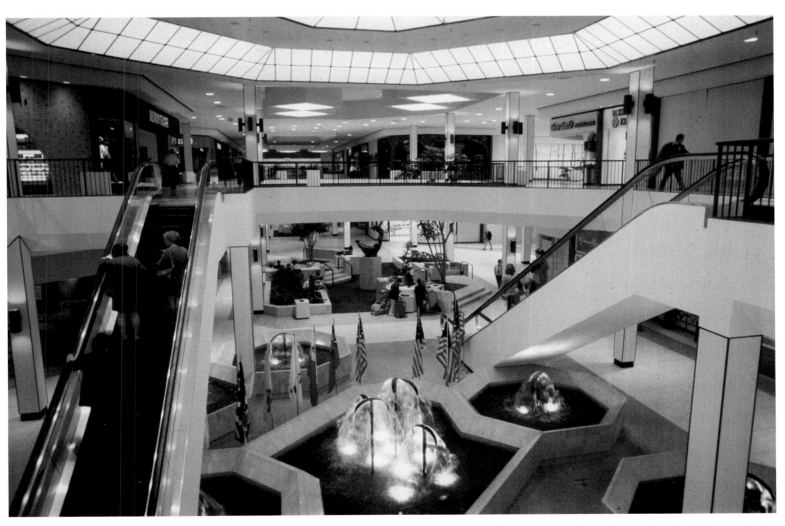

Regency Square, an enclosed shopping mall, opened in western Richmond in 1975 and still thrives. At the time, older outdoor malls such as Cary Court and Willow Lawn were considered passé; enclosed malls, with air conditioning throughout to keep shoppers cool during the city's muggy summers, were seen as the wave of the future. The circle has been closed, however, with the recent construction of open-air, faux-village malls such as Stony Point Fashion Park and Short Pump Town Center, now seen as the wave of the future for shoppers who prefer bricks-and-mortar stores to the Internet. This view, taken in February 1976, shows the mall's atrium.

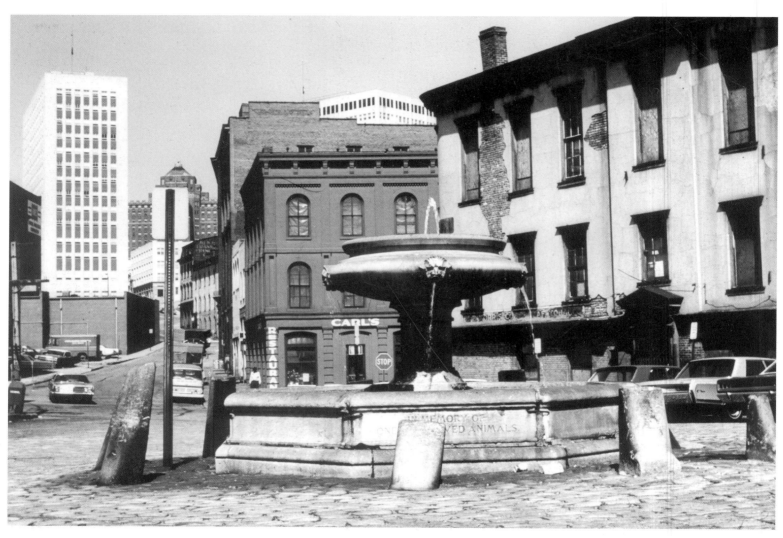

Shockoe Slip, photographed in 1976, has been since the 1970s one of Richmond's most-bustling downtown dining and entertainment venues. The area was destroyed during the Evacuation Fire of April 3, 1865, but was quickly rebuilt, largely in the Italianate style. Before the fire, cobblestone streets and a small piazza with a water fountain connected the financial district on Main Street with the James River and Kanawha Canal. That connection has been restored, although the canal is now part of River Walk, a pedestrian park on the north bank of the James River. Shockoe Slip had declined until a major restoration effort began in the 1970s, and since then has undergone a veritable explosion of restaurants, nightclubs, and shops.

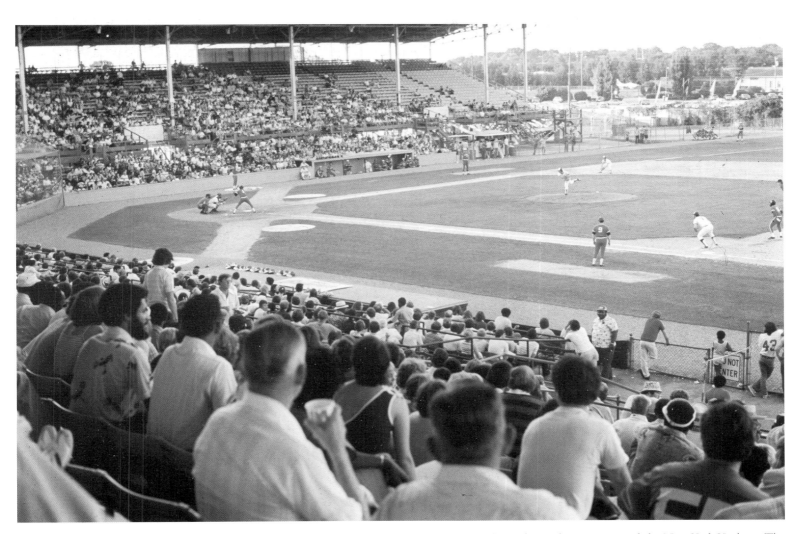

Parker Field opened on April 8, 1954, with a game between the Richmond Virginians and the New York Yankees. The Yankees won, 7–2. The Virginians, a triple-A minor-league team, later became affiliated with the Atlanta Braves and underwent a name change to Richmond Braves. This game was photographed in July 1977. In 1985, a new stadium known as the Diamond opened on the site of Parker Field.

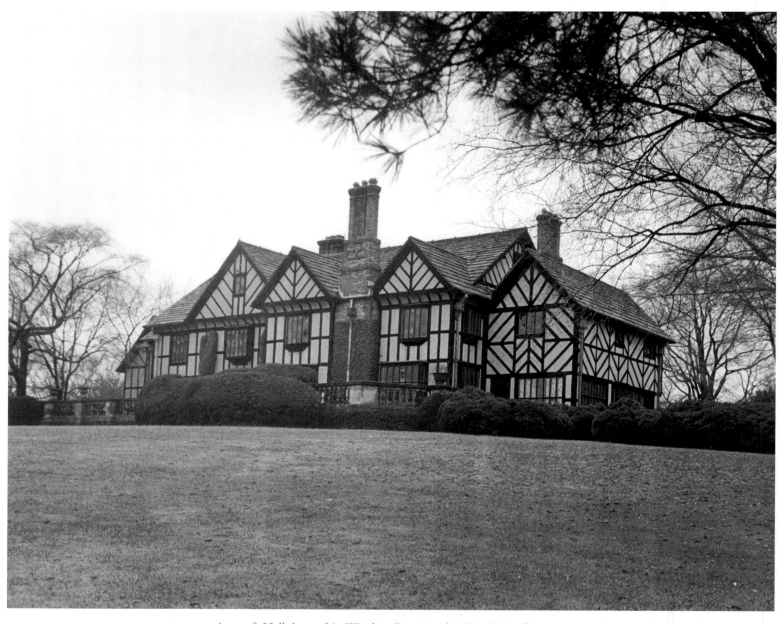

Agecroft Hall, located in Windsor Farms in the West End of the city, was photographed in 1978. Thomas C. Williams, Jr., who developed Windsor Farms, disassembled John Langley's post-medieval manor house near Manchester, England, in the mid-1920s and reassembled it in modified form on a bluff overlooking the James River. Noted landscape architect Charles F. Gillette designed the Elizabethan-style gardens and grounds.

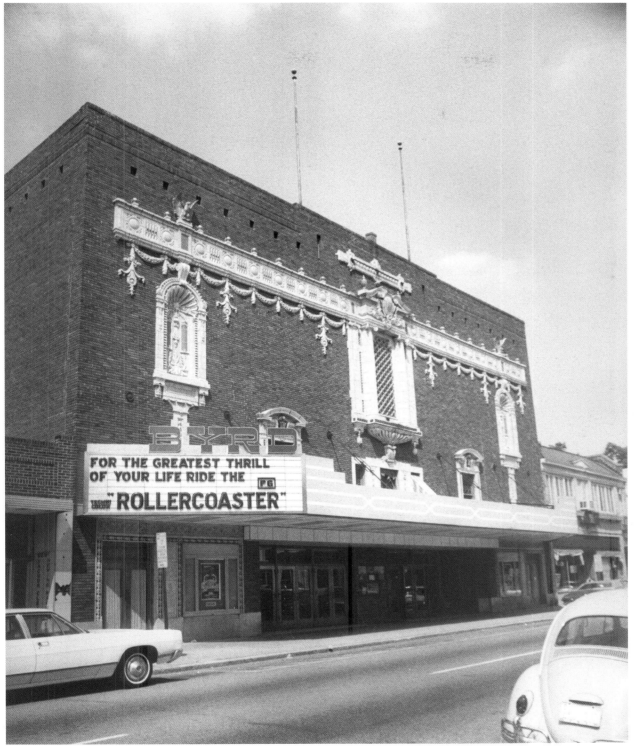

The Byrd Theatre, which opened in 1928, is located in an area of Richmond known as Carytown, on Cary Street west of Boulevard. It was one of the first movie palaces outfitted with sound equipment, the first successful "talkie" (*The Jazz Singer*) having premiered just a year earlier. This exuberantly decorated theater is still a popular venue, packing in crowds with second-run movies and discounts. For many years, local organist Eddie Weaver entertained the audience before each show on the meticulously maintained original Wurlitzer pipe organ.

Richmond's architecture represents many of the styles that were popular over the centuries. Some styles, though popular in different parts of the country, are relatively scarce in Richmond. One of them is the Art Deco style: it is not unknown in the city, but the examples of it are scattered and tend to be smaller buildings. An outstanding large exception is the former Central National Bank building, perhaps Virginia's best Art Deco skyscraper, located at 219 East Broad Street. Designed by New York architect John Eberson, it was completed in 1930. It is presently being rehabilitated for offices and condominiums.

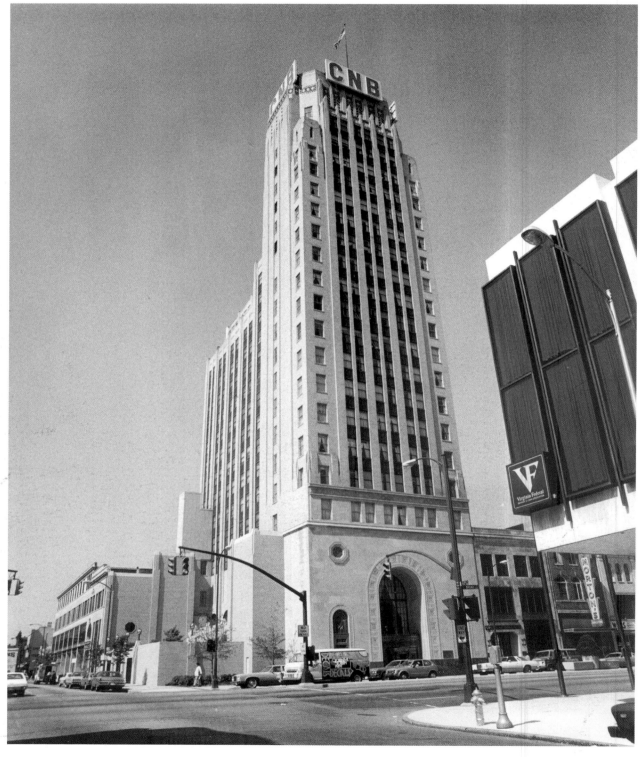

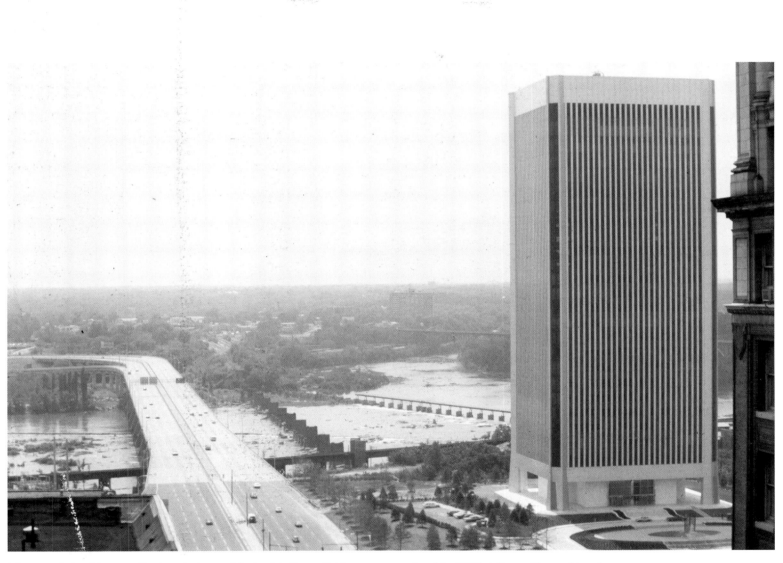

The new Federal Reserve Bank, seen here with the 9th Street Bridge, was completed in 1978. Minoru Yamasaki and Associates, the designers of the World Trade Center in New York City, also designed this building, which looks like a shorter version of one of the Twin Towers. Since the terrorist attack on September 11, 2001 (rumors swept the city that this structure had also been slated for attack), the then-open park around the building has been closed off and is now carefully guarded.

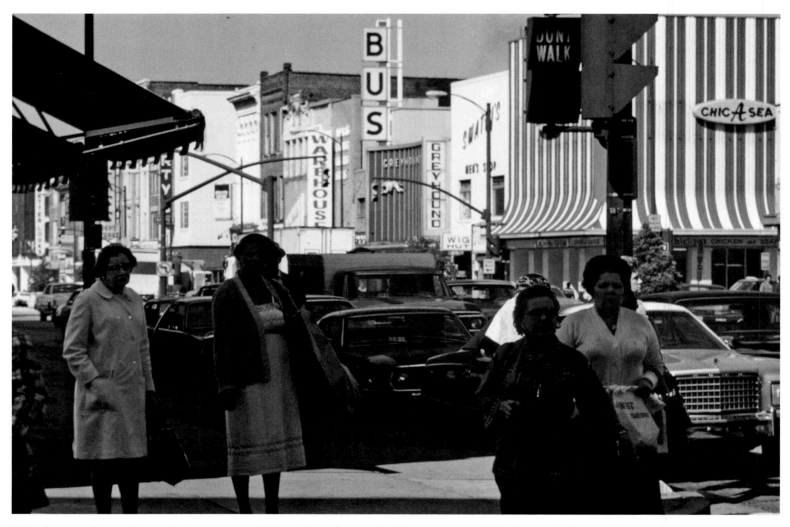

This photograph was taken at the intersection of 6th and Broad streets, looking west toward 5th Street and showing the north side of Broad Street in the sunlight. Part of the Richmond Convention Center now occupies the entire block where the Greyhound Bus Station once stood.

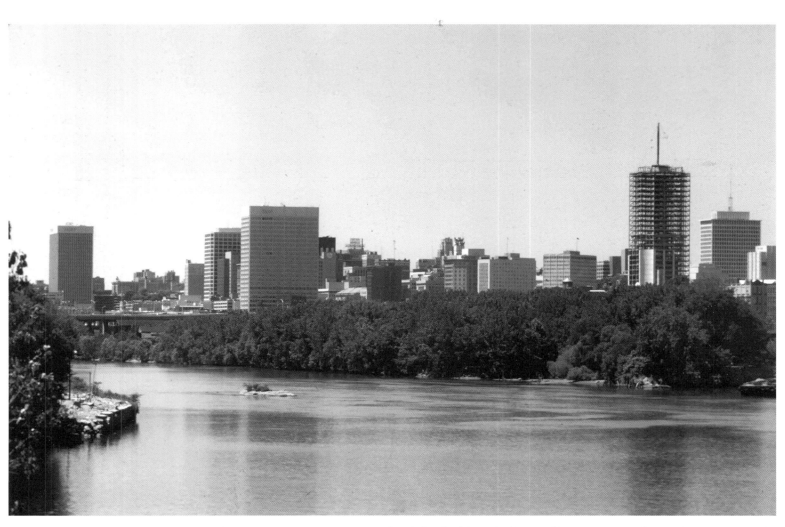

Late in the 1970s, the state government decided to build two high-rise office towers east of Capitol Square. One, the Monroe Building, is seen under construction on the right in this June 1979 photograph. It was completed in 1981. The other tower was never built, except for the base.

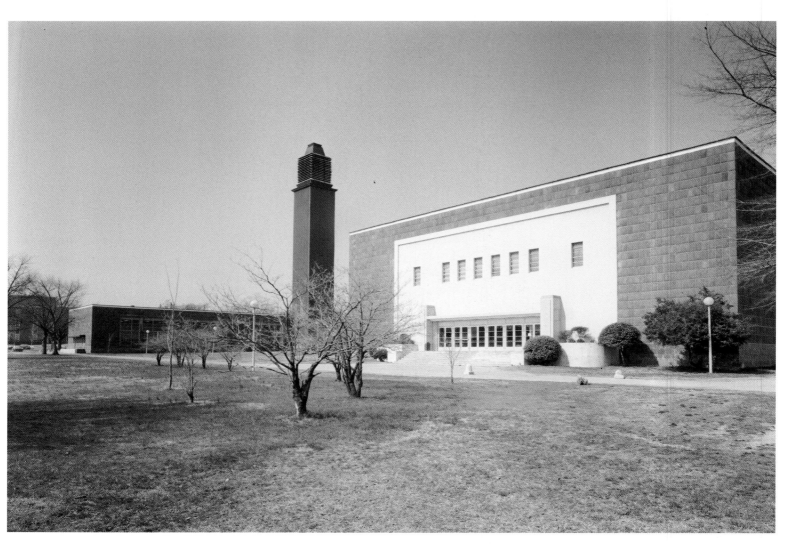

The Belgian Building, or Belgian Friendship Building as it is formally named, was designed for the country of Belgium to exhibit at the 1939 New York World's Fair. The structure was to be moved to Belgium after the fair closed, but the Nazi occupation of that country made it impossible. Instead, the building was given to Virginia Union University, a traditionally black institution of higher education in Richmond, and reconstructed on the campus in 1941.

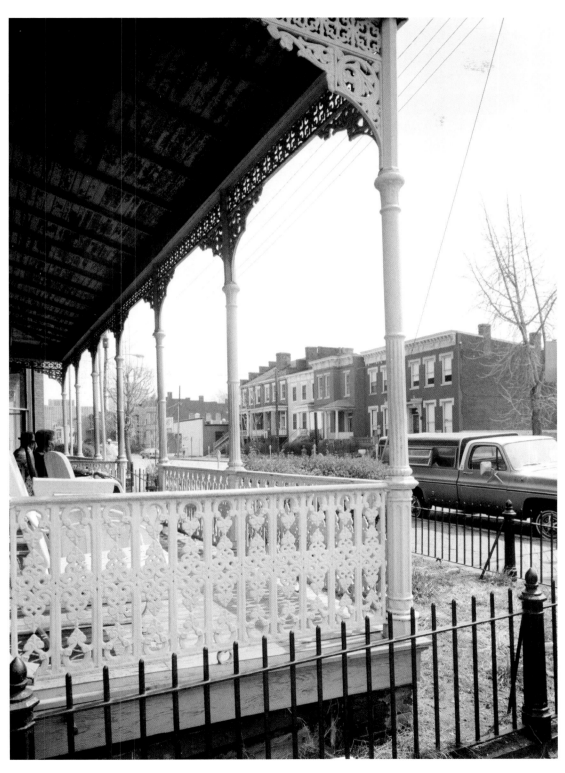

The Jackson Ward Historic District, a National Historic Landmark, was among the foremost African-American communities in the United States early in the twentieth century. Called "the Harlem of the South," it is the nation's largest historic district related principally to black enterprise and culture. Second Street, or "2 Street," as it was popularly known, was famous for its nightlife and was long regarded as the heart of the community. Among the neighborhood's noted residents were the first African-American woman bank president Maggie L. Walker, publisher John Mitchell, Jr., clergymen William Washington Browne and John Jasper, entertainer Bill "Bojangles" Robinson, and attorney Giles Beecher Jackson, the first black admitted to practice before the Supreme Court of Virginia. The district is so renowned for its cast-iron porches, such as the one shown here on Clay Street, that it is alleged that Jackson Ward has more of them than the French Quarter in New Orleans.

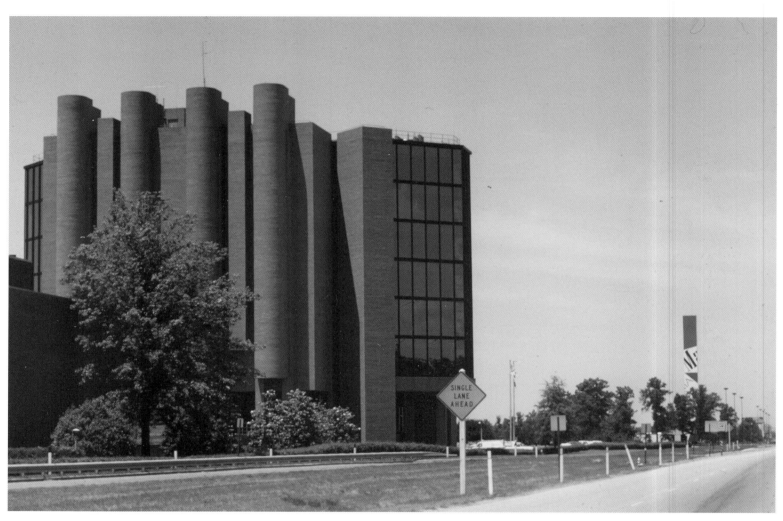

Philip Morris, the tobacco giant with British roots, began manufacturing cigarettes in Richmond in 1929. It opened a huge new plant on Stockton Street in South Richmond in 1939. This photograph of the plant was taken in June 1979.

Notes on the Photographs

These notes, listed by page number, attempt to include all aspects known of the photographs. Each of the photographs is identified by the page number, photograph's title or description, photographer and collection, archive, and call or box number when applicable. Although every attempt was made to collect all data, in some cases complete data may have been unavailable due to the age and condition of some of the photographs and records.

II INTERSTATE
Library of Virginia
10_0972_001

VI FRANKLIN STREET INTERSECTION
Library of Virginia
09_0145_00110_Rice112H1

X VIEW FROM CARY STREET
Library of Virginia
09_0145_00012_Rice144A1

3 ST. JOHN'S EPISCOPAL CHURCH
Library of Virginia
013389

4 JOHN STUART BATTLE INAUGURATION
Library of Virginia
09_0145_0002_Rice15K1

5 ART SHOW, BYRD PARK
Library of Virginia
09_0145_0001_Rice11A1

6 BYRD FIELD DEDICATION
Library of Virginia
013489

7 MILBURNE, WINDSOR FARMS
Library of Virginia
013294

8 BELLEVUE ARCH
Library of Virginia
013556

9 ABC LAB TECHNICIAN
Library of Virginia
014149

10 EASTERN AIR LINES FLIGHT 601
Library of Virginia
09_0145_00101_Rice53O1

11 MEADOWBROOK
Library of Virginia
013607

12 KEEL'S HOBBY SHOP
Library of Virginia
014462

13 EQUITABLE LIFE INSURANCE COMPANY
Library of Virginia
014467

14 THE MOSQUE
Library of Virginia
014989

15 FIRST ANNUAL VIRGINIA ANTIQUES FAIR GRAND OPENING CEREMONY
Library of Virginia
014990

16 SECOND ANNUAL VIRGINIA ANTIQUES FAIR
Library of Virginia
014892

17 FIRST ANNUAL VIRGINIA ANTIQUES FAIR
Library of Virginia
015007

18 AMERICAN TOBACCO COMPANY TASTE TEST
Library of Virginia
014191

19 AMERICAN TOBACCO COMPANY LAB TECH
Library of Virginia
014183

20 AMERICAN TOBACCO COMPANY WORKER
Library of Virginia
014176

21 LUCKY STRIKE CIGARETTE FACTORY
Library of Virginia
014180

22 ASHLAND DEPOT
Library of Virginia
014764

23 FORD PARTS DEPOT
Library of Virginia
014200

24 VIRGINIA HOUSE
Library of Virginia
014548

25 VIRGINIA HOUSE INTERIOR
Library of Virginia
014545

26 VIRGINIA BEACH SAND FESTIVAL DISPLAY
Library of Virginia
014973

27 MILLER AND RHOADS DEPARTMENT STORE
Library of Virginia
09_0145_00311_Rice97D1

28 FORD PARTS DEPOT BUILDING
Library of Virginia
014195

29 FORD EXECUTIVES
Library of Virginia
014193

30 RICHMOND DAIRY COMPANY
Library of Virginia
014153